IMAGES
of America

FAIRMOUNT

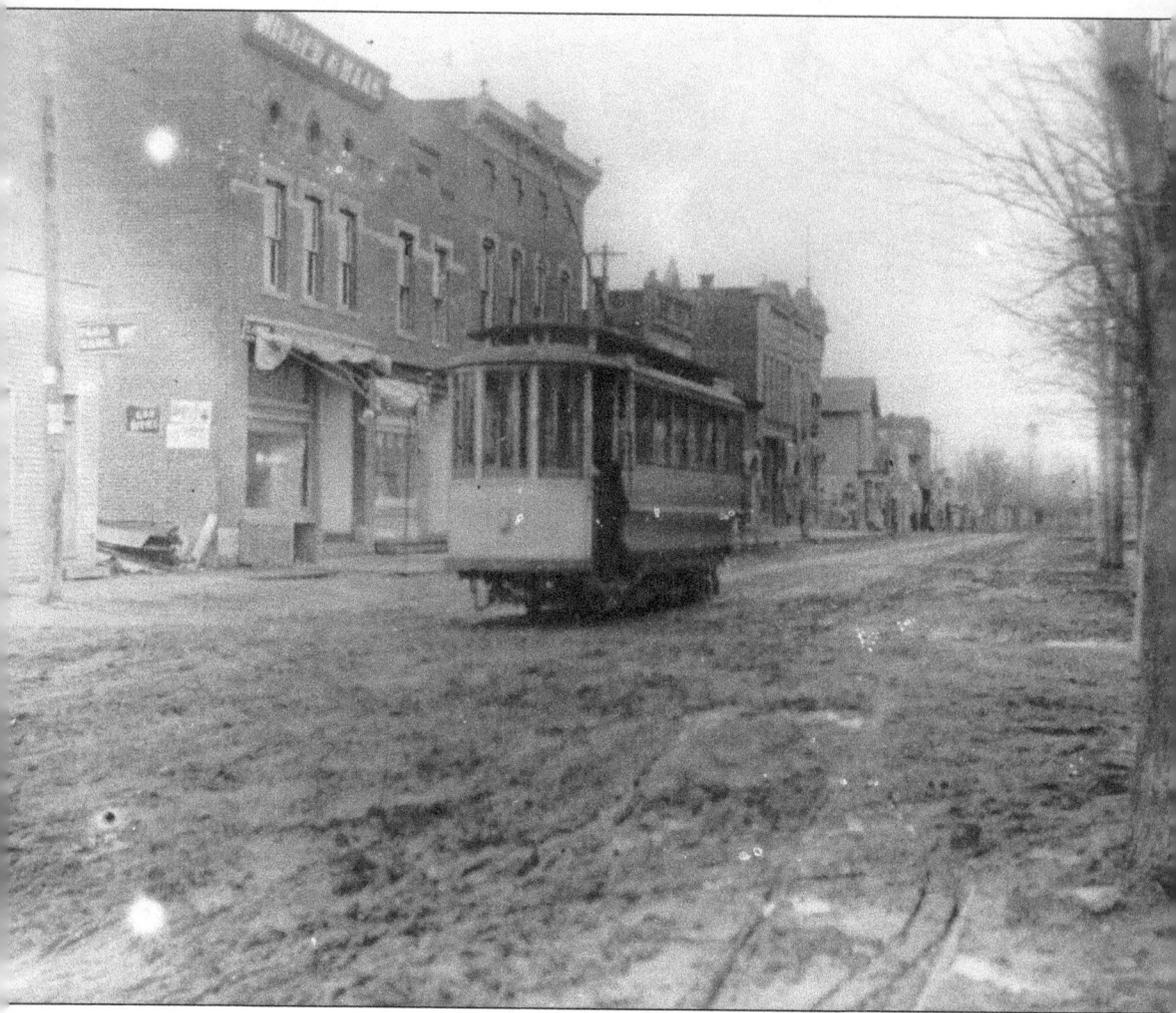

In the 1890s, the fare for the streetcar running from Fairmount to Jonesboro was 5¢. Here it heads north on muddy Main Street preparing to pass the Scott Opera House, built by civic and business leader Levi Scott in 1884. The 600-seat opera house was the setting for local plays, traveling theatre troupes, lectures, and readings by the likes of Hoosier poet James Whitcomb Riley and presidential candidate William Jennings Bryan. (Selby family collection.)

ON THE COVER: Taken in 1921, this was a holiday basket giveaway to those in need. The Kiwanis members are, from left to right, (first row) unidentified, Dr. P. D. Holliday, William M. Jones, Otho S. Compton, three unidentified, Ottis Wilbern, Otto J. Hamilton, Rhinehard Busing, Hal V. Dale, Dr. Harry Aldrich, Burl D. Jay, Ralph J. Parker, Bernard D. Allred, S. Brooks Hill, Palmer Ice, Wayne Fowler, Victor A. Selby, and unidentified; (second row) Guy Lewis, John Siegel, Lamont Brown, Albert Riggs, Jesse Hipple, unidentified, ? Wellman, W. Horton Ribble, and Clyde Lewis. (George Siegel.)

IMAGES
of America

FAIRMOUNT

Cathy Duling Shouse and the
Fairmount Historical Museum

ARCADIA
PUBLISHING

Published by Arcadia Publishing
Charleston SC, Chicago IL, Portsmouth NH, San Francisco CA

Library of Congress Control Number: 2009943816

For all general information contact Arcadia Publishing at:
Telephone 843-853-2070
Fax 843-853-0044
E-mail sales@arcadiapublishing.com
For customer service and orders:
Toll-Free 1-888-313-2665

Visit us on the Internet at www.arcadiapublishing.com

To Jim, Matthew, and Katelyn
and in memory of my father, Fred C. Duling

CONTENTS

ACKNOWLEDGMENTS

The Fairmount Historical Museum's photograph collection provided the inspiration for this book. I appreciate the museum board members, especially president Gale Hikade, for upholding Fairmount history and hosting the annual James Dean Festival the last weekend in September.

For their essential research help, my deepest thanks goes to the following people: Fairmount historian David E. Broyles, for assistance with photograph arrangement and text; John Selby, for after-hours work sessions at the Citizens Exchange Bank with me and David; David Loehr at the James Dean Gallery for his vision for the project; Marcus Winslow for James Dean photographs; and Ron Payne for making this book happen.

Special thanks goes to Matthew Shouse for his technical assistance, Katelyn Shouse for her organizing skills, Historic Fairmount, Inc., and Main Street Fairmount for passion for this project and our town.

It is impossible to list everyone who helped. However, I am grateful to the following people: Milford Adams, Jayne Babcock, Harold and Millie Bowman, Stan Corliss, George Dicken, Janiece Duling, Fairmount Antique Mall, Fairmount Public Library, Bruce and Mae Gossett, Jim Gaddis, Curt and Sheryl Hackney, Jim Hayes, Dr. Dennis E. Hensley, Jill Riley Henry, Betty Metzger Hiatt, Dian Hoheimer, Mary Carolyn Jones, Indiana Romance Writers of America chapter, Dorothy Leach, Ruth Lewis, Patryce Loftin, Marion Public Library Museum, Linda Marley, Bob Mcmanaman, Roz Carter McCarty, the Midwest Writers Workshop, Charline Mitchener, Gib Mitchener, Phil "Sparky" Mitchener, Paws, Inc., Marsha Smithson, Bill and Janice Payne, the Joe E. and Frieda Payne family, Joan Peacock, David Penticuff, the Rust family, George Siegel, Don Spahr, and Nancy Wood. Some photographs were duplicates, and I regret not being able to use everything. Any errors are mine.

I am grateful for guidance from Earl L. Conn, who passed away before the book's completion.

Photographs are courtesy of the Fairmount Historical Museum unless otherwise noted or by anonymous donors. The Selby Family Collection (SFC), the James Dean Gallery (JDG), and Marcus Winslow (WFC) also contributed numerous images.

INTRODUCTION

An 1830s map on the wall of the old state capital in Corydon still shows Grant County to be part of the Miami Indian territory. Nonetheless, the first nonnative pioneers had started arriving in the 1820s. McCormack's Tavern was established in 1829 in the northeast part of Fairmount Township at the intersection of the Old Indian Trail and the Indianapolis and Fort Wayne Roads.

Quakers from North Carolina came here to live in a slave-free state. They established themselves in what was to become Fairmount. Other pioneers and people of faith came from the South and East for the opportunity offered by federal land grants signed by Pres. Andrew Jackson.

The flat, featureless virgin forest was interrupted only by bogs, creeks, rivers, and occasional bits of prairie. The oaks and walnuts were 5 to 6 feet in diameter. The poplars, the state tree, were 10 to 11 feet in diameter. The soil beneath the trees was rich and ready for industrious farmers. Game abounded in the forest. Water sprang from the earth. A more ideal setting for a pioneer is hard to imagine.

The roads were Indian trails or nonexistent. Some visiting their land-grant property for the first time had to dismount their horses and clear the way with an axe. The forest blocked much of the sunlight, and the pervading shade and gloom was depressing to early settlers. Large trees were cut for cabins and barns; many more were cut and burned to clear the fields. This was a tragic waste by today's standards but was the only way to get sunlight down to the people and crops.

There were pitfalls and hardships. Timber wolves and timber rattlesnakes were more than plentiful and provided unwelcome hunting opportunities up until the late 1800s. Cholera, typhoid, diphtheria, whooping cough, and consumption took their toll. Getting lost at sundown in the great forest that looked all the same no matter what direction one faced was common and often tragic in the early days.

The pioneers usually made anything they needed, from shelter to farm tools to daily utensils, or they made do without. Farm families were large out of necessity. There were many types of crops to plant, tend, and harvest. Cattle, pigs, goats, and chickens were raised for farm use and for sale in nearby towns and to neighbors. There were sheep to tend and shear. There was wool to be spun and woven into cloth to be made into clothing. In winter, the people would go to the frozen rivers to harvest ice for the icehouses.

Fairmount was first platted in 1850. Previous to that time, it had been known by some as Pucker. No doubt this was a humorous reference to the boggy topography of the town site. David Stanfield, an early settler who the town's first addition is named after, wanted to call the town Kingston. Stanfield's son-in-law Joseph W. Baldwin had visited the Fairmount Water Works Park in Philadelphia and preferred that name. They left the decision to the surveyor who was laying out the Stanfield Addition, and Fairmount it became.

The channel for Back Creek only existed from the north side of town up to the Mississinewa River in Jonesboro. South of there, through town and three miles south, it was a half-mile-wide, mucky, juicy bog. To address this issue in 1854, Irish laborers were hired to dig the present

channel through town, providing a means of draining the flat land. East of Main Street ran a small tributary aptly named Puddin' Creek. The headwaters of this indistinct feature were fed by several natural springs. In 1889, some 12- and 15-inch drainpipes were laid to direct the wetness down to Back Creek.

The high water table that powered Puddin' Creek's springs also provided water for the town. Everyone had a well, and rivalry as to whose well produced the best water came to an end when the town water system came into being in 1889. It was good that the water supply was piped, as outhouses were in use well into the 1930s.

Fairmount's position between Indianapolis and Fort Wayne made it a natural station on the Underground Railroad, the means that slaves were smuggled north to freedom through Fairmount. Many local Quaker homes served this noble effort. The Quakers' enlightened views also brought higher education and a fine sense of community. The Fairmount Academy was one of the earliest institutions for learning beyond eighth grade. Writer Richard Simons stated in the July 30, 1950, *Indianapolis Star Magazine* that Fairmount was a "culture capital," especially in education and literature, and it had produced some of the nation's leading educators. Simons wrote, "For every 230 persons in town today, there has been one listed in *Who's Who*."

Discovery of bountiful gas reserves brought entrepreneurs and industry. The population boomed as workers came for factory jobs. The Scott Opera House and the Fairmount Fairgrounds brought hundreds and thousands, respectively, to town.

They came from Jonesboro down the turnpike, a wood-planked toll road. The journey could be made on an electric streetcar when streets were still mud. Two railroads and later the interurban connected Fairmount to the outside world.

Thousands still come to Fairmount every year, mostly to make a pilgrimage to James Dean's hometown. They visit his haunts, walk these tree-lined streets, and try to understand the roots that spawned greatness in Dean as well as so many others.

They discover the hands-on sense of unselfish accomplishment as typified by Fairmount's volunteer fire department, the Fairmount Historical Museum, the Friends of the Fairmount Public Library, the Helping Hands, and the Madison-Grant Youth Basketball League, in addition to Fairmount's Main Street organization. This can-do spirit has defined Fairmount.

Acclaimed artist Olive Rush went into the world as a girl with a dream and immense talent and produced a vast treasure of work that still delights. Jim Davis managed the same with Garfield, a cartoon cat recognized and loved around the globe. James Dean's acting greatness has withstood the test of time, inspired countless people, and continues to do so.

Fairmount High School graduate Robert Sheets ran the National Hurricane Center for many years, while Phil Jones became a television journalist for CBS.

The images contained here are not a comprehensive look at the Fairmount area but rather a collection of photographs to provide a glimpse of the establishment of the Fairmount community and show life in more recent times as well. In many ways, Fairmount streets of today are not so very different from days gone by.

One

BEGINNINGS OF A TOWNSHIP

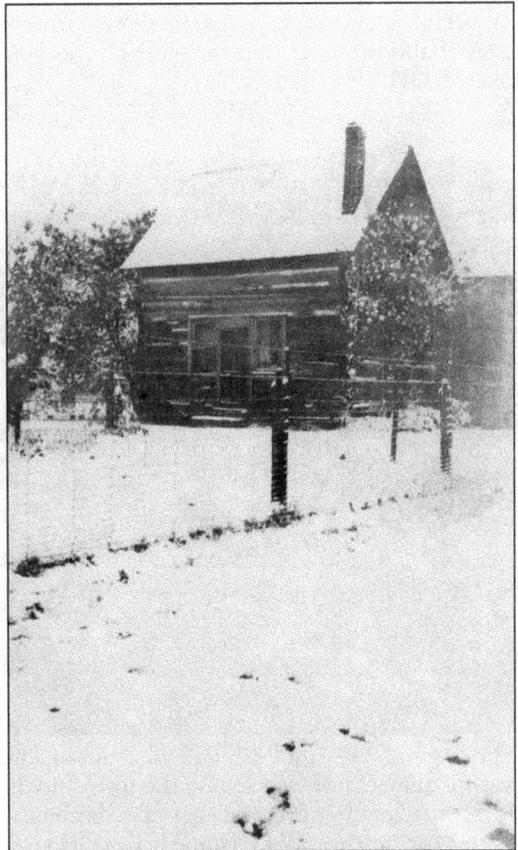

In 1856, Thomas Dean Duling and Nancy Miskimon Duling built this log house five miles east of Fairmount. The family had arrived in the township in 1845. Like others, they constructed their home from trees of the virgin hardwood forest. Duling family members lived there, with several renovations, into the 1950s when Helen, Don, Mae, Fred, and Linda Duling were growing up. About 1960, the Dulings sold the property, but the house remains, covered with aluminum siding.

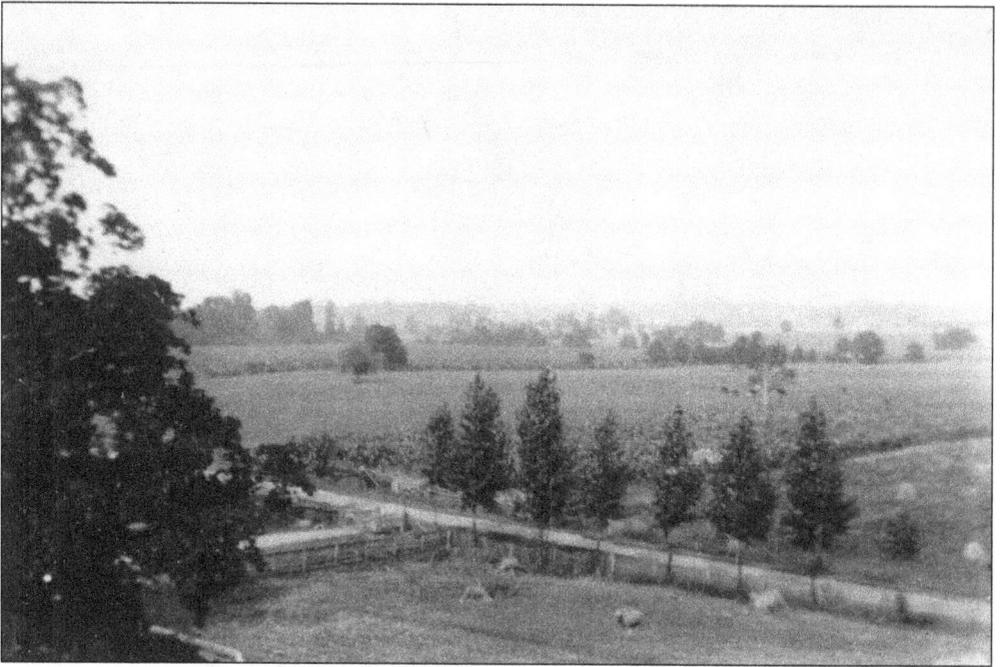

Taken in 1904, this scenic view is from the windmill on the Rush family farm situated atop Rush Hill. It is looking northeast toward what is now 100 East. *The Making of a Township,* by Edgar Baldwin, states that Iredell Rush was among the first settlers in the township, arriving around 1831.

The original home on Rush Hill was built in 1852 and remodeled about 1900. The Rush family was instrumental in developing the township. Nixon Rush's daughter Olive Rush was born in 1873, raised on the farm, and grew up to become a renowned artist. Olive's talent as an illustrator landed her steady work for *Harper's, Good Housekeeping,* and more.

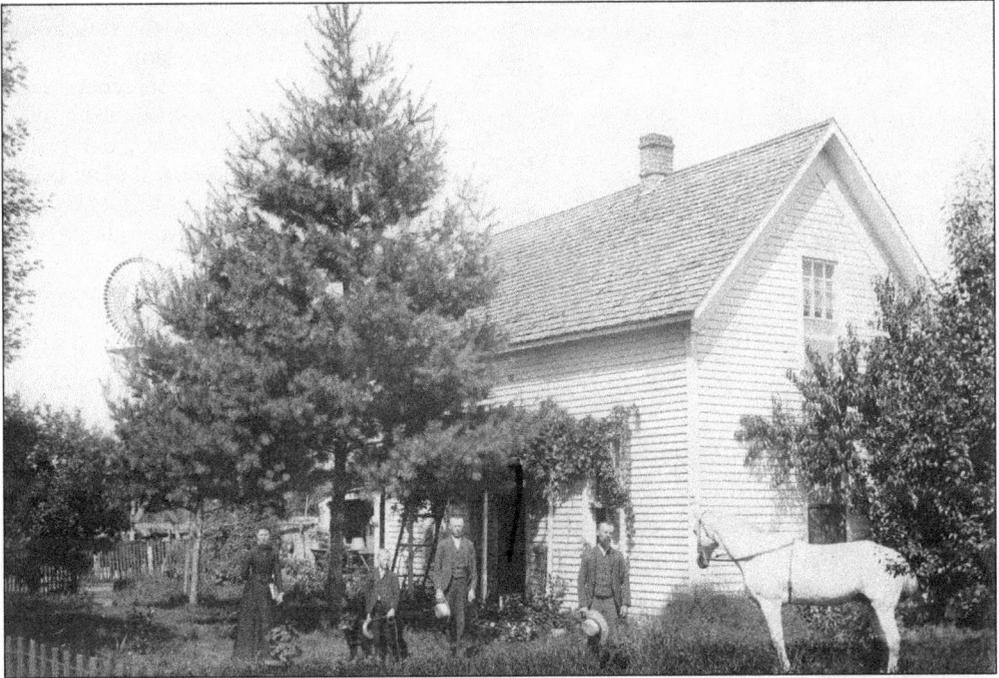

Members of the Selby family pose on their homestead located in Fairmount Township on County Road 362 East. From left to right are Harriett M. Selby, Will Selby, Victor A. Selby, John Selby, and "Charlie" the horse. Otho Selby homesteaded in 1837 on a very old trail that parallels a peat and cranberry bog that runs for some miles. The barrel of an old trader gun was found, lending credence to the theory that Gen. "Mad Anthony" Wayne may have used this as his line of march in 1794. (SFC.)

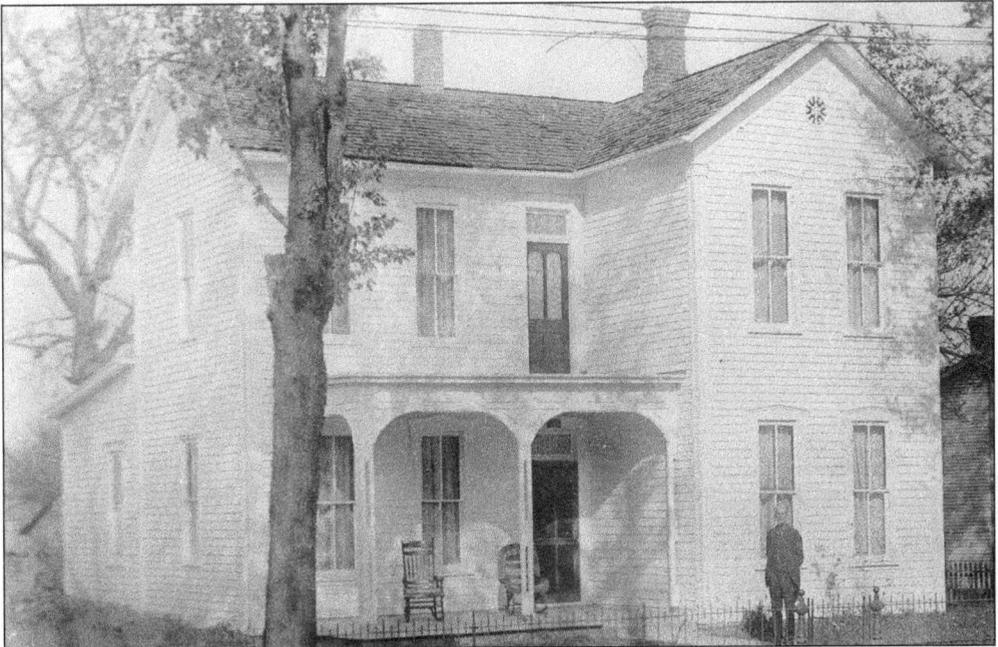

This house on Main Street, pictured in the early 1900s, remains in existence today. (WFC.)

This undated image shows Grant School and the students who attended the one-room schoolhouse open to first through eighth graders. It was located about a mile north of the Grant and Madison County lines. Charline Craw Mitchener remembers walking to this neighborhood school carrying her lunch, since there was no lunchroom. The school closed around 1938 when she was a fifth grader. (Dorothy Leach.)

This map of Fairmount appears on page 75 of the *Illustrated Historical Atlas of the State of Indiana*, which was published in 1876 by Baskin and Forster in Chicago, Illinois. In 1833, Thomas Baldwin and his wife, Lydia Baldwin, took up the land that reached to the center of Fairmount, and they helped plan the town. (Bracken Library, Ball State University.)

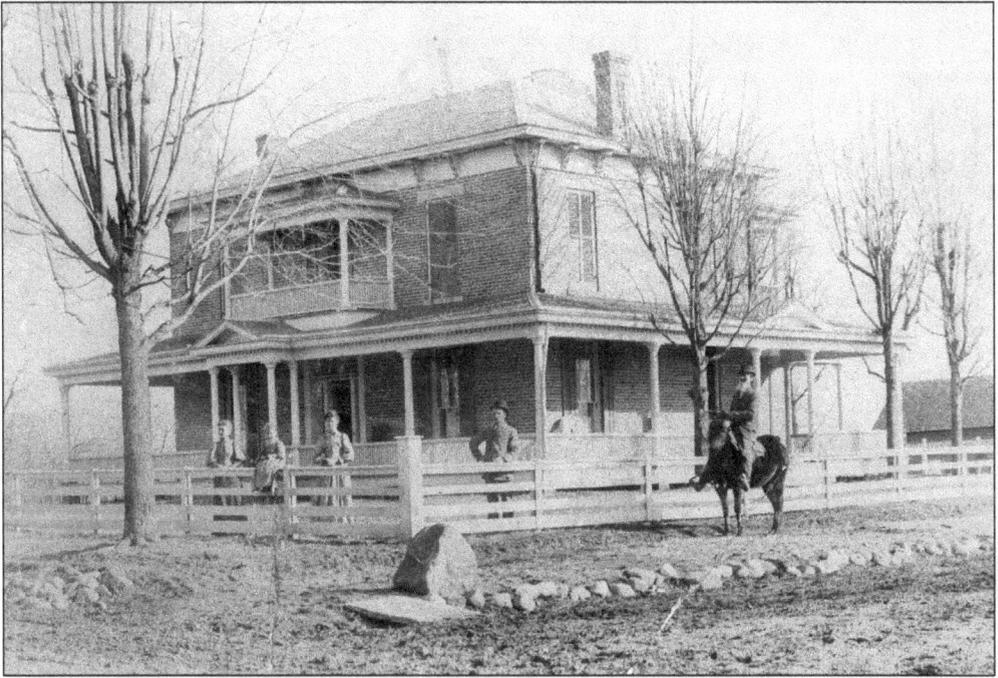

Born in 1831, Nixon Winslow is shown on his horse in front of his house on 1006 East Washington Street in 1873. He and his wife, Cynthia, had seven children, and he was president of the Citizens Exchange Bank from 1893 to 1909. An industrious businessman, he was also a Quaker who remained true to the pacifist beliefs of his forefathers and paid $300 rather than enter the army. (WFC.)

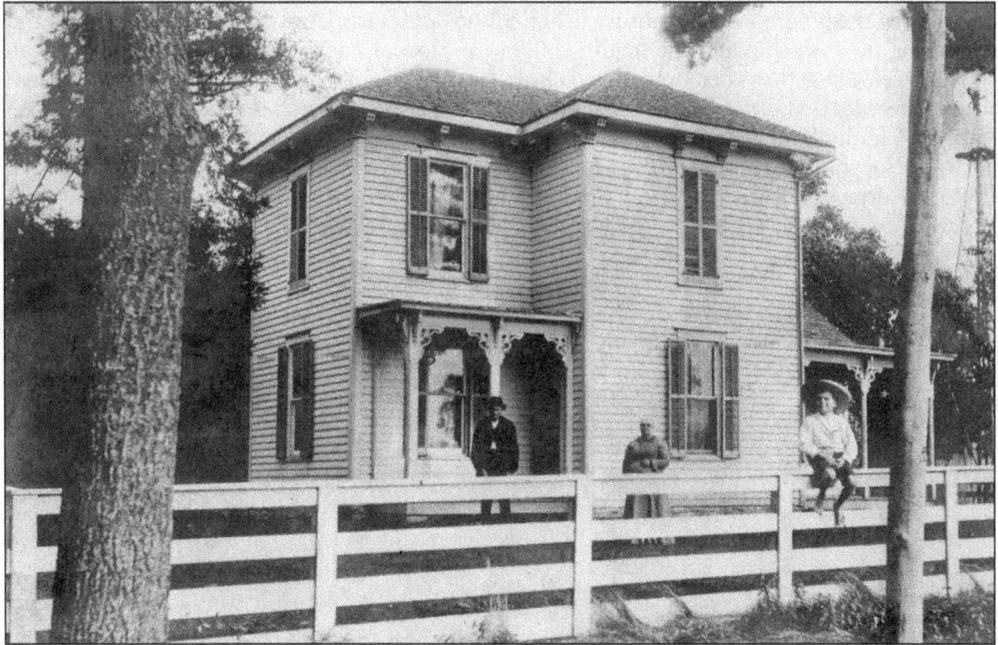

This Wilson family photograph was taken in 1890 in front of the family homestead located just east of Back Creek Friends Church. Their ancestors, John and Mary Winslow Wilson, came to Fairmount in 1837 and were prominent Quaker citizens of the township. (Milford Adams.)

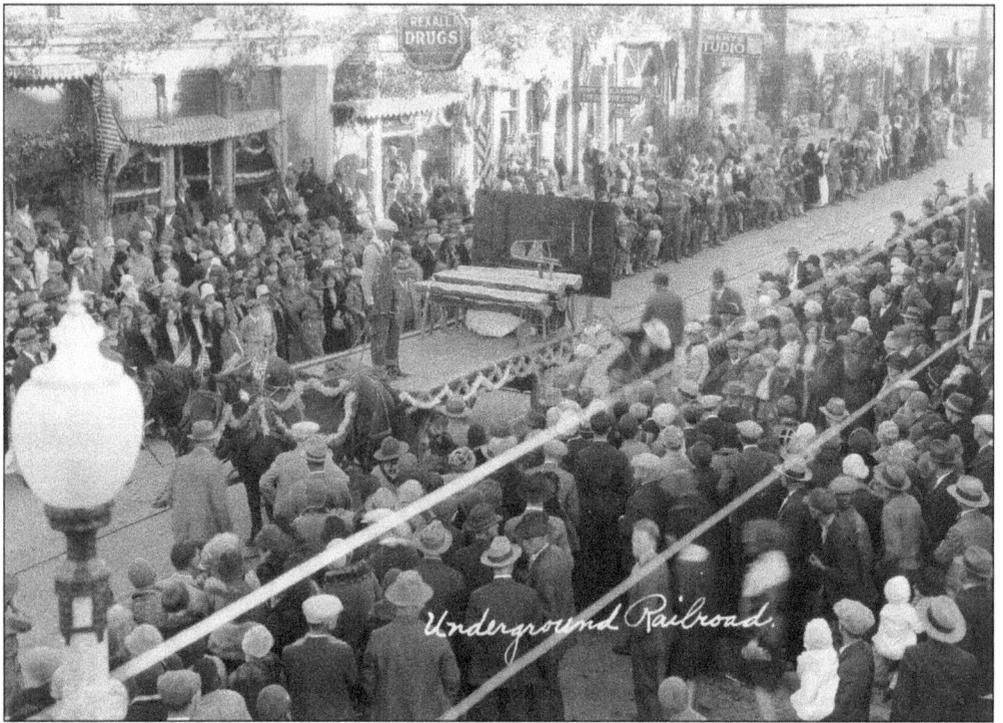

Invitations issued for this parade held on Saturday, October 26, 1929, stated it was a celebration "reviewing the passing of a century in Southern Grant County" and was held to dedicate the new boulevard lighting system. The long parade at 2:00 p.m. was headed by the Fairmount Band and showed the progress of the century in agriculture and transportation, including settling and organizing the township and the stealing of Francis Slocum, "a white maiden" who married an Indian chief. These floats demonstrated techniques of the Underground Railroad, which ushered slaves to freedom. Many of Fairmount's founding families participated in Underground Railroad stations. Charles Baldwin reported that slaves staying in his home sometimes depleted his food and other supplies, and his neighbors would leave more on his doorstep. About 1,500 slaves passed through Fairmount Township's Underground Railroad. (Both Fairmount Public Library.)

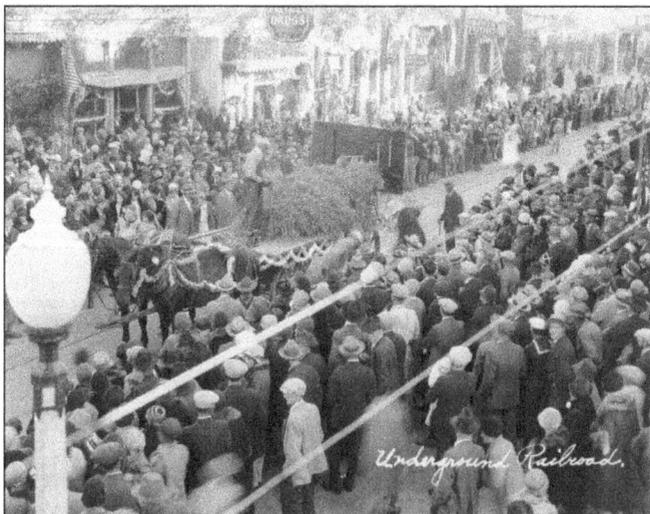

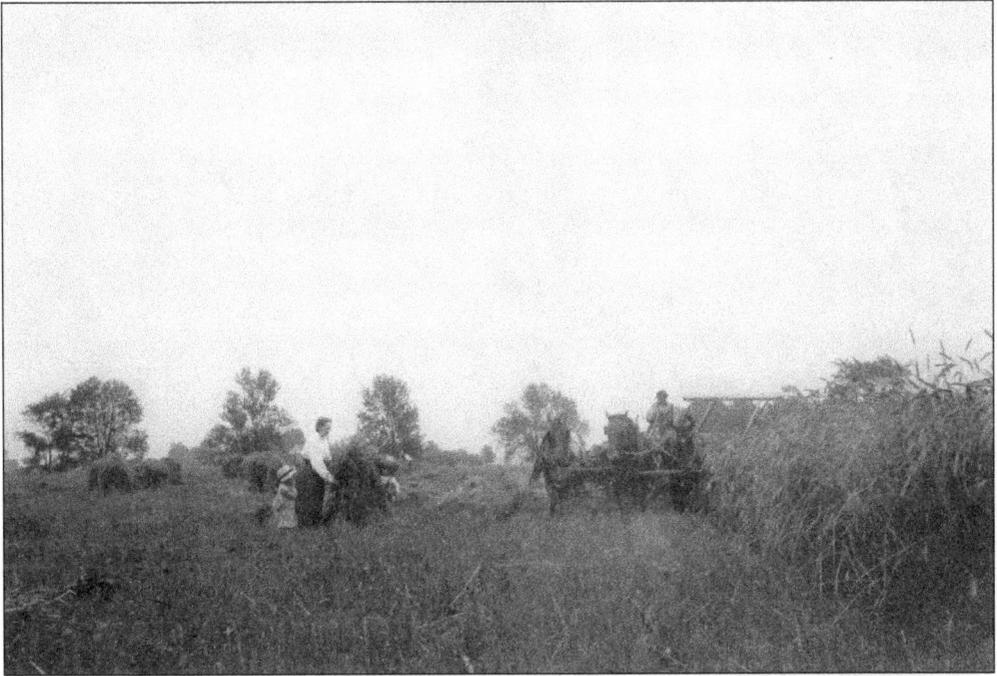

In 1899, members of the Rush family are seen cutting wheat at the Johnson farm, which was owned by Walter Rush's father-in-law. It was located on State Road 9 about a mile north of State Road 26. The rich soil in Fairmount made excellent farmland, which contributed to a thriving farming community.

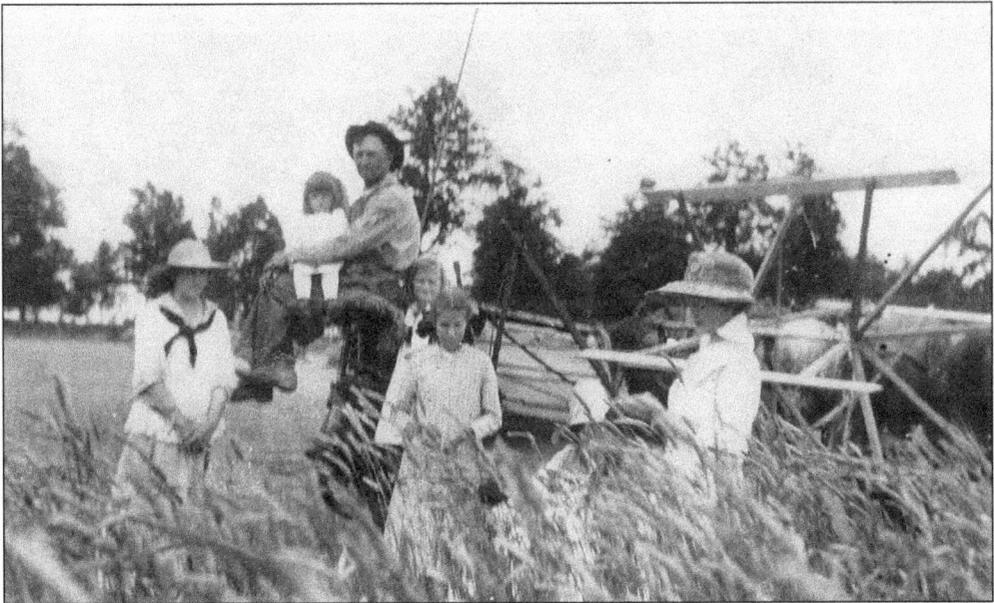

In 1918, Walter Rush is perched on the reaper, a type of machine that cut standing grain and left it in bunches. Walter is holding niece Eleanor Rush. From left to right are the Rush daughters Isadora and Dorothy Rush and nieces Julia Alice and Annette Rush.

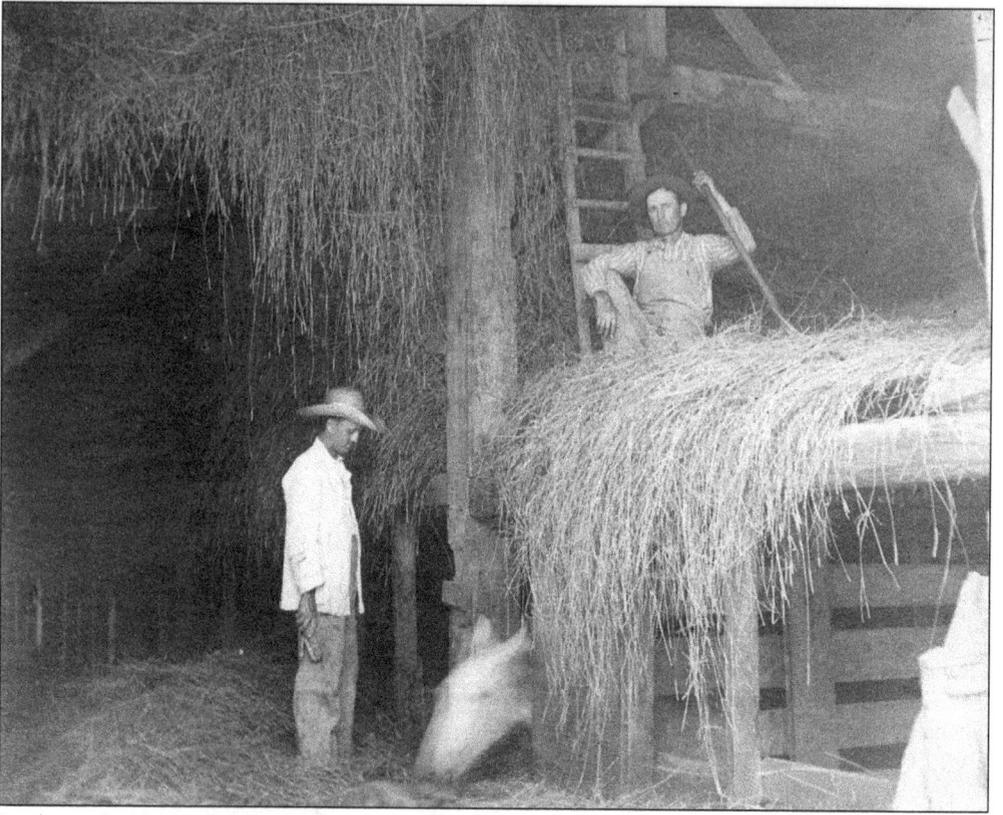

In the early 1900s, Calvin Rush stands in front of "Old Skip" the horse inside a barn at Rush Hill. Walter Rush is in the haymow.

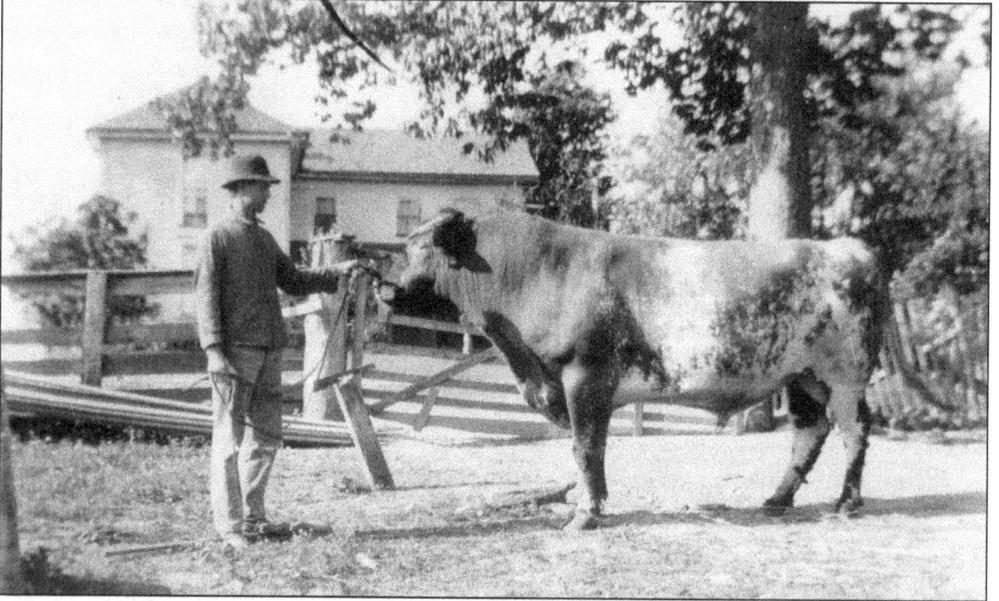

Walter Rush stands on Rush Hill in 1903 with his bull named Baron. His home is in the background. The family raised hogs, cattle, sheep, and chickens on the farm.

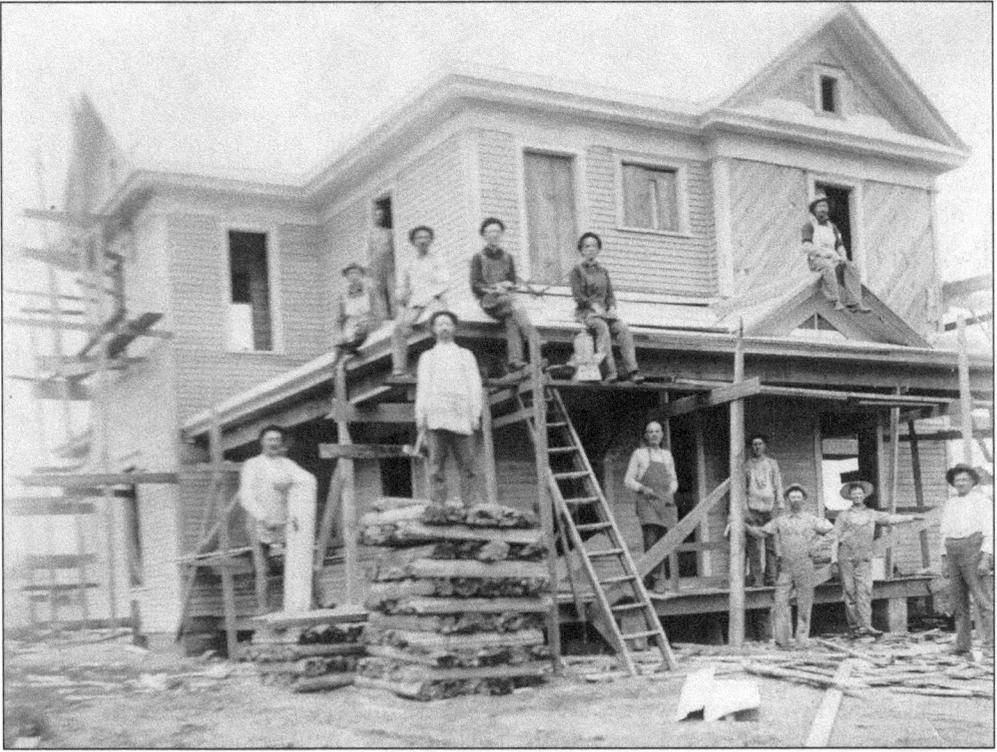

This home of Ancil Winslow was constructed in 1904. Workers are shown completing the house where the members of the Winslow family live to this day. James Dean's grandparents, Charles and Emma Dean, brought the 9-year-old boy here to live with his Aunt Ortense and Uncle Marcus Winslow after Dean's mother died. Dean's cousin Joan became like an older sister. (WFC)

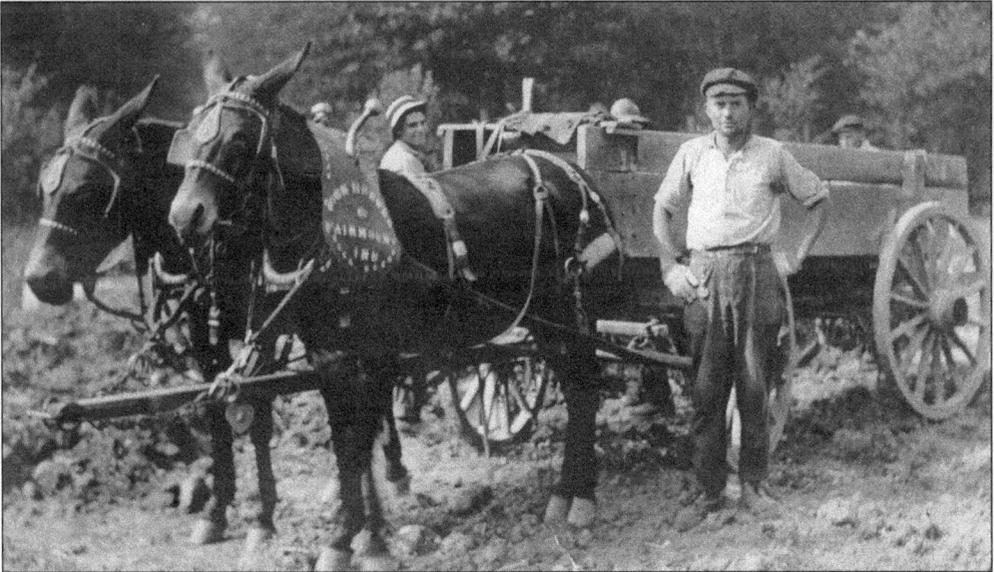

John Brewer is shown standing in front of his wagon in Van Wert, Ohio. He was driving the L. F. Brewer team, and the sign hanging from one of the horses indicates it was a Fairmount-based company.

In about 1886, the Rush family poses at their home on Rush Hill for Hockett and Hartsook Photographers of Marion. Family members from left to right are (first row) Charles E., Louisa, Olive, Nixon, and Calvin Rush; (second row) Myra Rush, Walter Rush, Clint Winslow, and Emma Rush. Later photographer S. A. Hockett relocated and went into business in Fairmount.

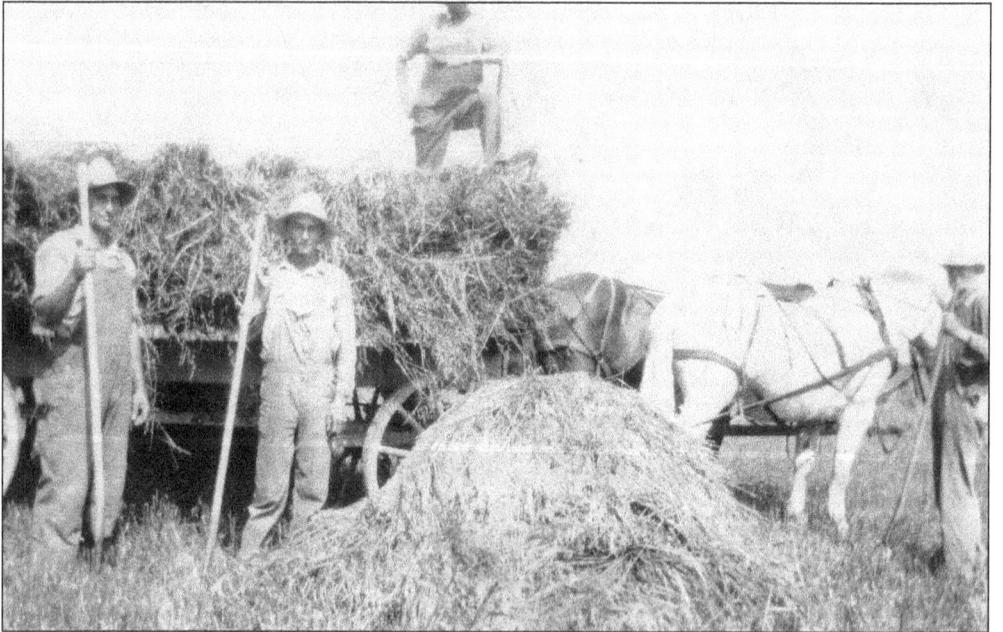

Taken about 1916, Ralph Mittank (far right) stands with his horse on the Rush Hill farm. Before machines were invented to help with farming, putting up a field of hay was a job requiring several workers and took many hours to complete.

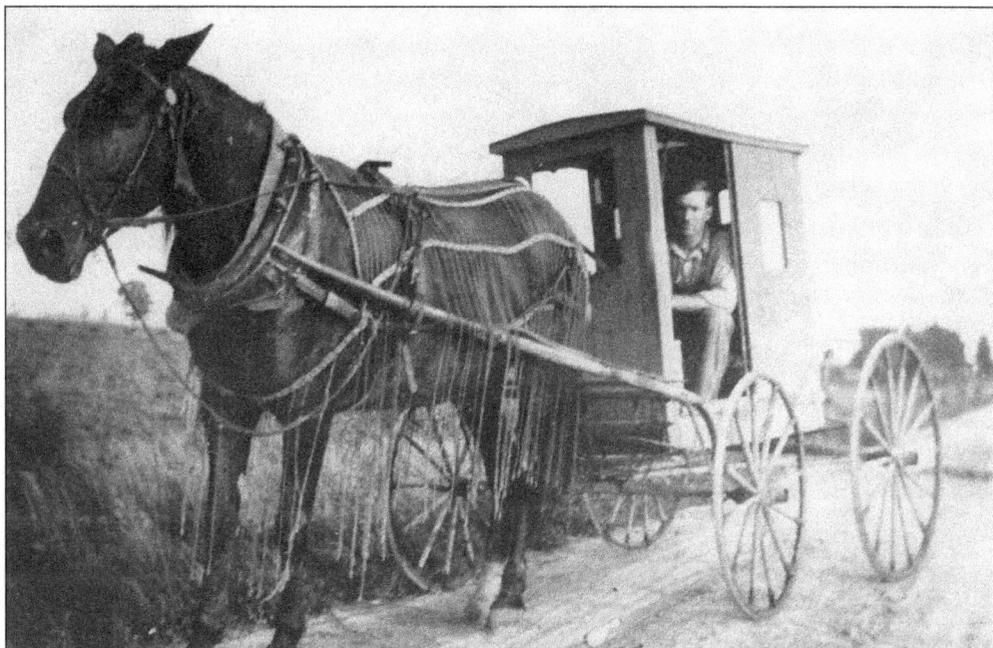

This unidentified man with a horse-drawn carriage may have delivered mail or provided another service. The horse has leather strands draped over it, which would sway as it walked to startle flies away.

In 1934, Bruce Gossett and his father, Clyde, pose in a wagon. Bruce says, "This wagon was used when we shucked corn by hand and if you found an ear that would make good seed, you put it in the seed box, since you didn't buy seed. I'd get sleepy and he'd put me in that box. I wasn't old enough to be in school, but I remember that." (Bruce Gossett.)

Photographed sometime in the early 1900s, an unidentified man is shown using a threshing machine on Rush Hill. Farmers would help each other and go from farm to farm until all the seasonal work was completed.

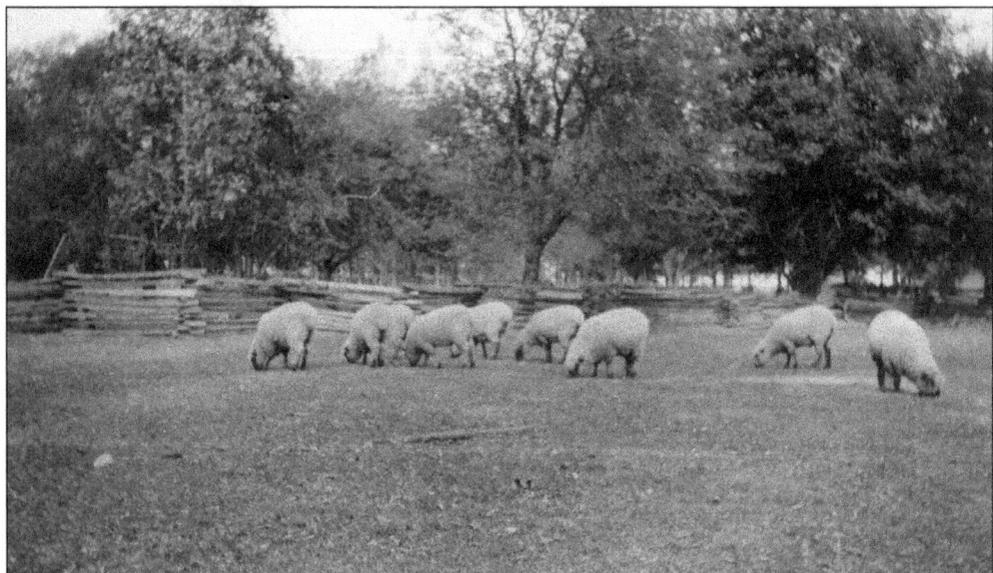

Sheep are grazing tranquilly on Rush Hill in 1920. The Rushes spun and wove cloth for their own use while any surplus wool could be sold to the woolen mill located at First and Sycamore Streets. Split rail fences were common. In the early days, Fairmount Township had a "density of forest" according to the *Combination Atlas Map of Grant County*. In 1829, Joseph Winslow's wife became lost in the woods and could not be rescued until the next day.

Two

GAS BOOM ERA

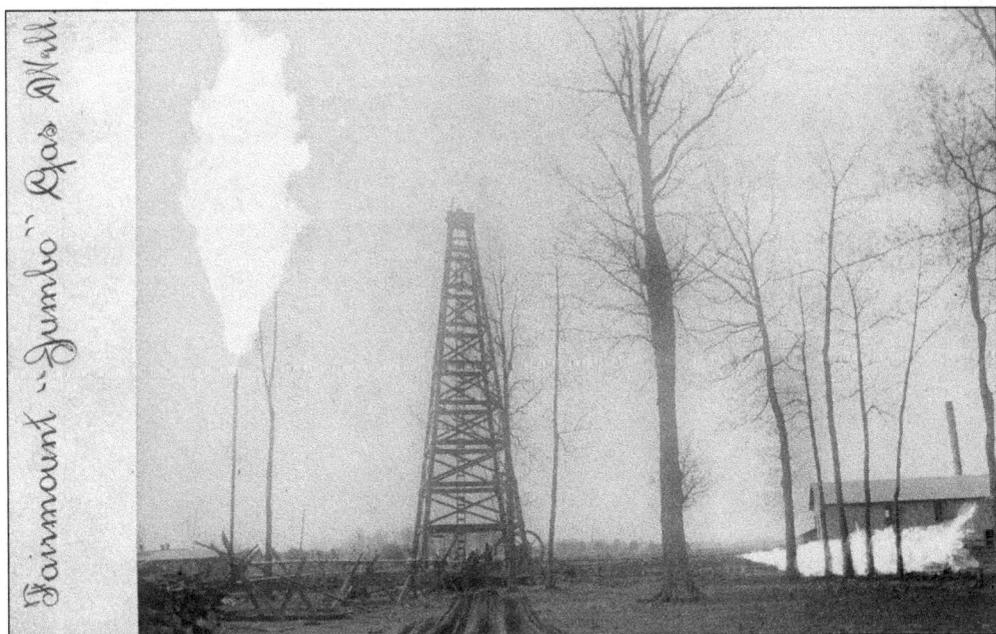

This photo postcard depicts Jumbo, a natural gas well discovered in 1887 so large it was named after the famous Barnum and Bailey Circus elephant. Finding gas wells in Fairmount Township ushered in a new era, attracting industries of many kinds and bringing workers in droves. Jumbo produced 11,500,000 cubic feet per day and was promoted as the largest natural gas well of its day.

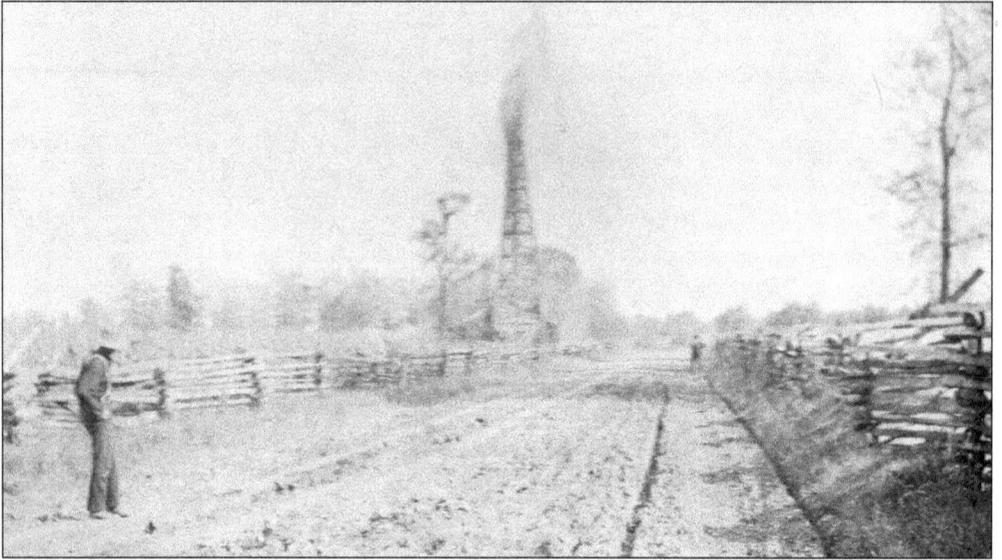

The wells produced so much gas that it was thought the supply would never run dry. The above, faded photograph from the 1880s shows an unidentified worker with Jumbo in the distance. The image below is murky but shows a crew standing under the gas well. The second worker from the left is Emory Ault, and the photograph was donated to the Fairmount Historical Museum by Edna Ault Soultz. The natural gas was allowed to flow freely and large gas jets called "flambeaus" on the street corners lit up the town at night and remained on throughout the day. Located near the fairgrounds, Jumbo eventually caught fire and burned for nearly a month, being too strong to cap.

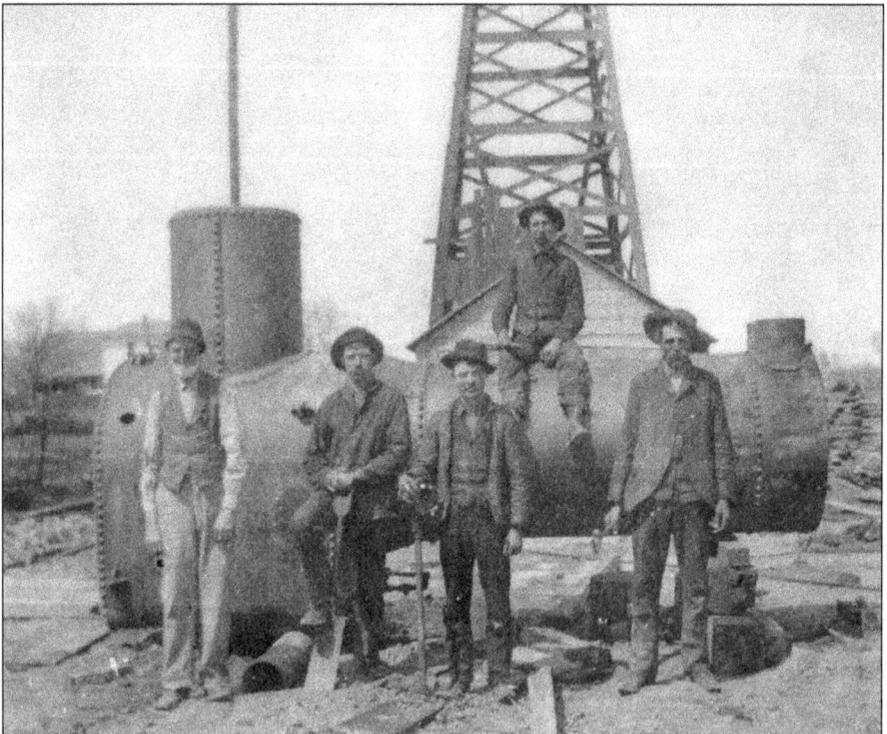

This photograph was taken prior to 1900. When gas wells were discovered in Fairmount, drillers used special equipment to drill for natural gas and release it. The unidentified wagon driver is transporting glass bottles of nitroglycerin, which was used to break through the layer of shale and release the gas. The nitroglycerin bottles were placed in metal tubes and dropped down the well pipe. These were aptly named "Go Devils" and would detonate on impact. The notoriously unstable nitroglycerin would sometimes detonate for no reason and in a thunderous flash blow wagon, horse, and driver to smithereens.

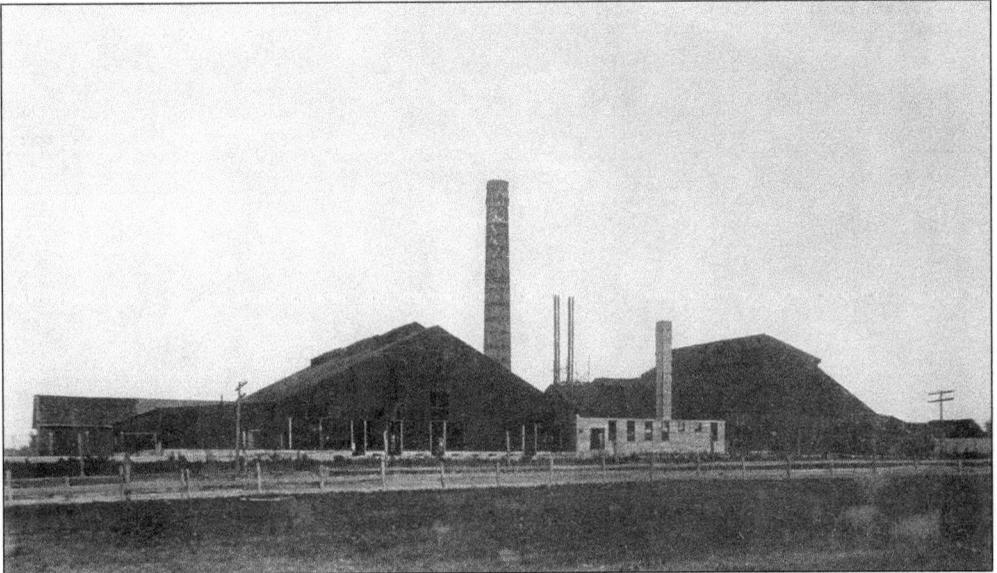

The Model Glass Factory began operation prior to 1900, after natural gas wells were discovered and more industry came to the area. The building was a distinctive sight in the background at the fairgrounds. Ramona Stroup Draper says, "When I was a little girl, we would go to the area around the glass factory and sit and pick up little pieces of colored glass."

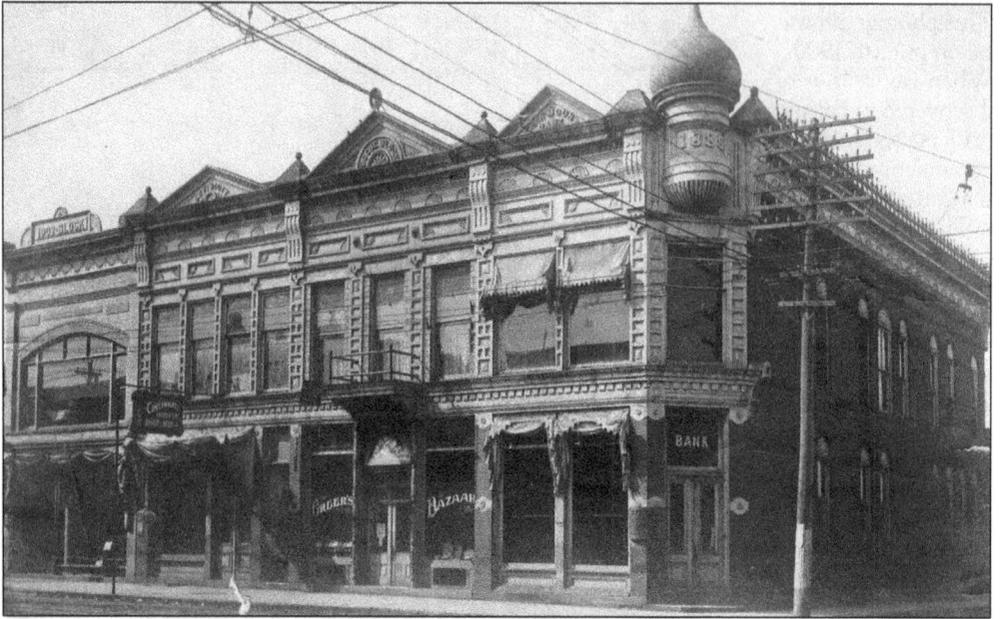

The Bogue Block was built in 1889. Businessman Levi Scott's name is still on top of the building, which originally housed Scott's Farmers and Merchants State Bank. The bank failed in the panic of 1893, and on July 15 the Citizens Exchange Bank was organized with Nixon Winslow as president. In 1894, one of the founding directors, John Selby, became a cashier, and eventually the bank became the Citizens State Bank with John Selby as president and his son Victor A. Selby as vice president. The Selby family continues to operate the bank as the Citizens Exchange Bank, the oldest bank in Grant County. (SFC.)

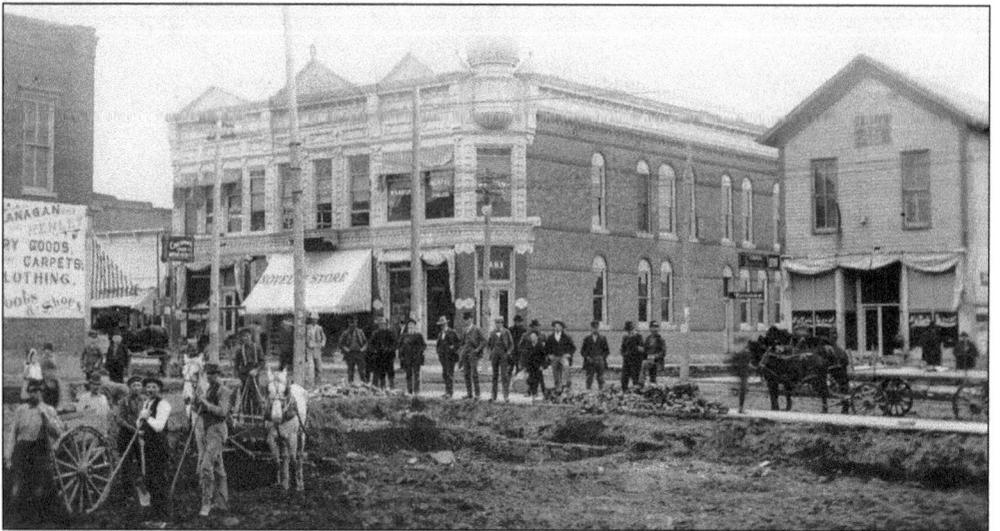

This early-1900s photograph shows excavation of the Borrey Block, which was diagonally across from the Bogue Block. The Bogue Block housed the Cincinnati Liquor Company and Greer's Bazaar. On the second floor were the W. W. Ratliff Dental Parlor, a law office, and the Fairmount Mining Company. The Fairmount Telephone Company was in the rear. The two-story, wood-frame building on the right is the International Order of Oddfellows, named for helping fellows in need, which was considered an odd thing to do. (SFC.)

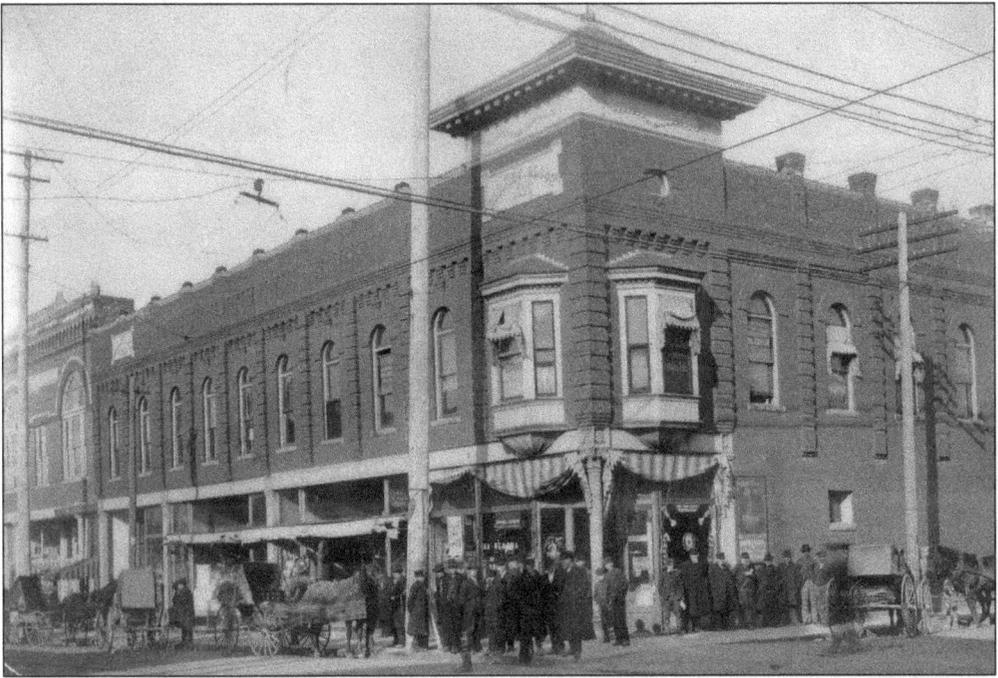

The above photograph shows the finished Borrey Block in the early 1900s. (SFC.) The photograph below is of the Borrey home around 1910. The Borreys also owned a glass factory. Their daughter is pictured with her husband, ? Welch. Their chauffeur lived in the top part of the house. (Above, SFC; below, David Broyles.)

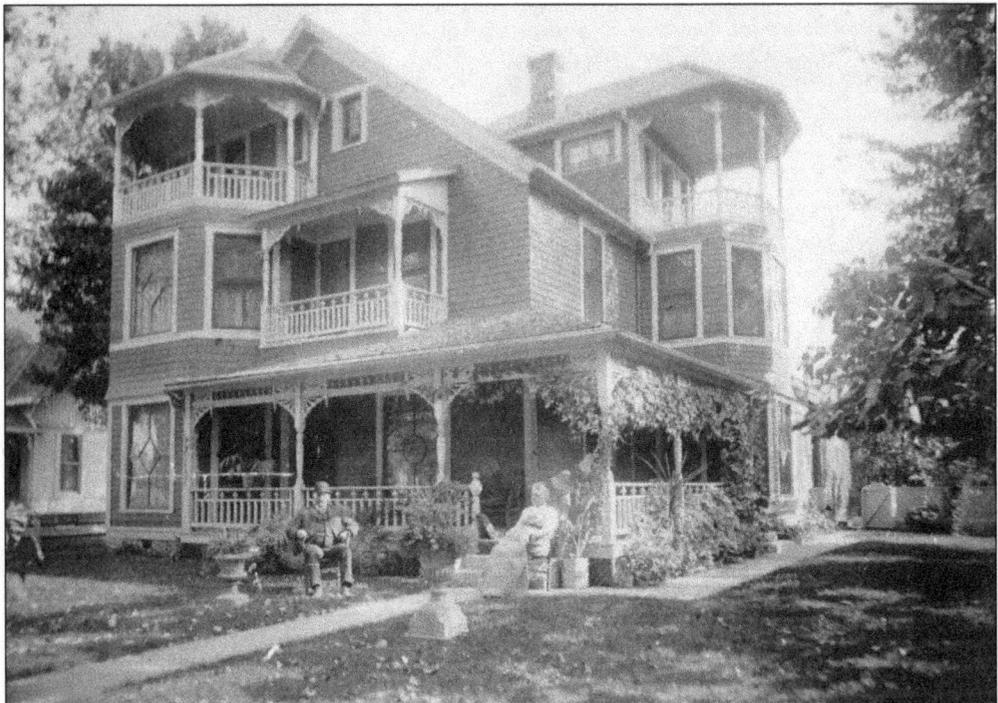

The Big Four Window Glass Works cost $16,000 to build and was located between Sixth and Seventh Streets East of the railroad. It operated from the early 1890s to 1900. Other glass factories close by were the Model Glass Factory, Wilson, McCollough Fruit Jar Works, and Winslow and Rua's Fairmount Glass Works, which cost $20,000 to build.

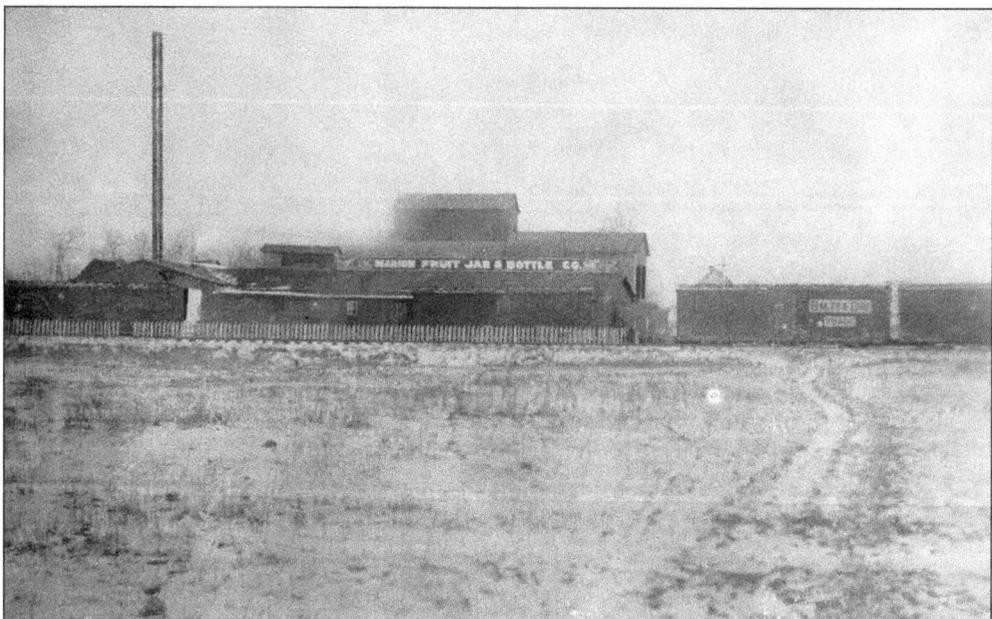

The Marion Fruit Jar and Bottle Company is shown here. Fairmount officials attracted workers by advertising the Fairmount Academy as the "Pride of the Town" and provided a photograph of "the Jumbo Gas Well of the World." Besides the glass factories, the area offered a flour mill, an excelsior, planing mill, stave and brick factories, a machine shop, and a foundry. Town leaders boasted of six churches to choose from and a town surrounded by a "splendid agricultural region." (SFC.)

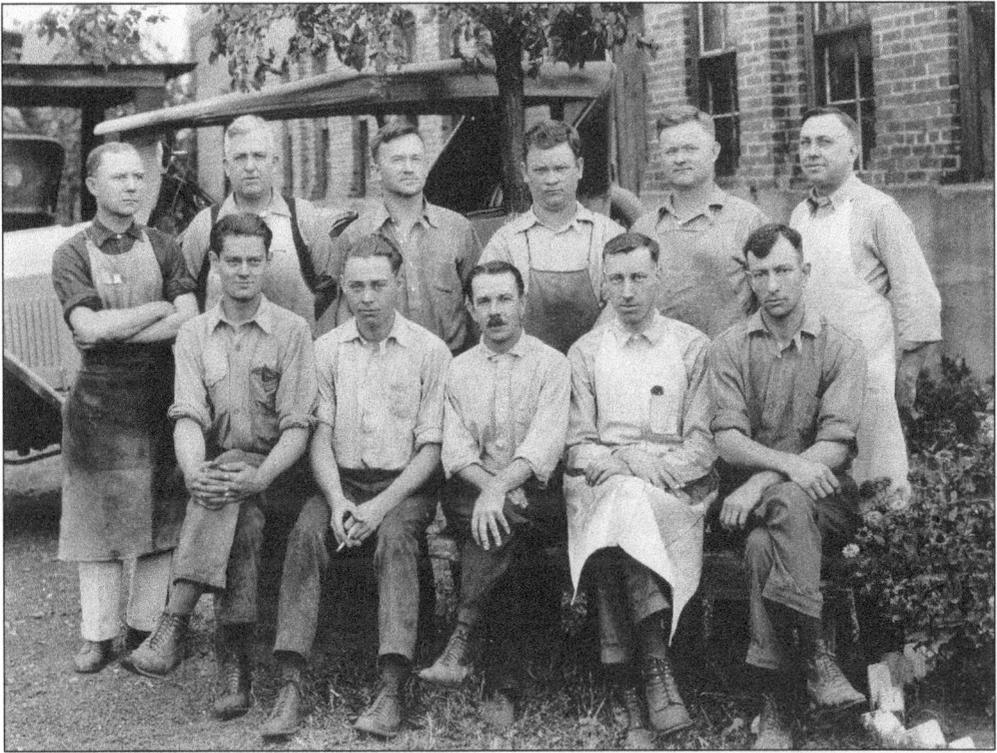

The above 1922 photograph shows employees of the Hoosier Mould Company, which was established in 1919. George Siegel worked there from 1941 until 1950, with the exception of two years starting in 1944 when he served in the military. Stationery from the company shows it was located on Tyler Street and had P.O. Box 129 and phone number 228. The photograph below was taken for a centennial celebration event held from July 31 through August 5, 1950. This is a display of glassware created from the cast-iron molds, which the Hoosier Mould Company manufactured. (Both George Siegel.)

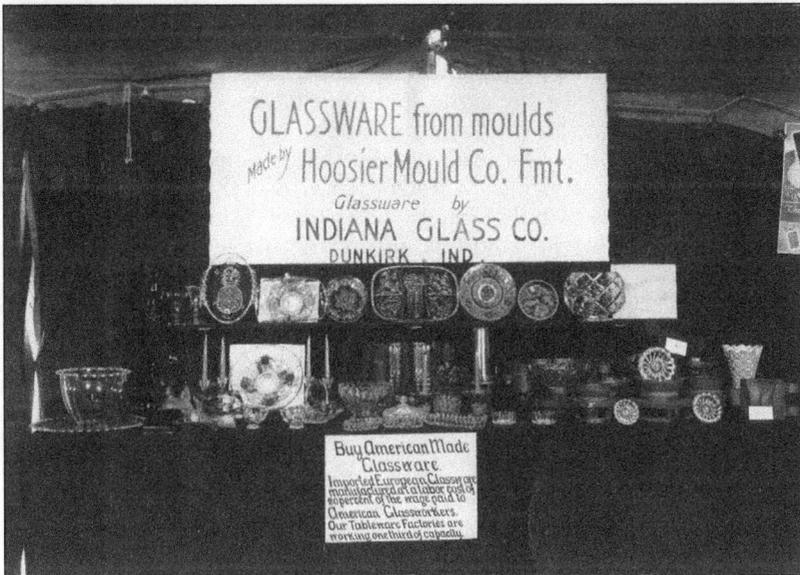

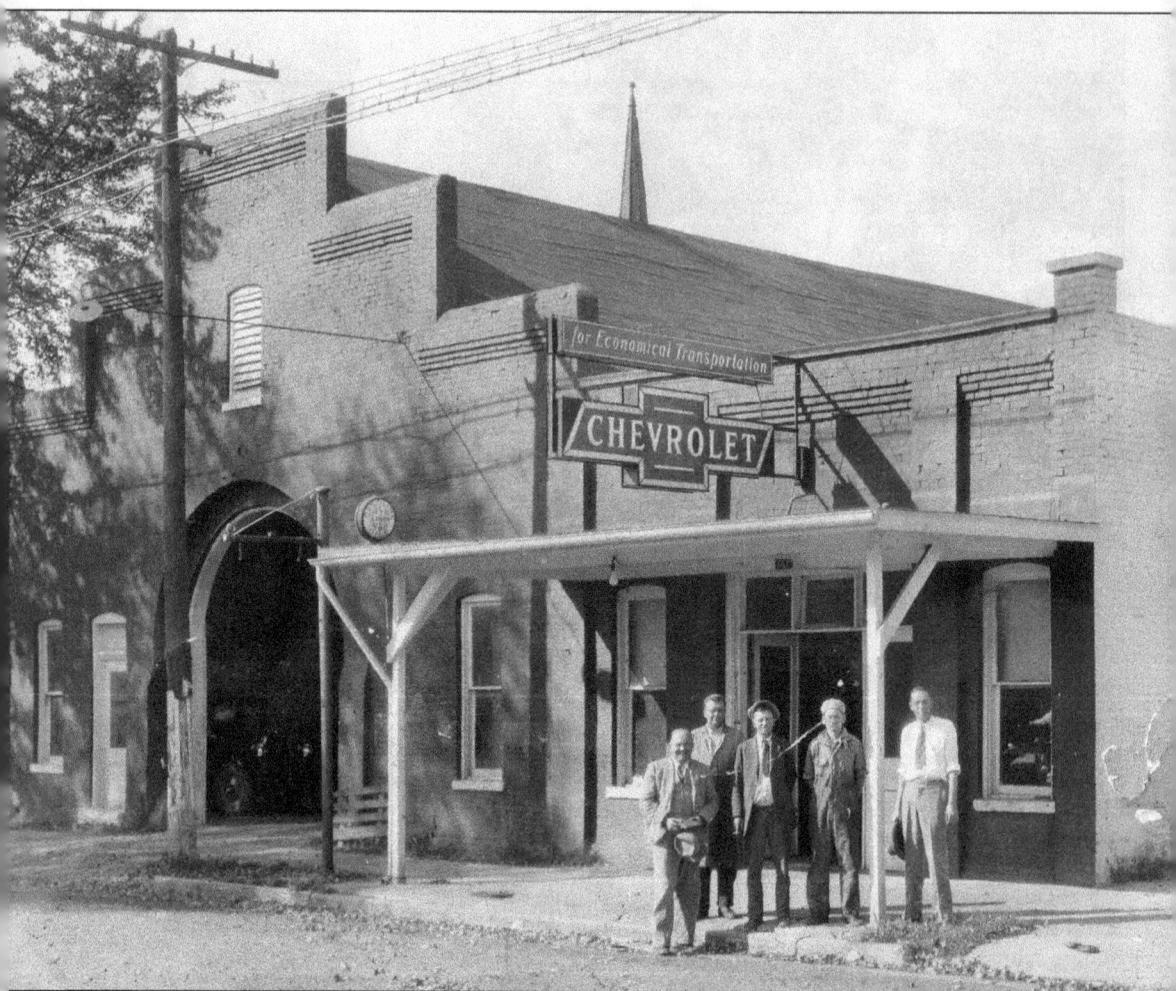

Historic 215 East Washington Street was a Chevrolet dealership in the early 1920s. Men pose out front, and from left to right they are unidentified, Denver Riggs, two unidentified, and Ray Underwood; Creed Yarber may be one of the unidentified men. The original building with the arched door was "the Machine Shop," run by blacksmith and inventor Orlie Scott. The shop serviced and repaired the stationary steam engines that powered local mills. In June, steam traction engines lined up for service to be ready to power the threshing machines during the hay harvest. Sharpening gas-well drilling bits provided steady business during the boom. Puddin' Creek, a boggy tributary, ran in what is now the alley on the west side and provided a ready supply of water for quenching hot metal. Scott was joined by Nathan Armfield and Charles T. Payne in attempts to create an automobile here in 1888. By 1891, they managed to fabricate a brakeless conveyance—during a test drive it went off the road and rolled onto its side. The wreck was sold to Elwood P. Haynes, inventor, metallurgist, and leasing agent for the Indiana Natural Gas Company in nearby Greentown. Haynes moved the Scott wreck to Kokomo in 1892. With the help of machinists Edgar and Elmer Apperson, he managed to create a car that ran successfully on July 4, 1894.

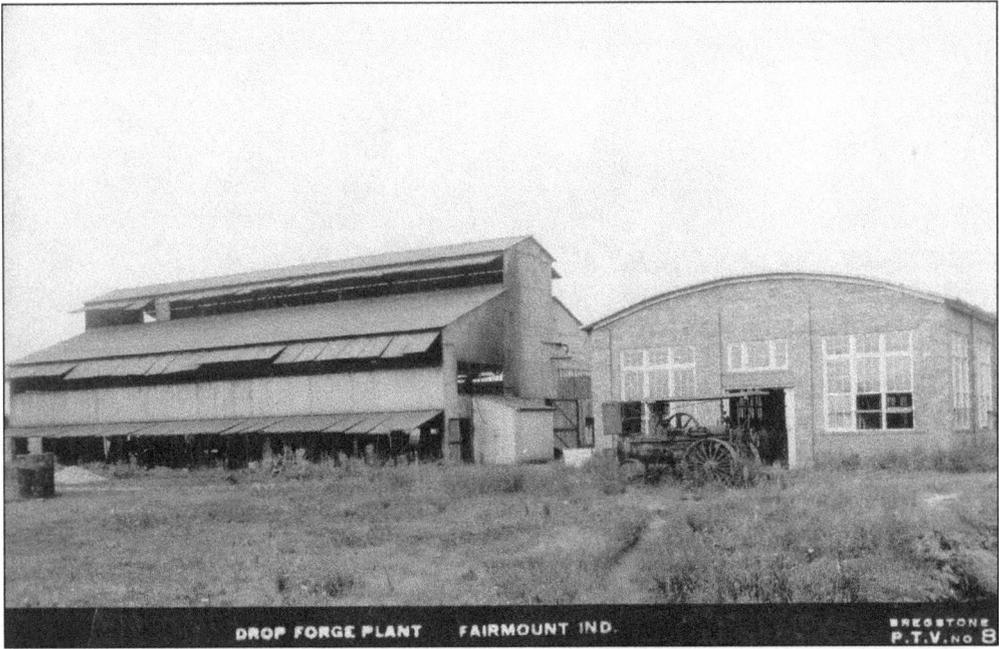

DROP FORGE PLANT FAIRMOUNT IND.

BREGSTONE P.T.V. NO 8

The Drop Forge Plant was a steel foundry that cast, forged, and manufactured new parts and did repairs. In this 1923 photograph, a steam traction engine awaits repair. The plant replaced the machine shop at 215 East Washington Street. The new facility had gas piped in and state-of-the-art machinery. (SFC.)

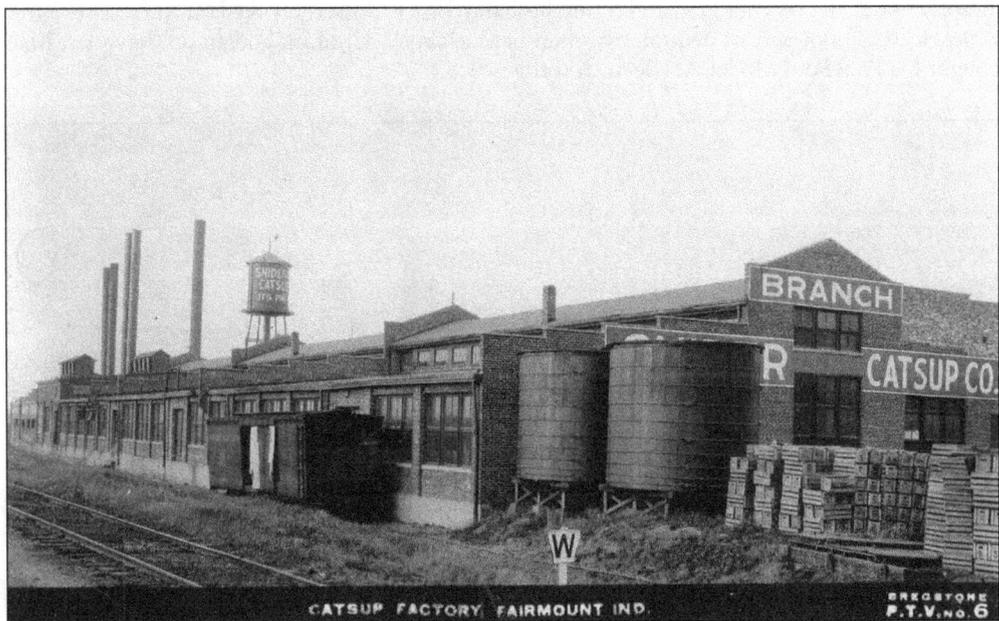

CATSUP FACTORY FAIRMOUNT IND.

BREGSTONE P.T.V. NO 6

In 1906, the T. A. Snider Preserve Company built a Fairmount factory based on finding satisfactory soil composition and farmers willing to grow tomatoes. By 1917, Fairmount had become one of its most successful tomato-growing locations. In the 1940s, many families were growing tomatoes for sale, including Ralph Payne, who had a tomato stand at home on U.S. Highway 9 besides supplying the Delco Remy cafeteria where he worked.

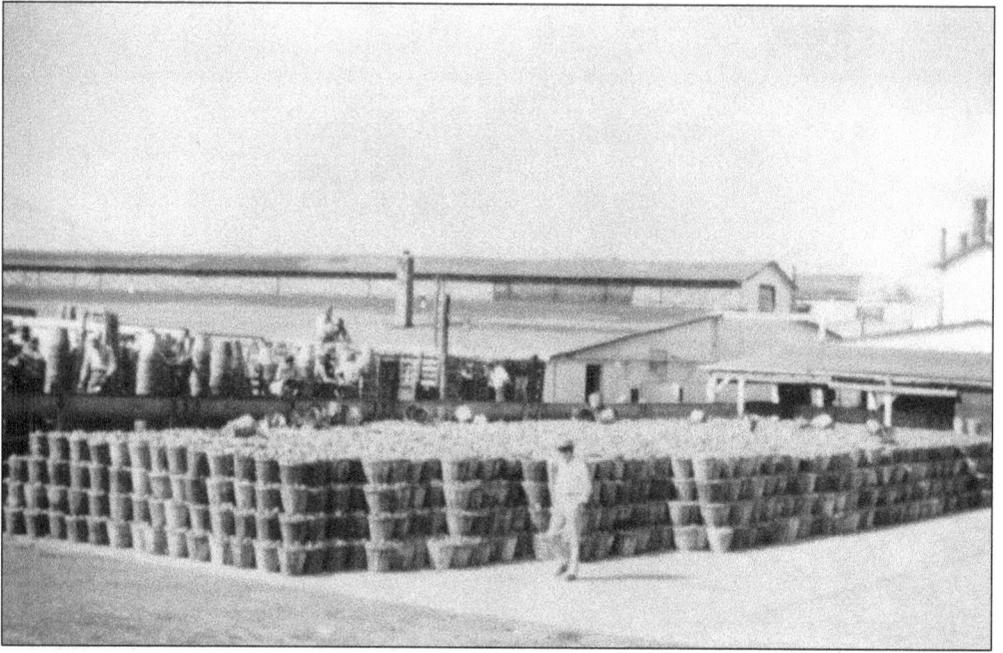

The above image shows Midwest Canning Factory, which was located by the railroad tracks in Fowlerton. In the photograph below, R. J. Meguiar stands by his Packard convertible, his workers, and vehicles. Mae Duling worked in the factory office from 1946 to 1949 and rode a Cushman motor scooter. Her brother Fred and future husband, Bruce Gossett, worked on the scooter, after which it would not run in neutral. So when her father, W. Clinton, bought a Chevrolet, Mae bought his 1929 Ford Model A. (Both Dorothy Leach.)

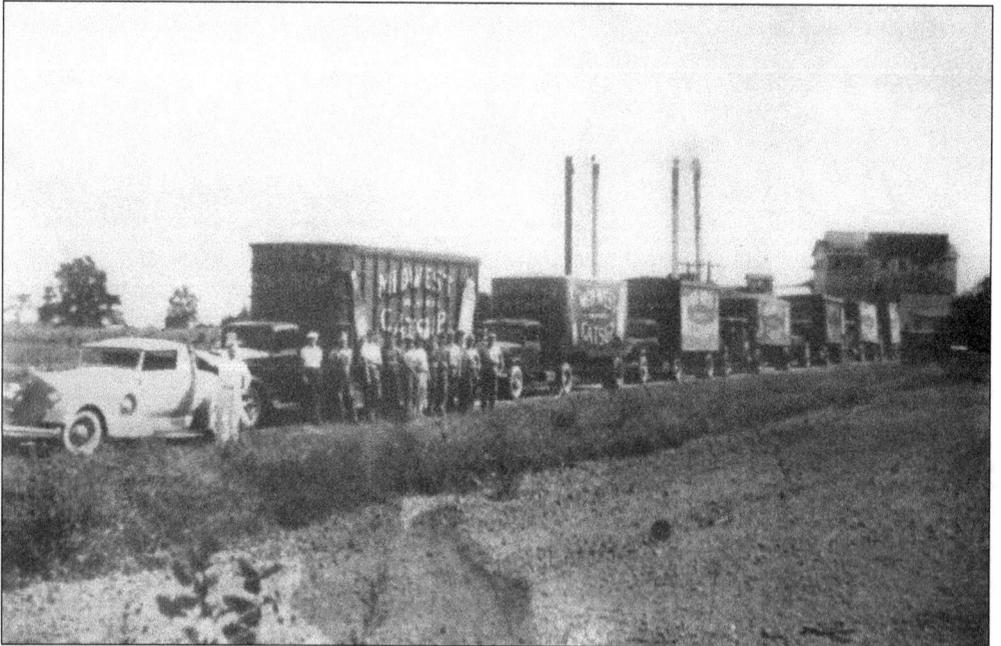

Pictured above around 1900, unidentified children on Rush Hill are playing with hoops. Leisure-time pursuits and enjoyment of scenic views had their place in family life. In the photograph below, renowned artist Olive Rush (right) stands with Myra Baldwin on Rush Hill. In 1893, Olive exhibited at the Columbian Exposition. Her studies and exhibitions took her to New York and Paris. She spent her last 40 years working out of her Santa Fe studio. One of her works has graced the White House. Upon her death in 1966, she left her studio to become a Society of Friends Meeting House.

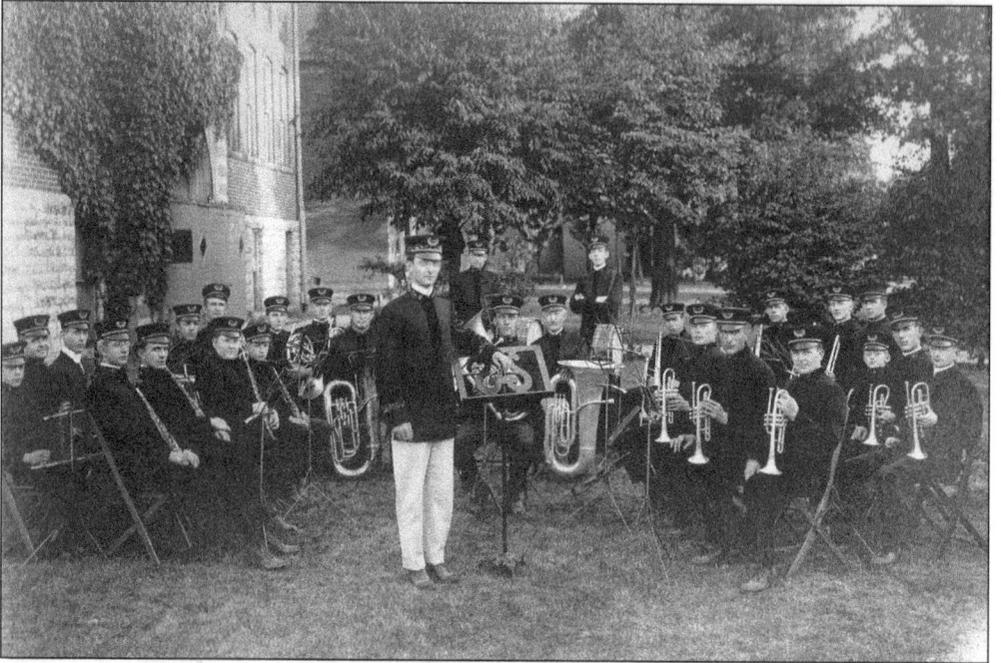

In the above photograph, the Fairmount Concert Band poses next to Fairmount High School. John Montgomery (center, with tuba resting on the grass), who had a stone-making business, played tuba. Otto Morris played clarinet (first row, far left). Harold Bowman (not pictured), a 1933 Fairmount High School graduate, played tuba alongside Montgomery in another band that played Saturday nights. Their platform was a wagon pulled up in front of the Citizens Exchange Bank. Just months before he died, Fairmount historian Ralph Kirkpatrick commented, "My dad said people would bring their cars and park in front of the bank in the afternoon, walk home, and then walk back so they could listen to the band from their cars." Pictured below, the Fairmount Marching Band leads a group of schoolchildren holding their classroom number on signs. (Below, SFC.)

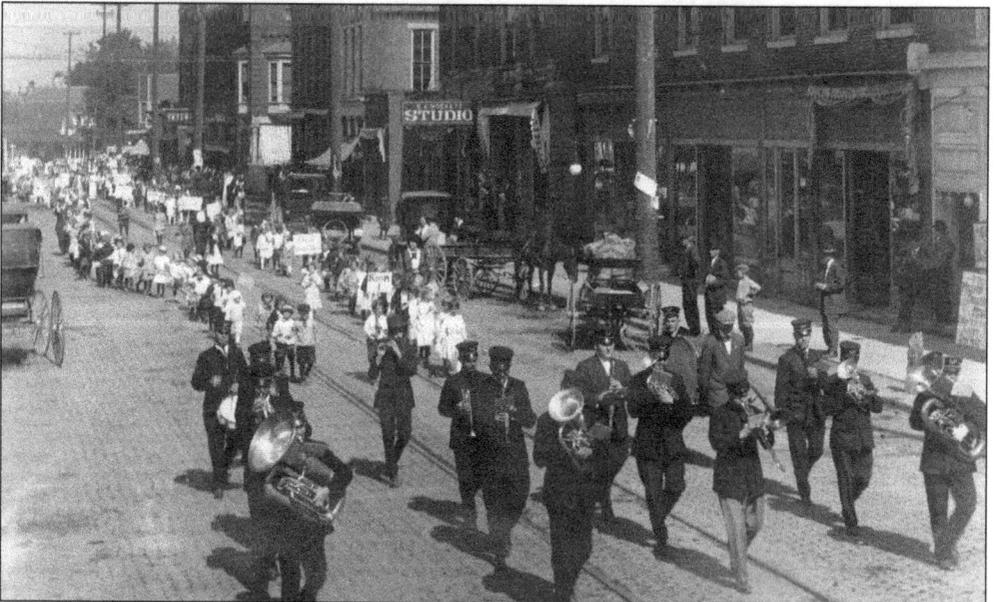

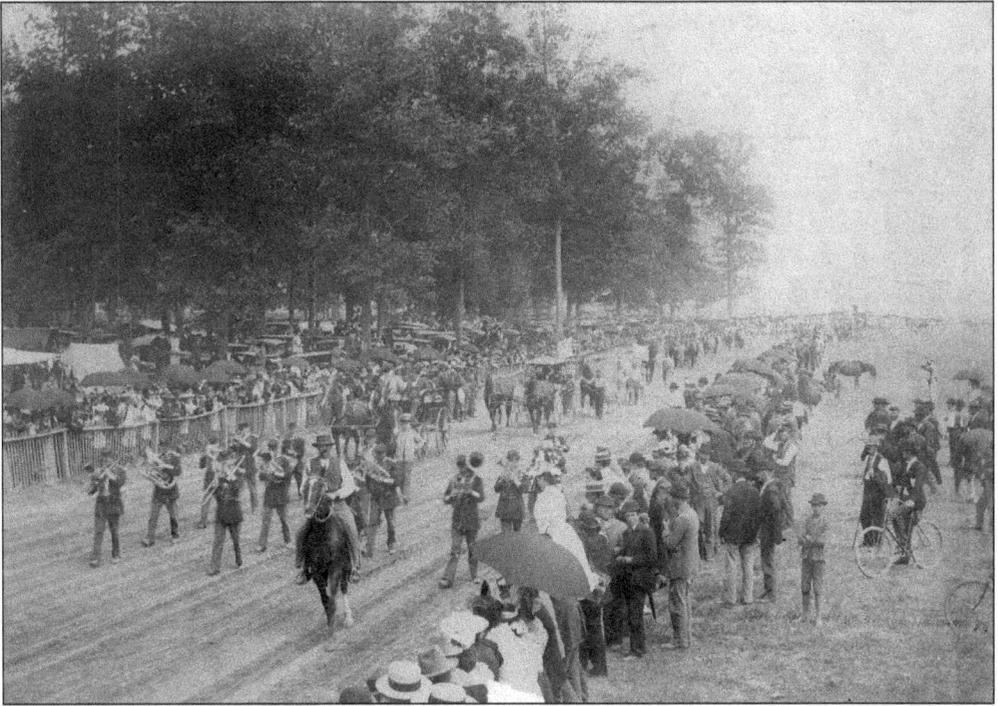

At the Fairmount Fairgrounds in the 1890s during the county fair, a band marches around the dirt track while members of the crowd huddle under umbrellas. The tents to the left were for vendors. In 1889, the *Fairmount News* reported 6,500 people came in a day, and "the stock parade was the finest and largest in the history of the fair. The Jones Twins were a big attraction and thousands went to see them." The Grant County Fair was in Fairmount from 1884 through 1952, when it moved to Marion.

Harold Bowman learned to play tuba at Fairmount High School and had many opportunities to play, including the Friends Orchestra at the Friends Meeting House at 124 West First Street. Harold's wife, Millie, remembers coming to town in the 1920s as a girl when her father, Mark Hix, performed as high tenor in the Basket Brothers Quartet. These days, Bowman, 94 years old, plays John Montgomery's tuba in the Mississinewa Valley Band. (Harold Bowman.)

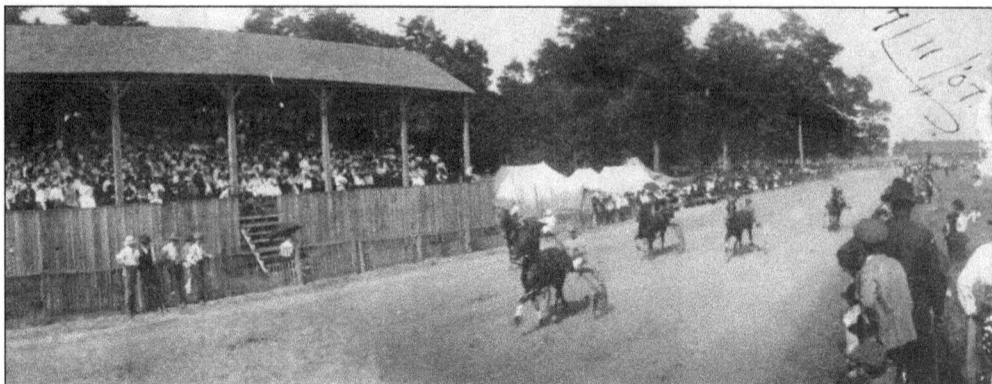

Horse racing was a popular activity during the county fair at the Fairmount Fairgrounds. An 1889 issue of the *Fairmount News* reported, "The racing was a great feature, and tho' there was vigorous and heated rivalry on the track, nothing occurred to mar the good nature of the crowds."

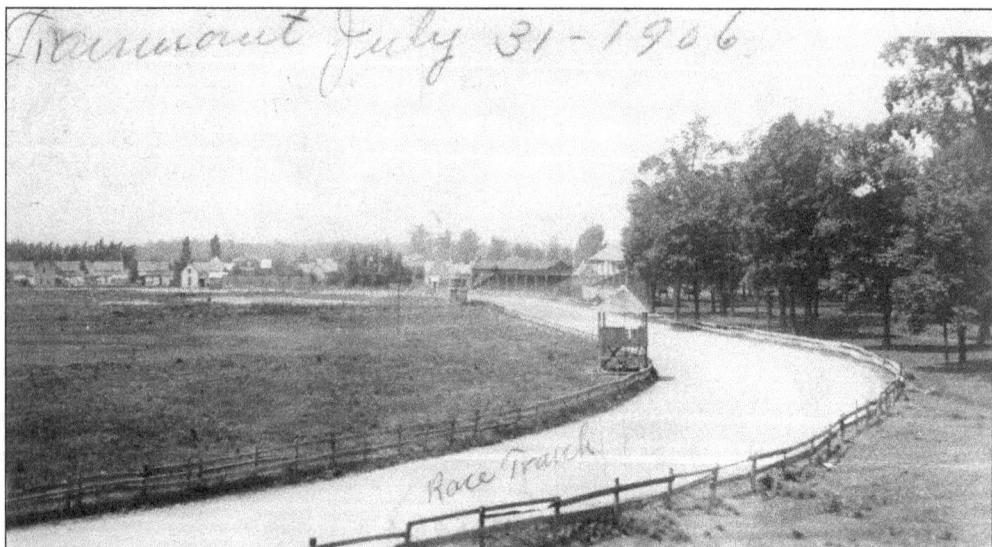

The fairgrounds were a major venue—even Buffalo Bill's Wild West Show came there. Bill Payne says his friend Theodore Payne remembered an unusual encounter with Buffalo Bill while with his grandfather Bailey S. Payne. "We were sitting in the bleachers and I was three or four when Buffalo Bill rode by on his horse. Grandpa called out some name and Buffalo Bill pulled up his horse and said 'Bailey S. Payne, where are you?' The two of them talked and I got to shake hands with Buffalo Bill," Theodore told Bill.

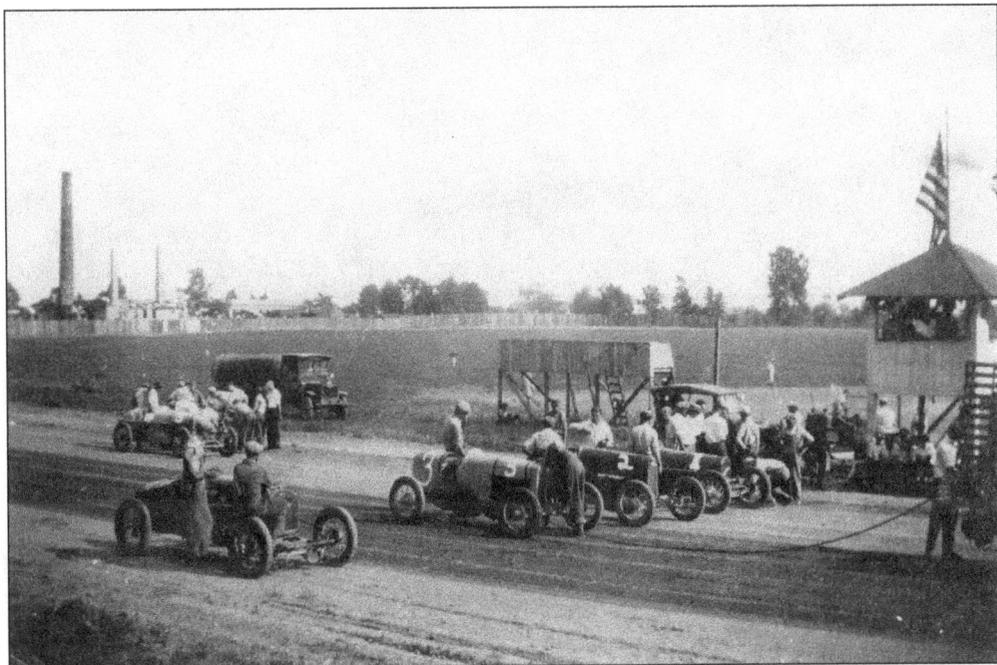

In 1925, the Fairmount Speedway Association managed the racetrack at the fairgrounds. Charles Hackney was one of the promoters of the Fairmount Speedway. "They used to go around that thing," says Ray Bushm, "boy, you ought to see the dust fly." In the photograph below, a race is beginning, and the pace car is out front. (Both Curt Hackney.)

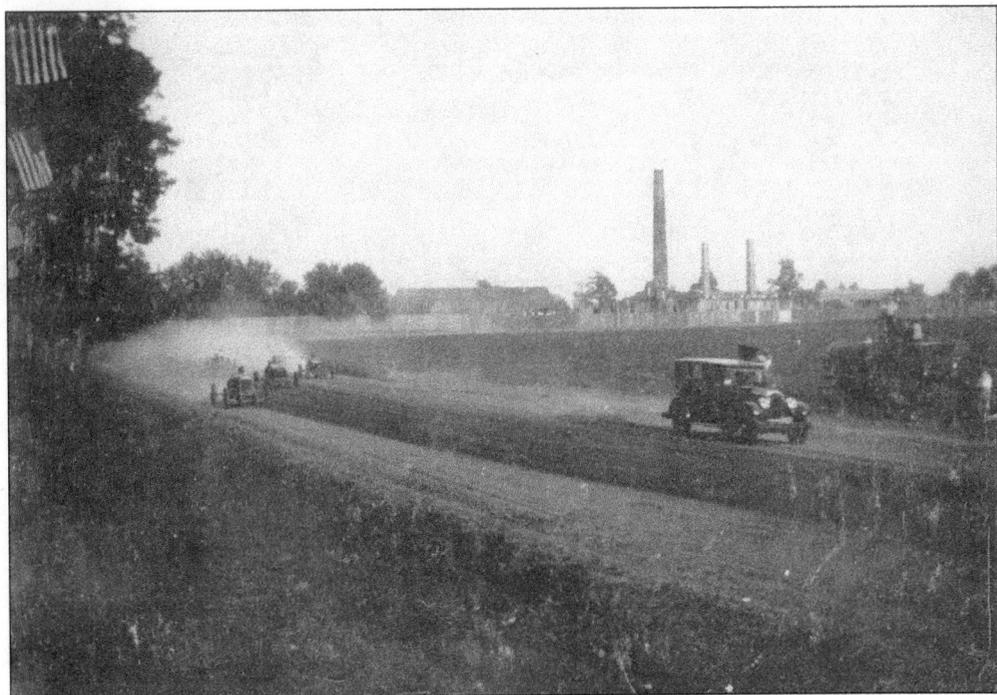

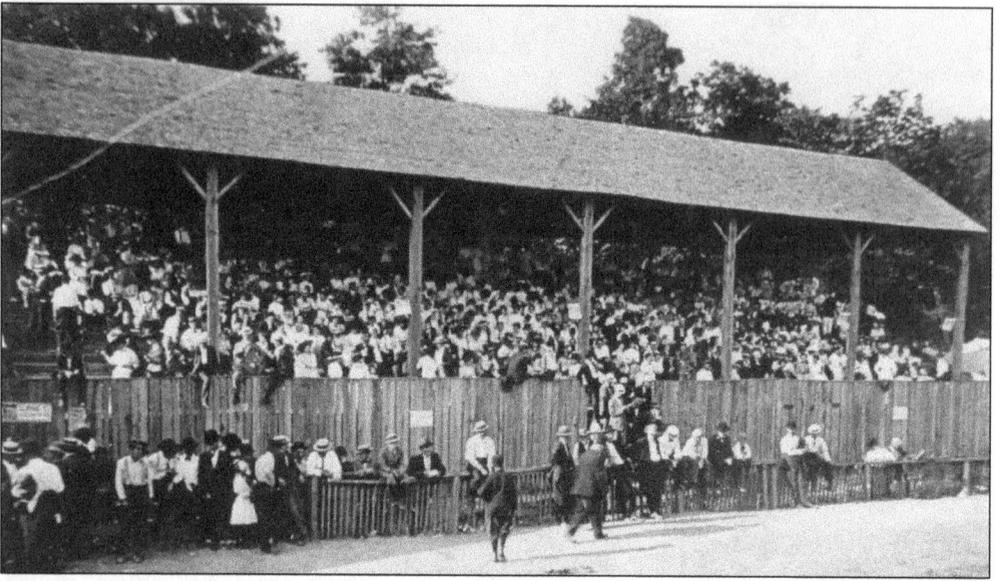

The grandstands were full on this day, as town officials hoped for when they set out to create the fairgrounds in 1884. That summer, the Fairmount Union Joint Stock Agricultural Association was organized and the fairgrounds were designed. The property offered shade and also an open space perfect for a track. (Curt Hackney.)

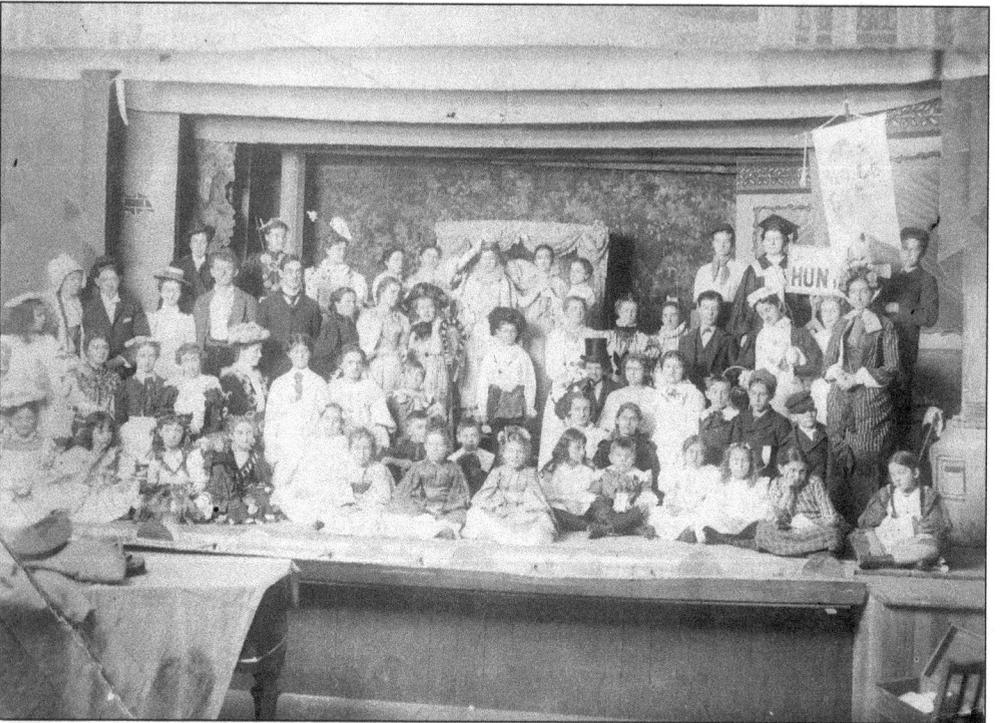

In 1897, the Scott Opera House gave a show and the performers had a photograph taken. At center stage, a girl wearing a hat with stars holds a giant buttonhook printed with "Hollingsworth," which was a local shoe seller. Advertising was prevalent at this time, and the theatre was not immune to such displays.

Three

FAMILIAR VISTAS

Taken in 1937, Russell "Rusty" Gaddis plants corn on his farm at County Roads 7911 South and 150 East. The home now houses a bed and breakfast called the Loft Inn, which is run by his granddaughter Patryce Gaddis Loftin. (Jim Gaddis.)

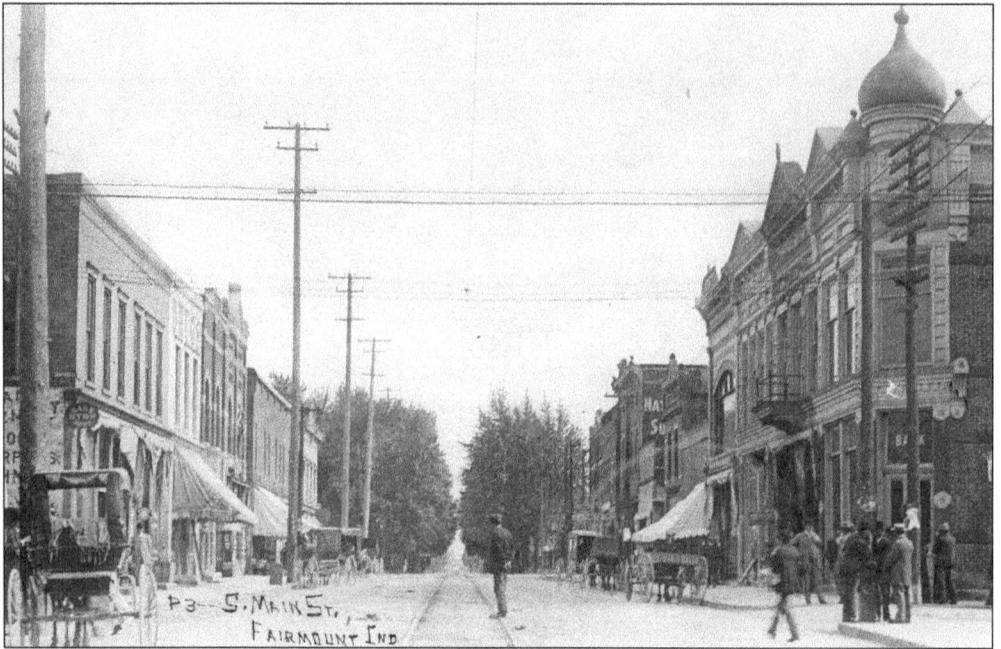

P 3—S. MAIN ST., FAIRMOUNT IND.

Pictured above, a man waits for the interurban, which provided transportation and also carried newspapers from places like Chicago and Los Angeles. Ray Bush was born in 1917, and at the age of 13 he began selling and delivering newspapers in Fairmount. "I got up at 4:30 a.m., and with not too many streetlights or sidewalks. I knew every crack in the sidewalk—in the dark," he says. "For the evening route, I got out of school early. In the end, I had 601 customers daily for the *Marion Chronicle-Tribune*. We had 13 newspapers. The interurban would come in and dump them off." The photograph below is an early scene of East Washington Street.

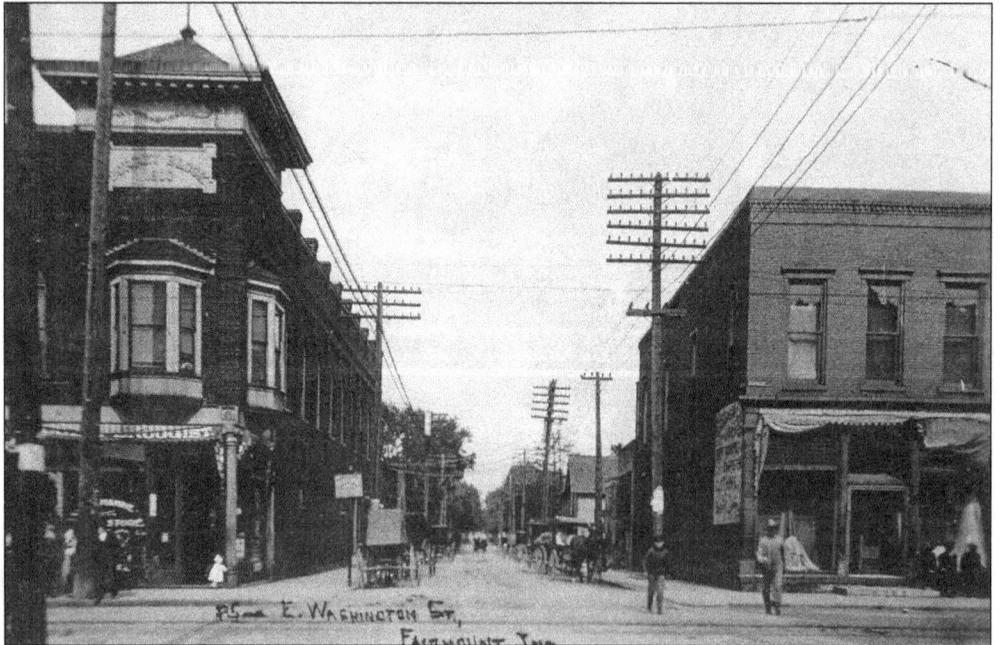

P 5—E. WASHINGTON ST., FAIRMOUNT IND.

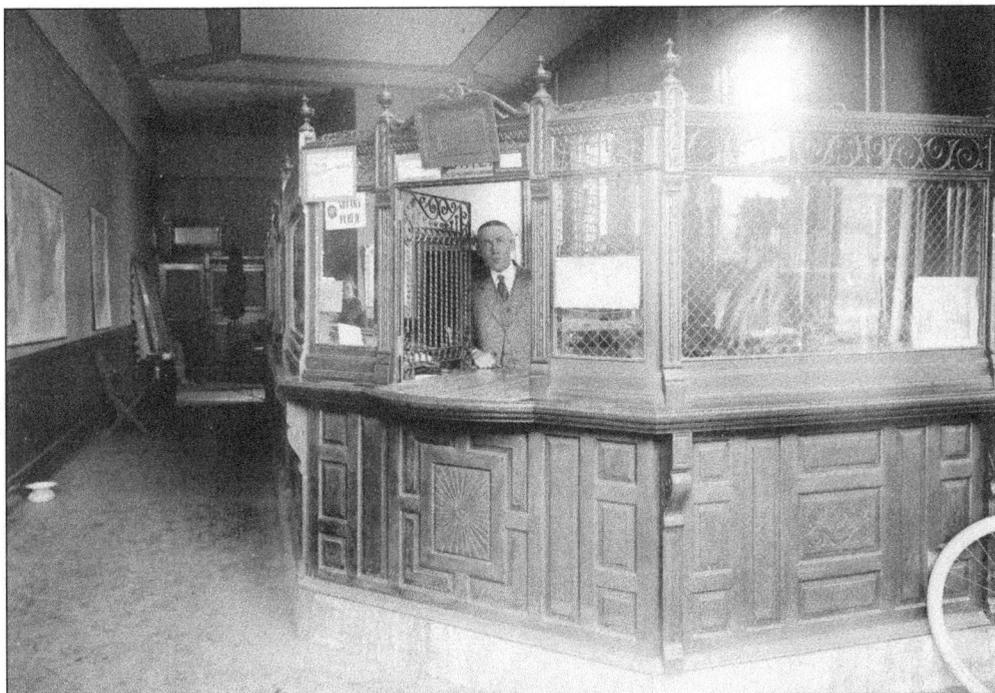

The Citizens Exchange Bank had wire mesh behind the glass of the teller's cage to discourage robberies. Victor A. Selby became president of the bank in 1917 following the death of his father, John Selby, who was one of the founders of the bank. (SFC).

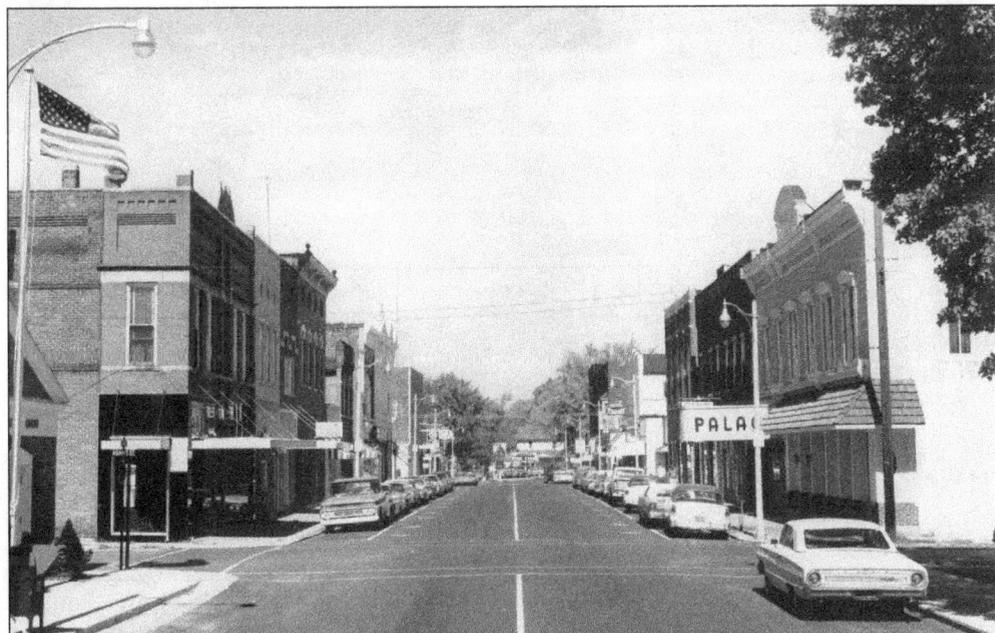

In this 1964 street scene, on the corner before the Palace is a hardware store that has been there for decades. The Dale brothers ran it in the 1930s, and Russell Dale played flute in the band. When farmers had their chores done, they would sit around the nail keg and play checkers. Sometimes they had checker tournaments. (SFC.)

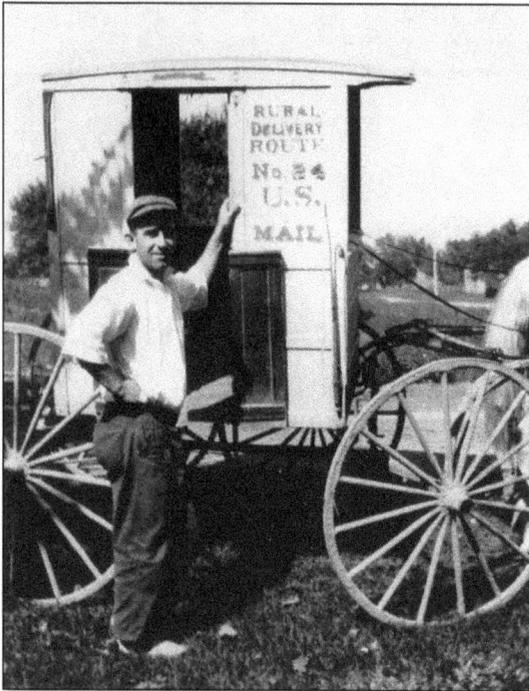

This picture, taken in the early 1900s, shows an unidentified postman with his postal buggy with 24 as his rural route. The Rural Free Delivery program started on April 2, 1900, and Fairmount eventually had six routes. (Milford Adams.)

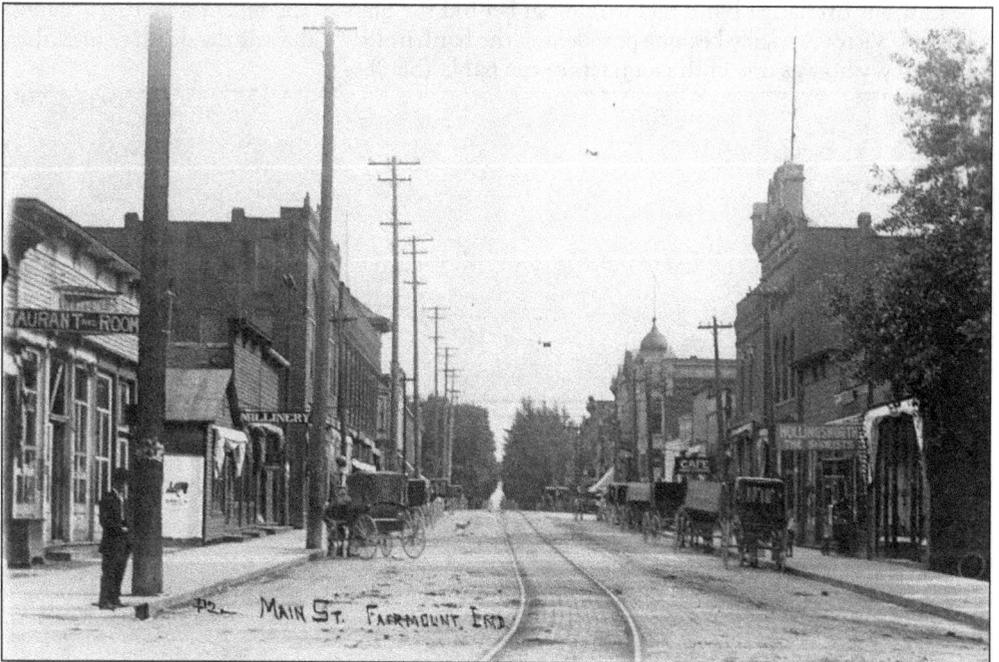

This street scene has a sign on the left-hand side promoting a hat shop. Mrs. Jennie Sutton's Millinery Parlor advertised in the county fair's brochure, stating that she "always keeps on hand the daintiest display of hats and countless variety of trimmings at her millinery parlor. She spares no pains to present to the ladies an array of styles that embraces everything in the line of fine millinery." She referred to it as "the Sutton block." The White House (far left, with the "Restaurant and Rooms" sign) offered billiards, a sampling room, a restaurant, and rooms. (SFC.)

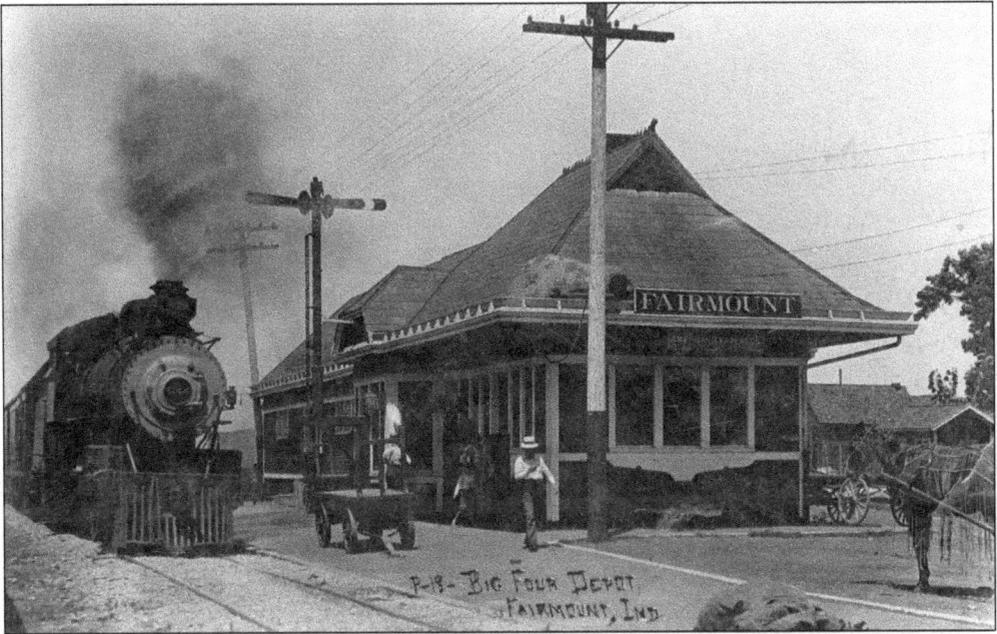

A 1905 photograph of East Washington Street shows The Big Four Depot. "The Big Four" represents the Cleveland, Cincinnati, Chicago, and St. Louis Railroad. Telegraph, passenger, and freight services were available. The first trains were for freight with only the caboose for passengers. In 1889, they were serving pie onboard. Later came passenger trains with dining cars. Note the mailbags in the lower right corner and the horse draped with fringe to shoo the flies away. (SFC.)

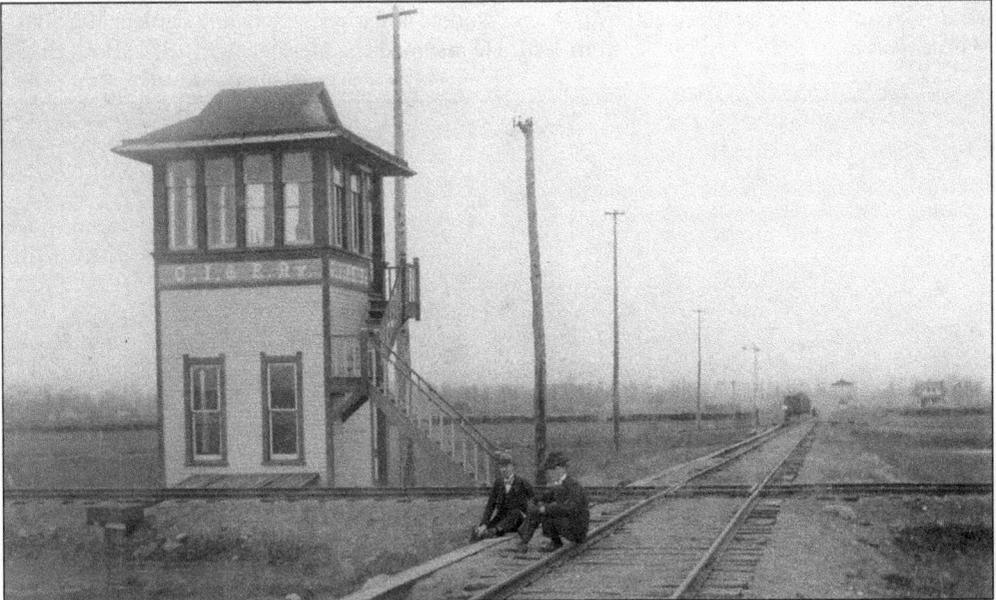

Victor Selby (left) and his brother William wait at the crossing of the Chicago, Indiana, and Eastern (CI&E) Railway and The Big Four for a ride to the Saturday night dance in Matthews. Matthews was a gas boom creation, and the very first section of the CI&E Railway connected it to this crossing of The Big Four Railroad a quarter mile south of the Fairmount Fairgrounds. The block tower controlled the signals and the switches. (SFC.)

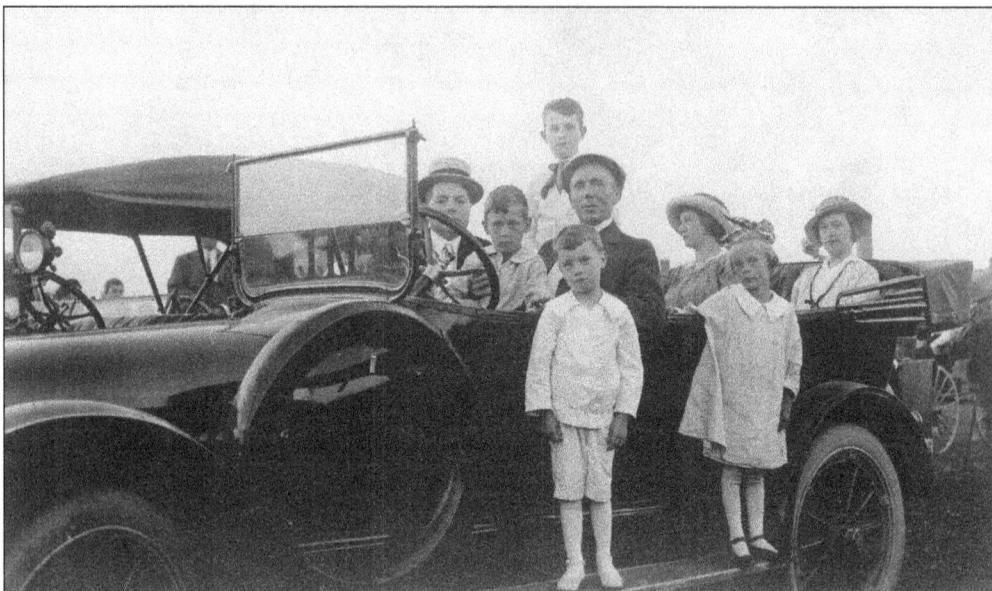

About 1920, Victor Selby, seated behind the wheel, drove his 1916 Hudson 6-40 touring car west to Phoenix, Arizona, with his family. They camped along the way. In front on the running board are Fred Edwards and Virginia Selby; in the car, from left to right, are Xen Edwards, Victor Selby Jr., John Edwards, Mabel Selby, and Ethel Edwards. They visited a Fairmount native, artist Olive Rush, who gave them an oil painting with the handwritten note on the back, "For Mrs. Victor Selby, With love and many happy memories of a joyous trip over the Mesas and through the arroyo hondos [Spanish word for "deep gullies"]." Victor worked at Citizens Exchange Bank at 102 South Main Street from 1895 until his death in 1951. He assumed the presidency in 1917. (Both SFC.)

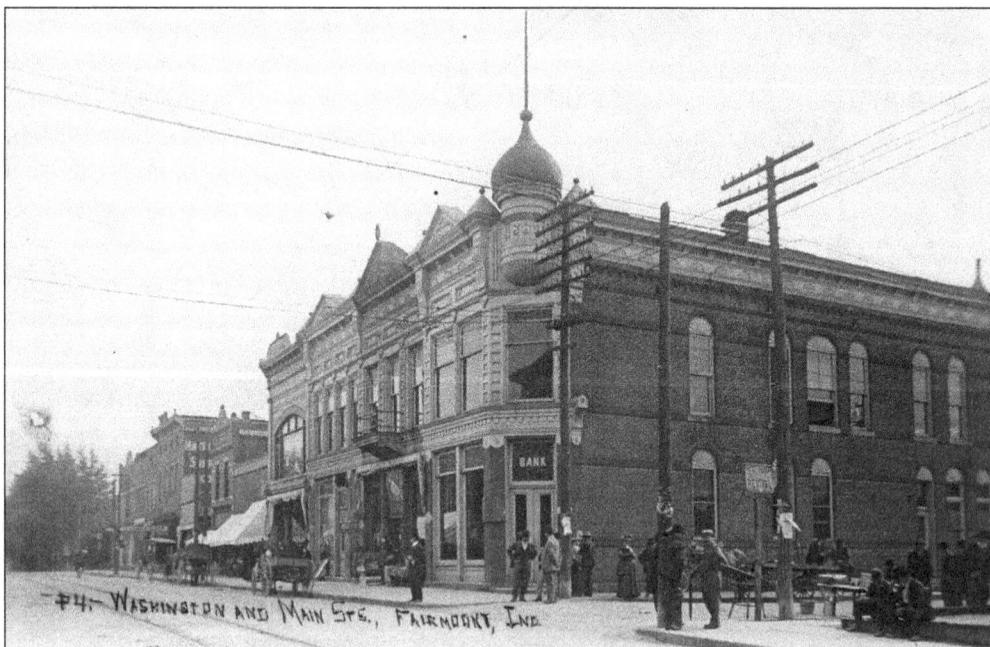

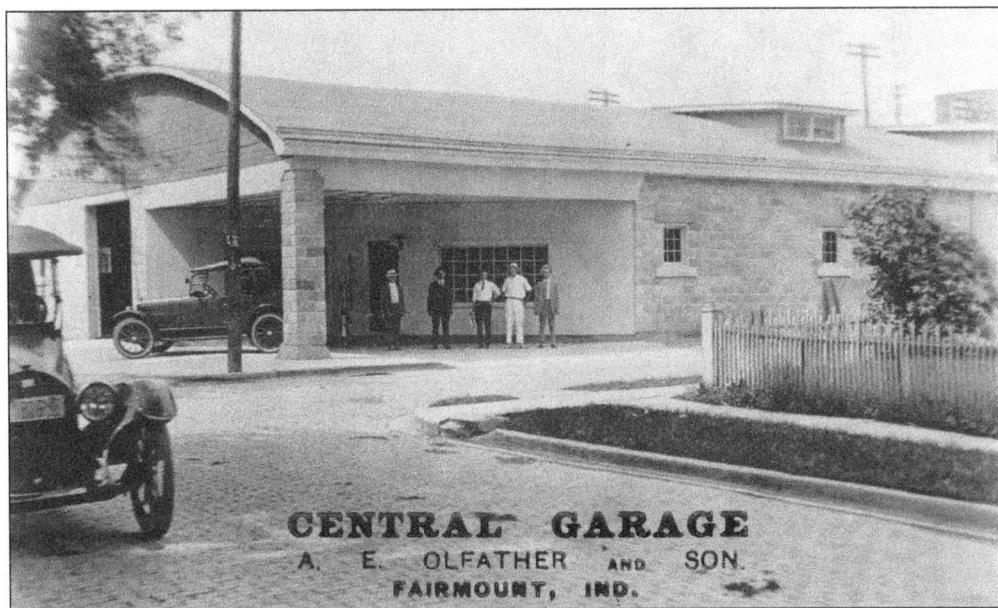

Traveling photographers produced advertising postcards such as this one for the Central Garage in the 100 block of East Washington Street. The car license plate indicates it was 1920. (SFC)

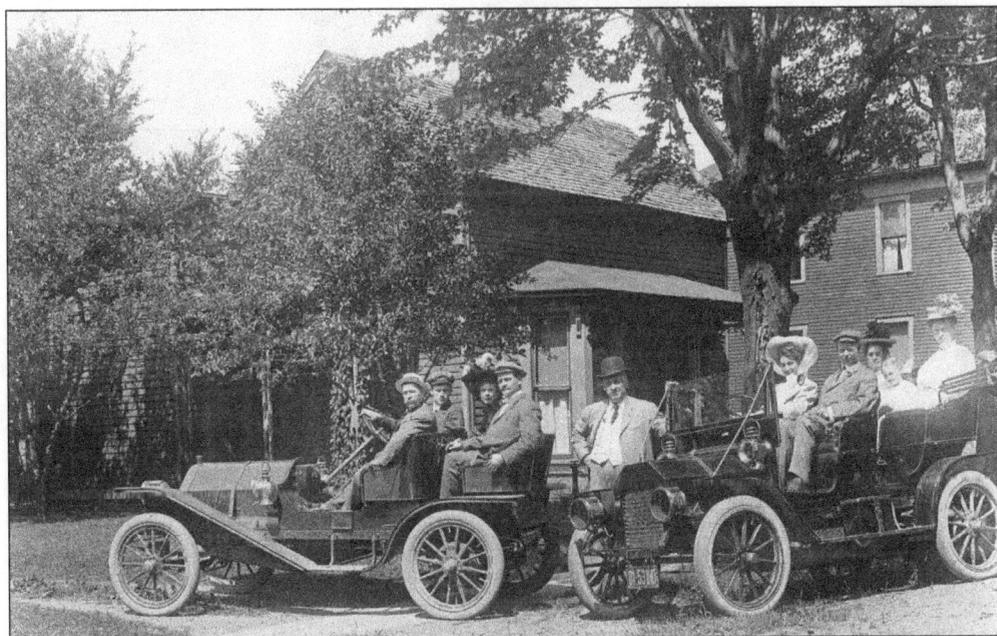

In 1910, these finely attired Fairmount motorists are prepared to go for a Sunday drive in some of the earliest cars in the town. Events were constantly going on. Historian Ralph Kirkpatrick reported to Bill Payne that the evangelist Billy Sunday came to Fairmount and preached on Main Street in a specially made tabernacle, which seated 2,000 people. A 1902 *Fairmount News* article stated the former baseball player preached to 1,500 people one night and received $1,620 the last day in the tabernacle that cost $8,550. "He was there for a month," Bill says, "then someone bought the tabernacle and built two houses from the wood. I was also told Theodore Roosevelt came to Fairmount on the train and didn't get off, but he gave a campaign speech."

In August 1941, the Rich-Osborn reunion was held on the Gaddis farm. Family members are enjoying a meal at a picnic table on the property. The Dutch Mill, an ice cream parlor, is in the distance. (Jim Gaddis.)

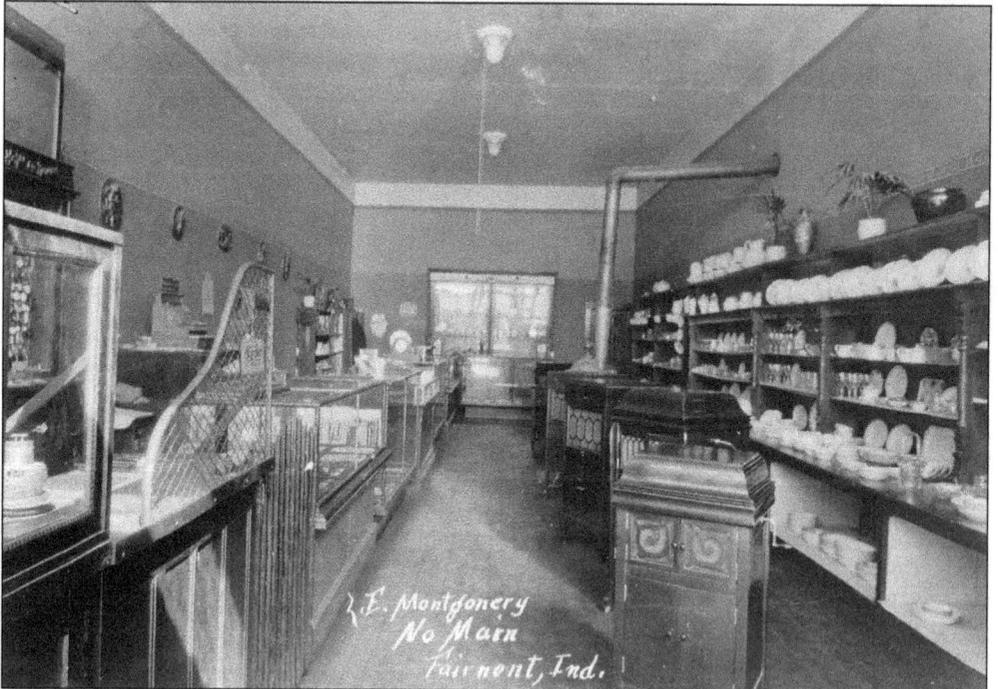

This is the interior of Leonard Montgomery's jewelry store at 124 South Main Street, where he sold Victrola record players and glassware among many other items.

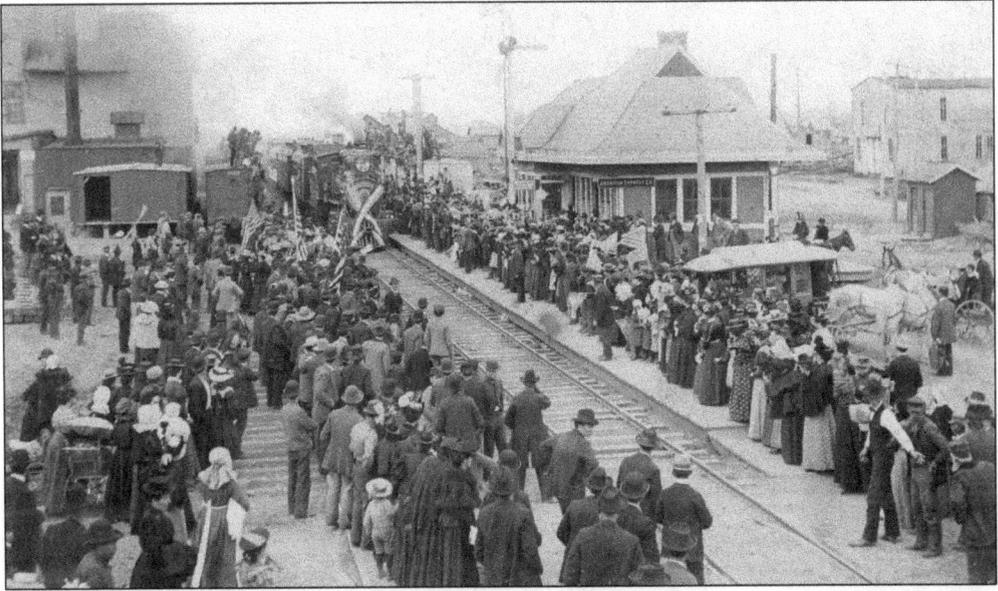

The train in Fairmount took the Warsaw, Wabash, and Marion militias to Indianapolis on April 26, 1898, the date this photograph was taken. The image originated from Schuyler and Rosa Smithson. Schuyler's grandfather David Smithson and his wife, Betsy, were early settlers. They had 12 children and owned 320 acres of land. (Marsha A Smithson Payne.)

This unidentified photograph of a marshal and his family was taken by S. A. Hockett Studios. Hockett worked in Marion, and then moved to Fairmount on Barclay Street before joining with Fairmount photographer ? Miles in the building run by the local Mason's group. In 1904, he moved to a new studio with a large skylight at 111½ South Main Street, above what is now the Hi Fi Stereo Shop, the oldest record shop in the state, owned by Helen and Leo Broyles since 1960. In this time period, photographs were taken using glass plates. Some locals referred to the photographer as high-pocket Hockett. (Fairmount Antique Mall.)

This early-1900s postcard depicts the place where Main and Henley Streets intersect, known by local townspeople as "The Point." Memorial Park is located here today, and a 105-millimeter Howitzer makes it distinctive. (SFC.)

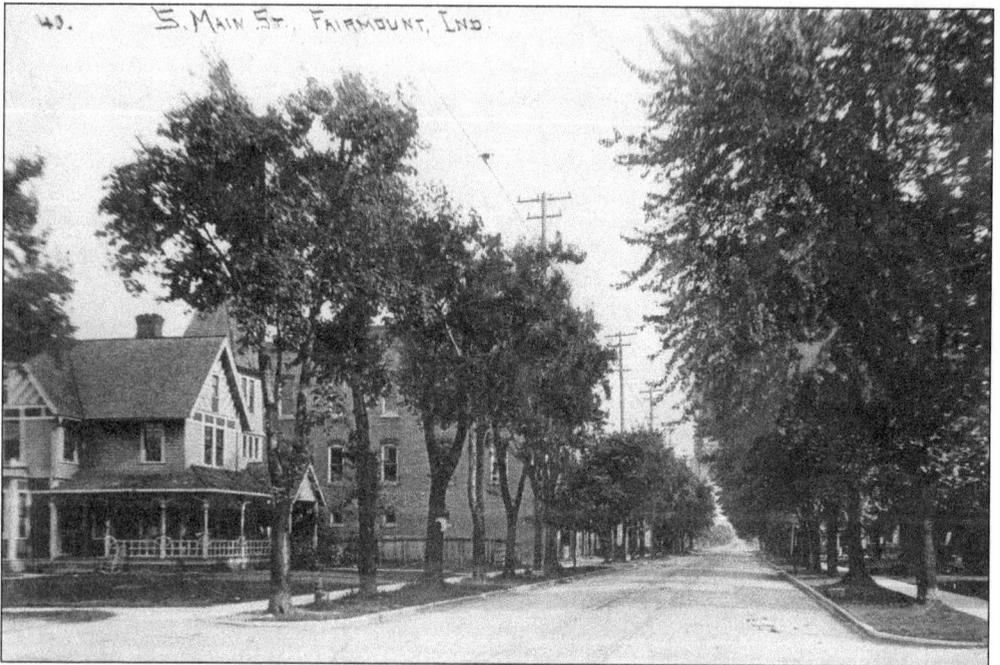

Through the generous donation of Dr. L. D. Holliday, the Fairmount Public Library acquired and moved into his former residence. Opening day was September 18, 1930. Congoleum carpet and fresh bouquets brightened the well-appointed facility. Throngs of people visited throughout the day and into the evening, and 180 library cards were given out.

46

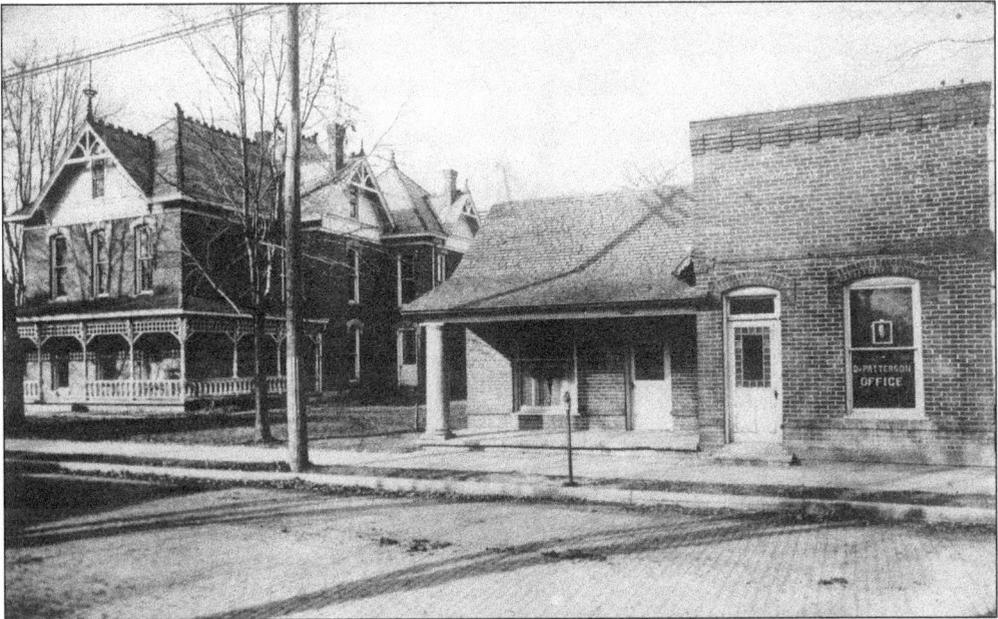

Dr. Joseph W. Patterson and his family resided at 203 East Washington Street, which was also his office until 1900 when he moved it next door. Today the Queen Anne–style residence typical of the gas boom era is the home of the Fairmount Historical Museum. Both buildings are on the National Register of Historic Sites. (David Broyles.)

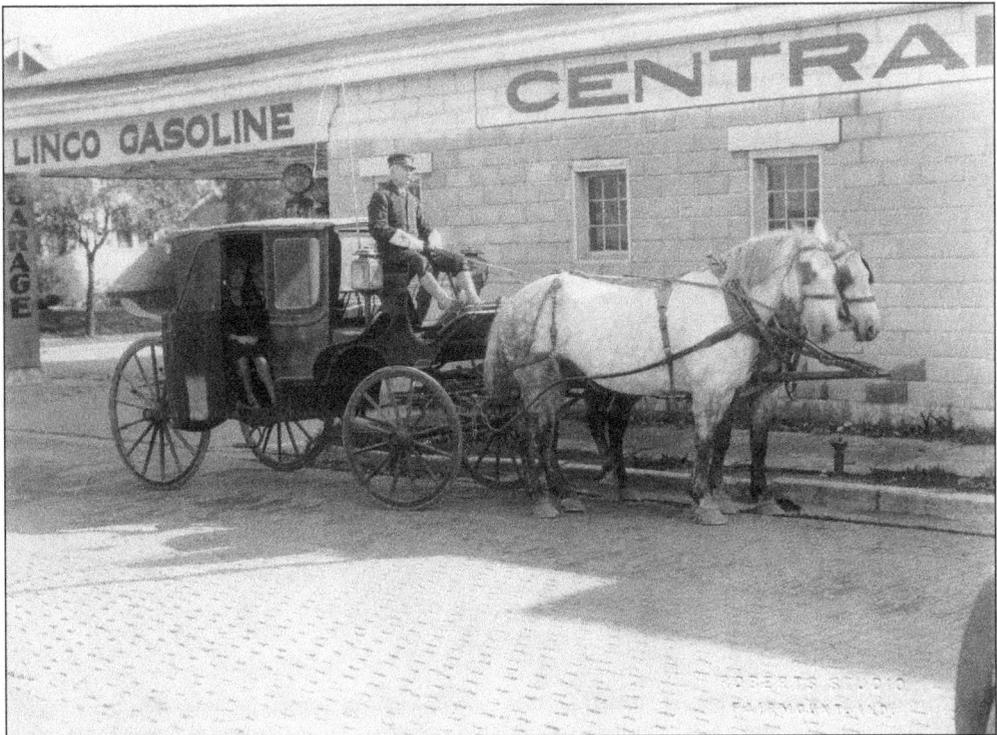

Harley and Myrtle Fritz pose with their buggy in front of the Central Garage and gas station at 112 East Washington Street. They participated in the 1929 boulevard lighting parade. (SFC.)

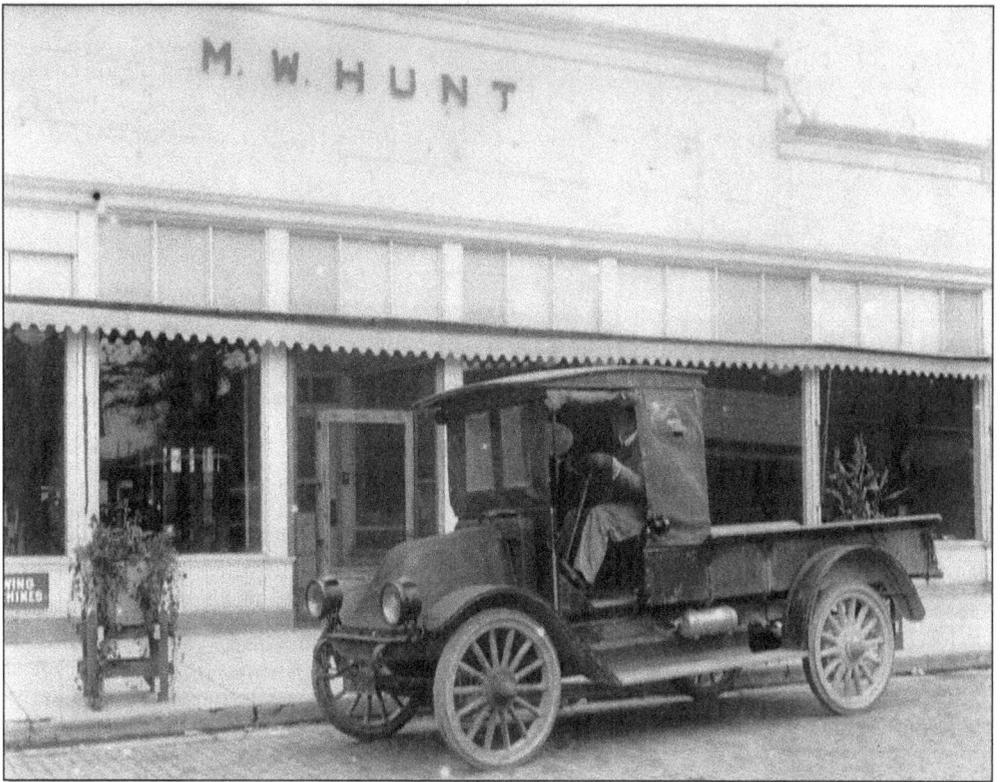

M. W. Hunt had a funeral home and a furniture store, which also offered sewing machines among other items. This was his first delivery truck. Eri Thomas was the driver of this 1914 or 1915 International truck sold to Mr. Hunt by Robert Breedlove.

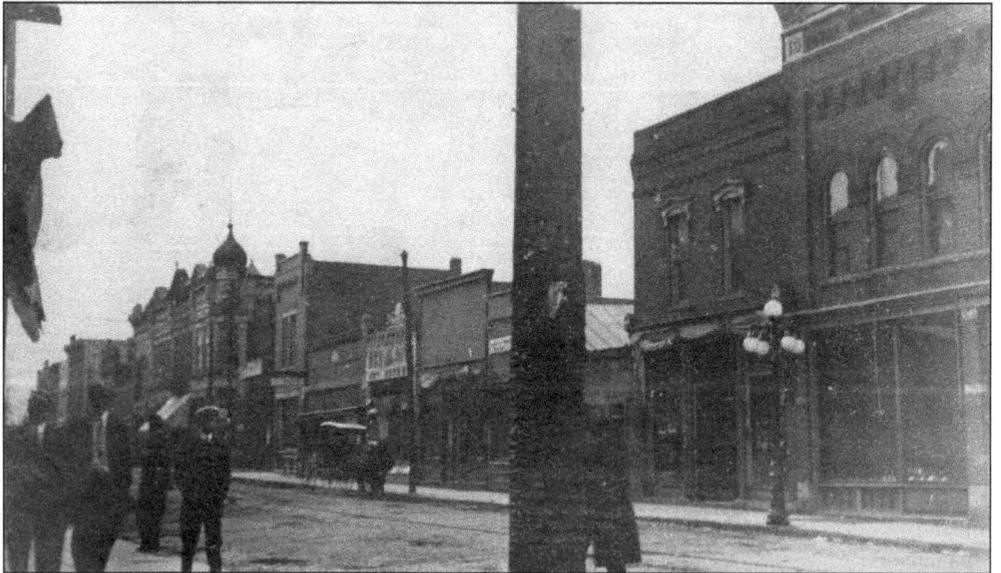

Left of the light pole and above the horse is the garish front of the Beehive dry goods store, with a wood depiction of an actual beehive. George Seigel's mother, Inez Vetor, worked at the Beehive and had a spool cabinet with a glass front and drawers for the spools, which came from there.

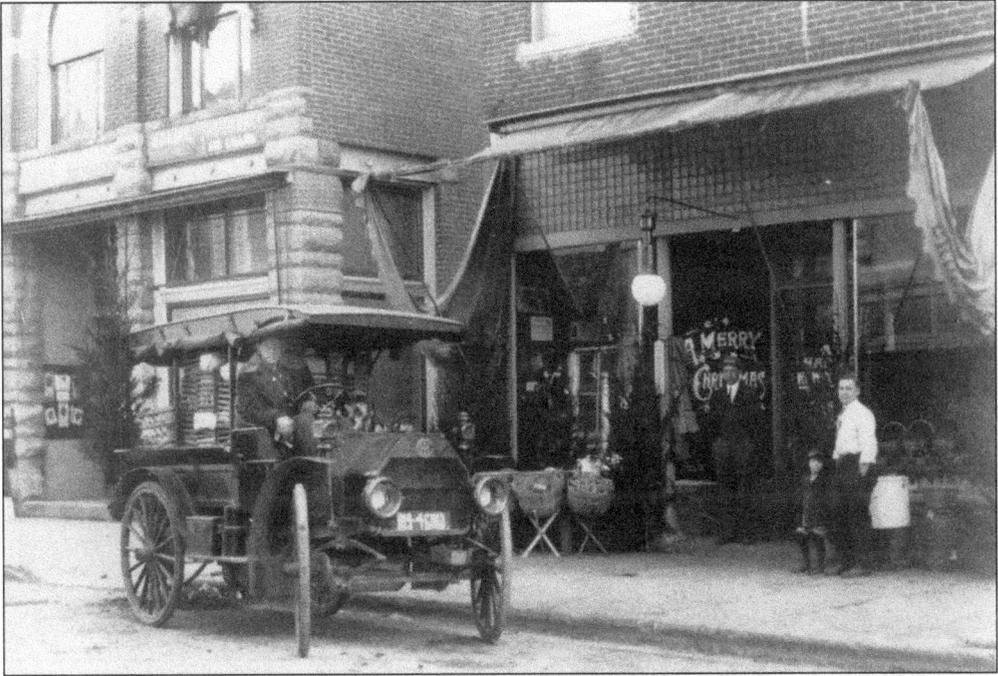

Bundled against the cold, the unidentified driver sits at the wheel of his 1913 International delivery truck that sports homemade license plates. Wilson's "green grocery" has fruits and vegetables as well as Christmas trees. (Ruth Lewis.)

The Union Traction Company interurban took over the original streetcar line. "Homer Day took tickets at the Fairmount terminal and ran the traction station around the late 1920s to the middle of the 1930s, when it closed," says Harold Bowman. "People who invested in it lost money because the automobile came along, and they lost customers."

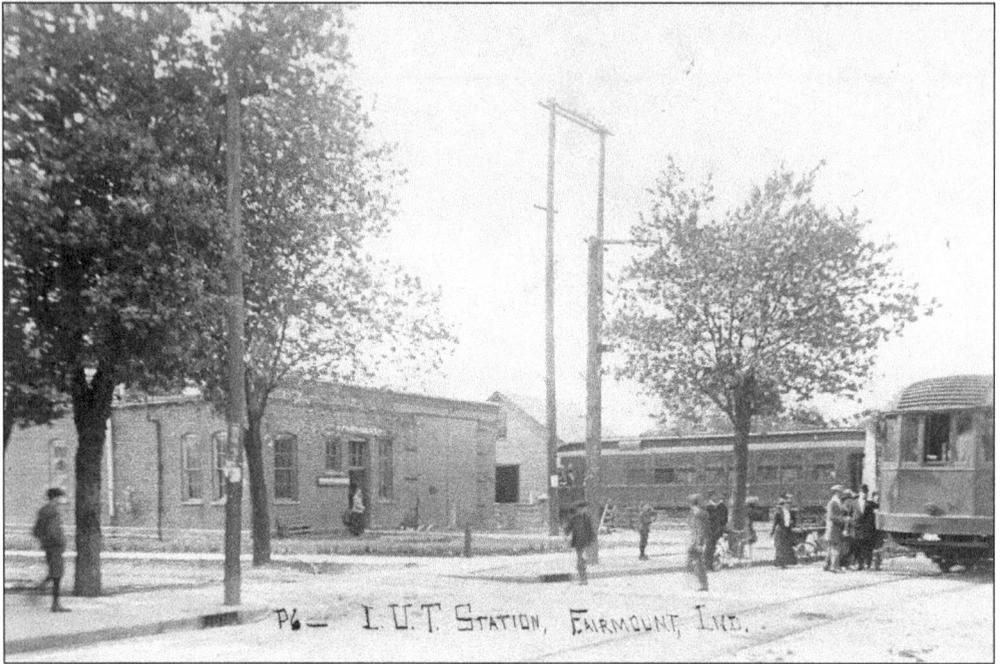

Above is Fairmount's Indiana Union Traction terminal in the 1920s, and passengers are boarding a northbound car. The interurban line grew to over 1,800 miles before the Depression, making travel to Chicago and major Ohio cities convenient and fast. Interurban rider Leo Broyles said that the acceleration when riding the interurban could be so fierce that a person could not walk forward in the car to get to his or her seat. It would make it to Indianapolis in an hour flat, even with many stops along the way. (Above, SFC.)

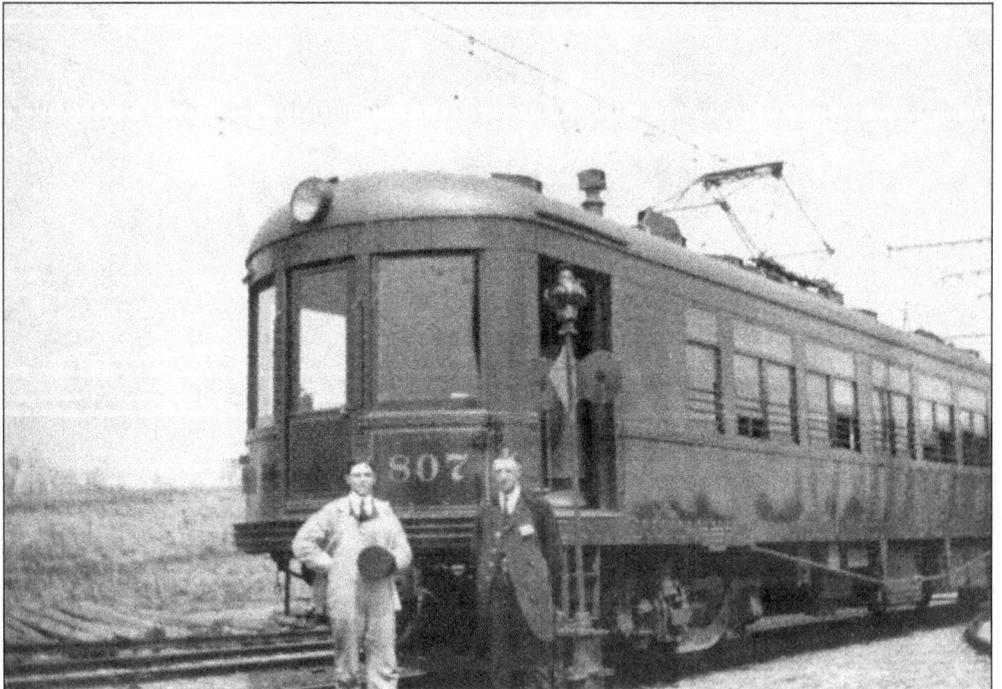

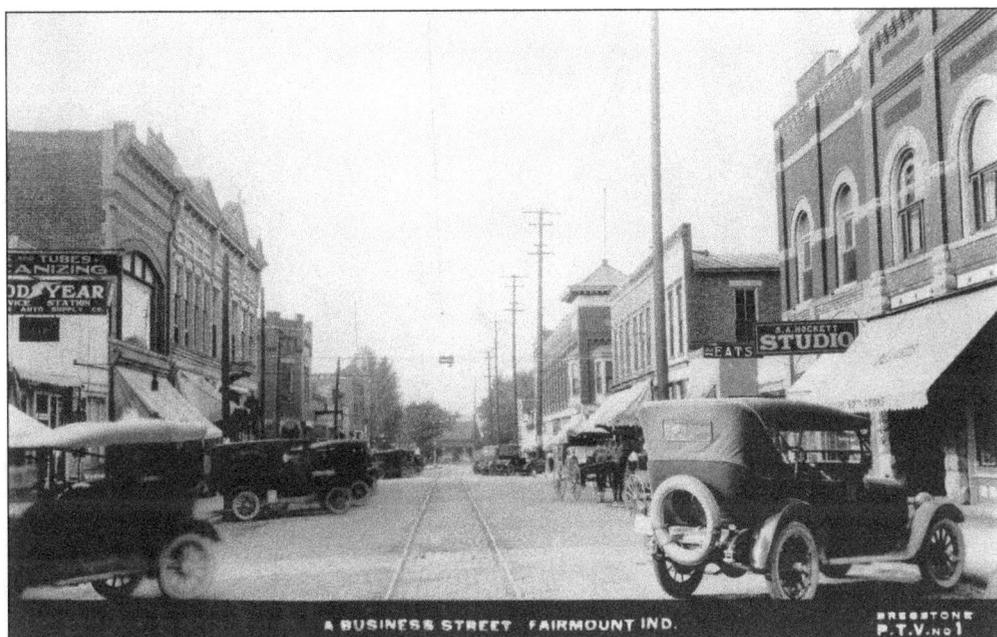

A BUSINESS STREET FAIRMOUNT IND.

In mid-1920s Fairmount, a sign for S. A. Hockett Studio indicates where many people had their portraits taken by the photographer. Hockett produced the photography for the Fairmount Academy's annual called *Queen of the Hilltop* in return for the students selling circuit photographs, which were made using a rotating panoramic camera. A circuit camera would expose a narrow slit of moving film as the camera rotated. This feature allowed spry pranksters to run behind the crowd faster than the camera panned, and thus they would appear in both the beginning and end of a crowd photograph.

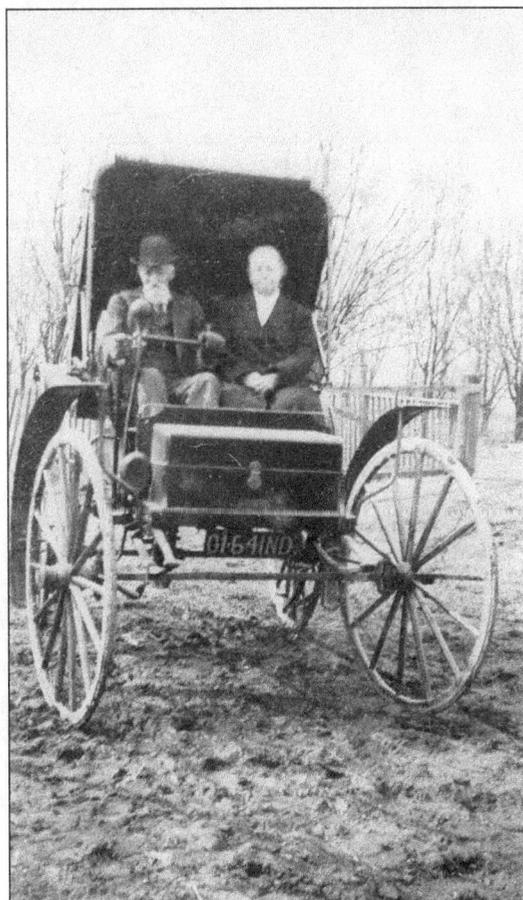

The unidentified owners of this tiller-steered Holsman automobile are shown on a farm around 1905. There are two rubber-ball horns, and its high wheels made it well suited for the rough roads of the day.

51

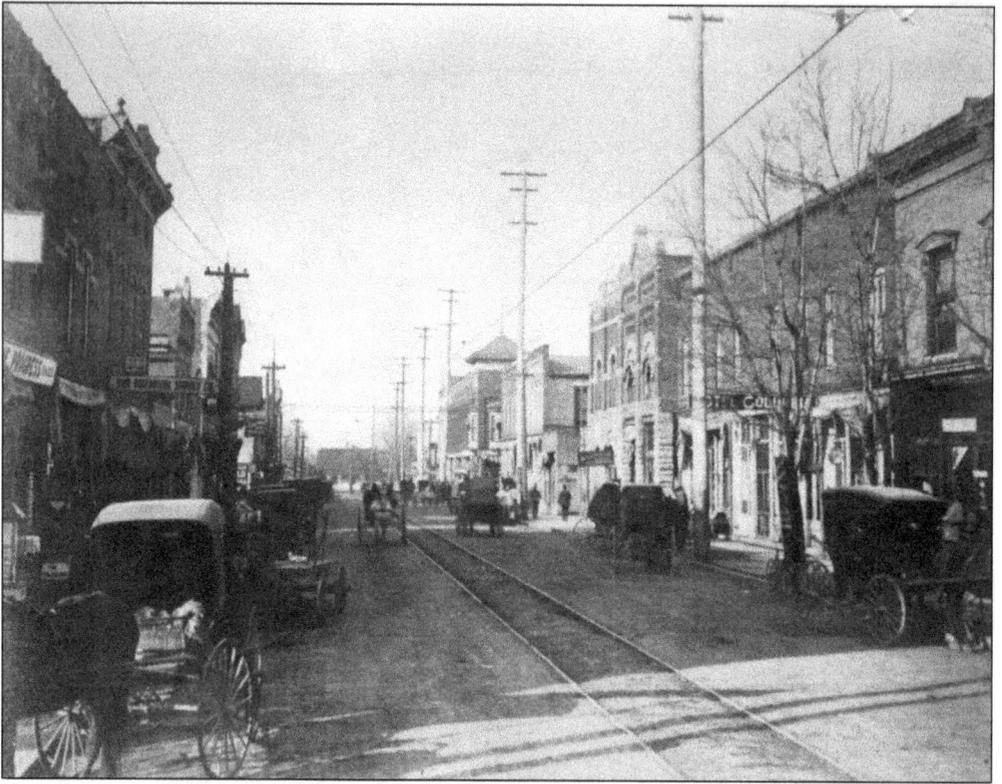

This is from Adams Street looking north on Main Street after 1900. On the right is the Hotel Columbia, originally known as the Central Hotel and briefly as the De Marsh in the 1890s. A lobby, dining room, and kitchen were downstairs and sleeping quarters upstairs. On the left is part of a sign that reads, "Cars Stop Here," indicating a place to get on the streetcar.

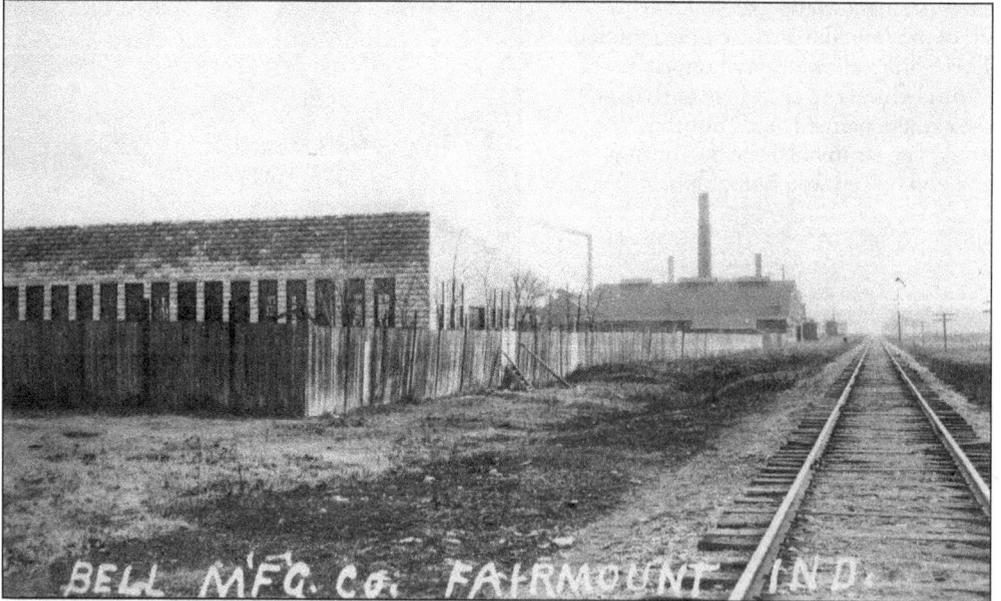

The Bell Manufacturing Company was located east of the fairgrounds across the railroad tracks.

Four

SCHOOLS

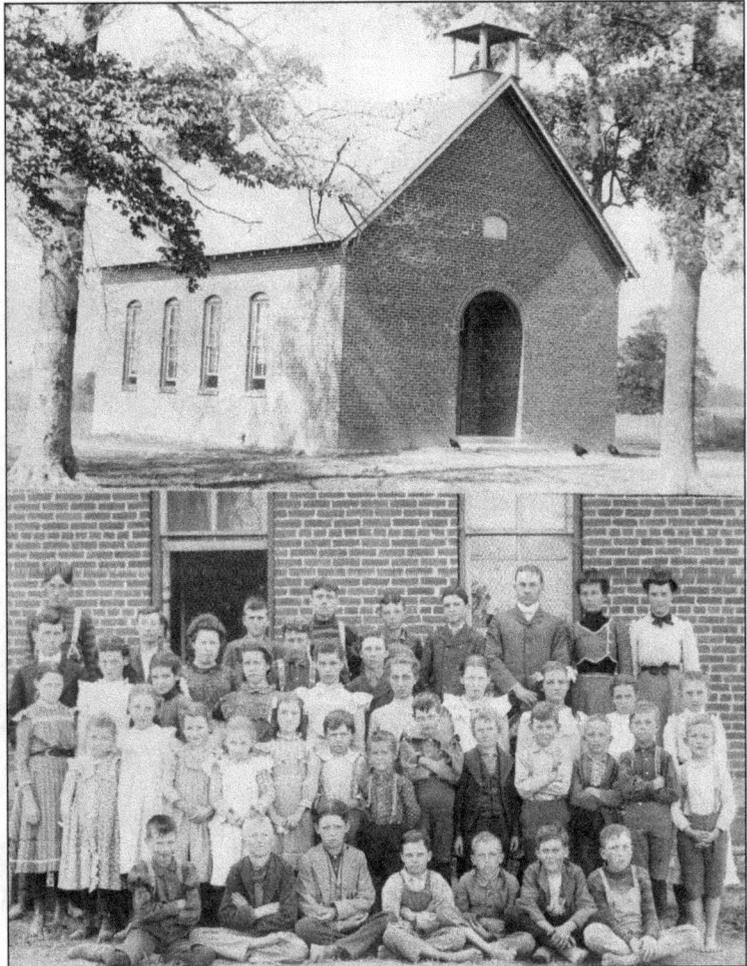

The Back Creek schoolhouse is pictured here in the early 1900s, along with a school photograph of the students. From the 1940s through the 1970s, the building housed the Indian Motorcycle Shop, where James Dean purchased his first motorcycle. (WFC.)

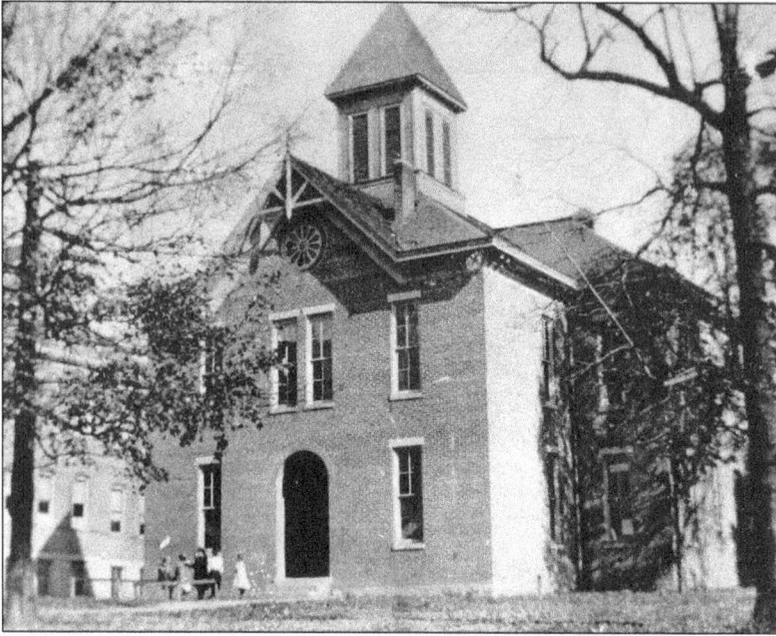

This building housed the first Fairmount Academy. The idea to have an academy was first introduced in 1883 at a meeting of the Society of Friends in the area. When the new academy was constructed, this building was sold to Fairmount Public Schools for $8,000. (Ruth Lewis.)

The 1912 advanced home economics class from the Fairmount Academy is pictured in front of the school building. Dora Elizabeth Wilson, Milford Adams's mother, is in the front row, the fourth person from the left; the others are unidentified. (Milford Adams.)

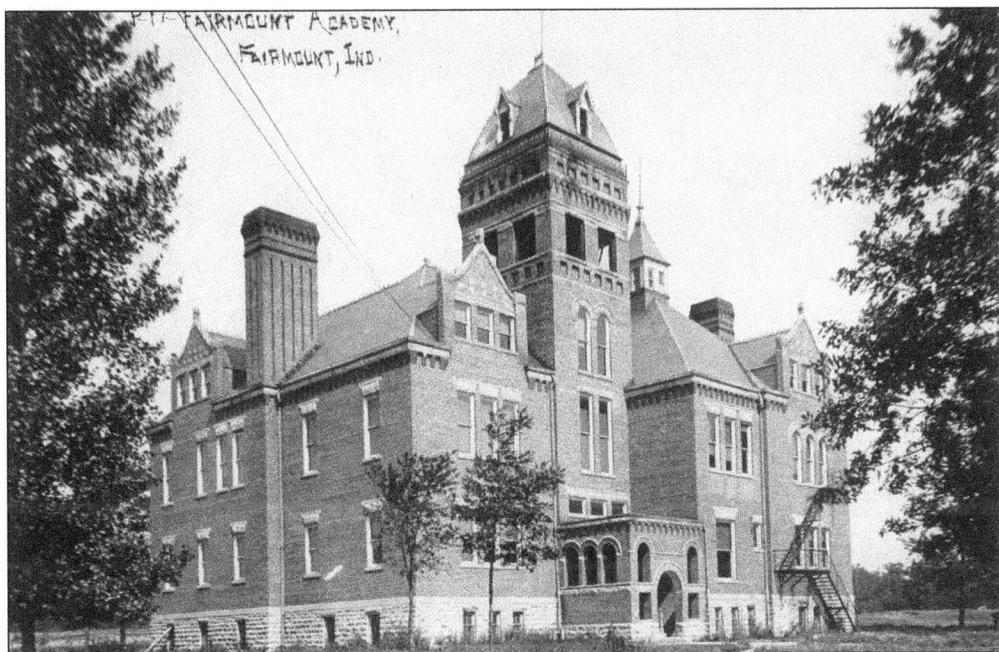

The Fairmount Academy's architecture is of the Romanesque Revival style, which was popular for Indiana schools built in the late 1800s. It is easy to see how it came to be called "Queen of the Hilltop." The school was started by Quakers, and the land it was built on was given by the Rush family, as well as thousands of dollars in donations. The academy offered higher education, going beyond the eighth grade.

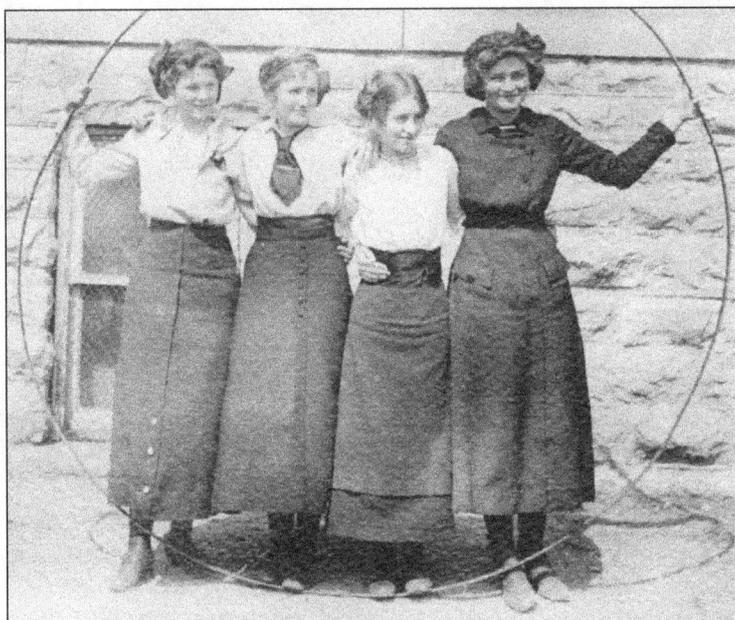

These girls and their hoop are seen in front of the Fairmount Academy in 1917. The girls are, from left to right, Lois Hockett Mittank, Nellie Fowler, Helen Scott, and Isadora Rush.

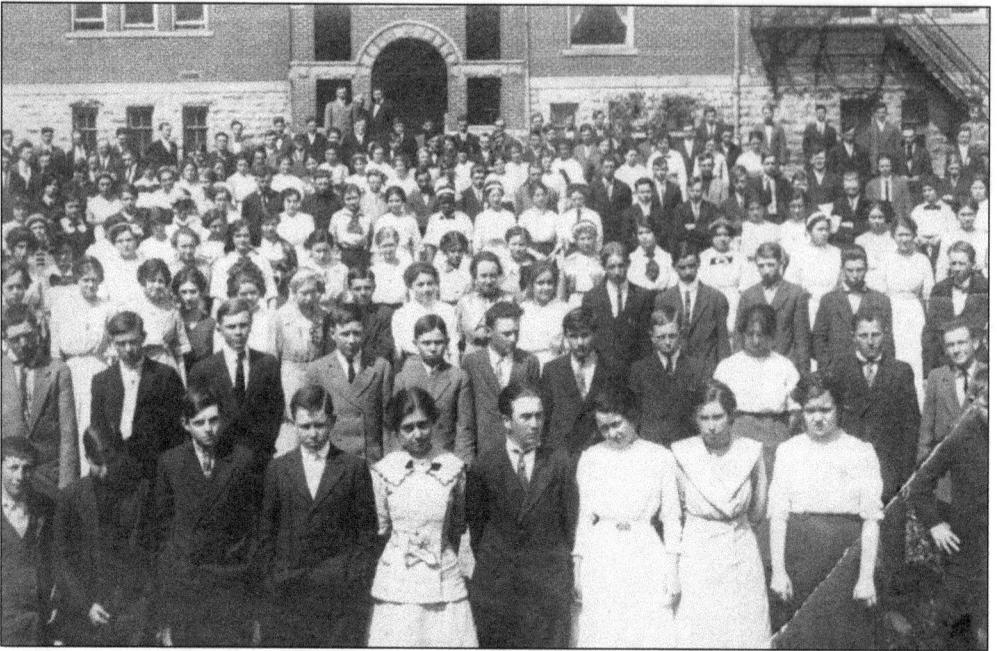

In the spring of 1913, the pupils of the Fairmount Academy pose for a picture. This birds-eye view shows the entire student body and faculty. (SFC.)

The Fairmount Academy later became the West Ward Grade School, where James Dean was a student. The school adopted the national safety patrol program. Tom Bennett's participation one year was to hold the door for the students as they came out of West Ward School. In the sixth grade, Tom used a long bamboo pole with a red flag to stop traffic on State Highway 26 coming past the school so kids could cross safely. (Duling family collection.)

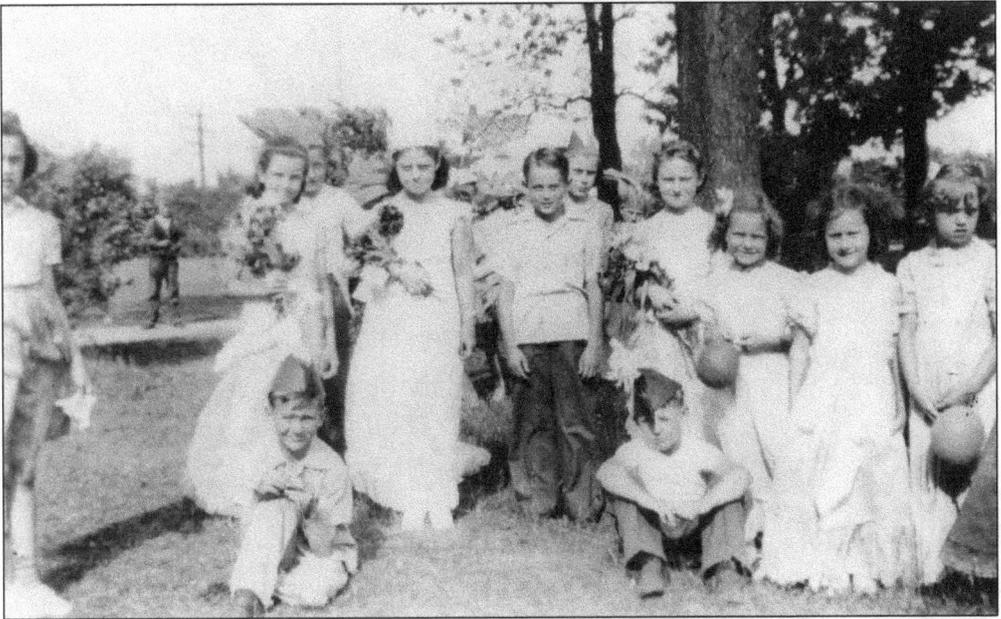

In a 1942 picture at the West Ward School, formerly the Fairmount Academy, James Dean (without the hat) is king at the May Day celebration; the others are unidentified. The children in the area typically celebrated May Day. (JDG.)

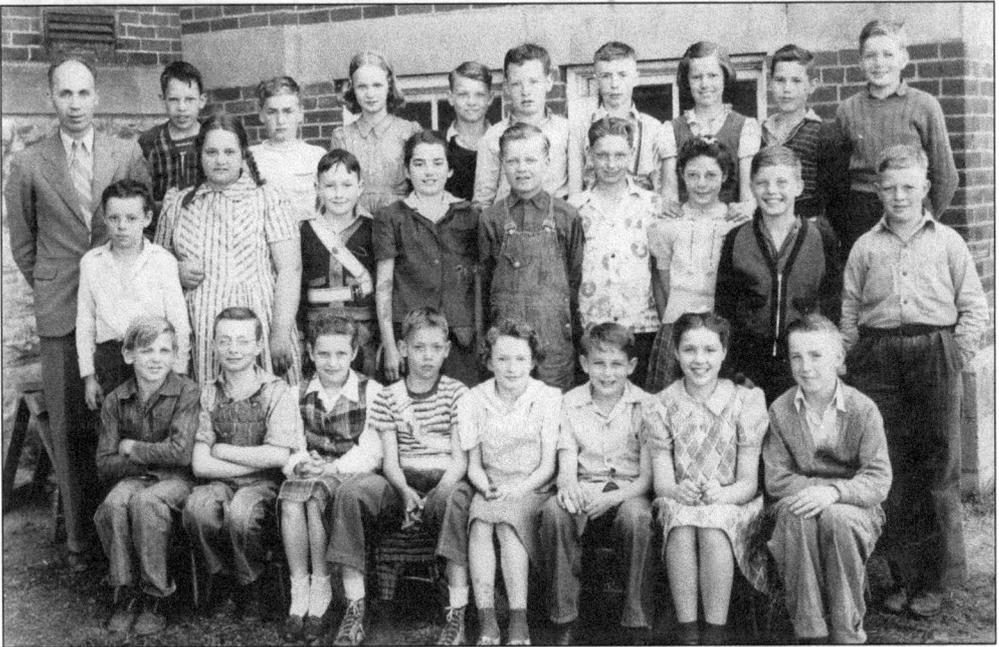

The students of West Ward School included James Dean, sitting in the first row, third from the right; Harrold Rust was a friend of Dean's and is pictured in the first row on the far left; Harrold's brother Willard is in the first row on the far right. Ivan Steward was the teacher of the class. After Dean acted in the movie *East of Eden*, he brought famed photographer Dennis Stock to visit Fairmount and take pictures of him and introduced the photographer to Harrold. (Rust family collection.)

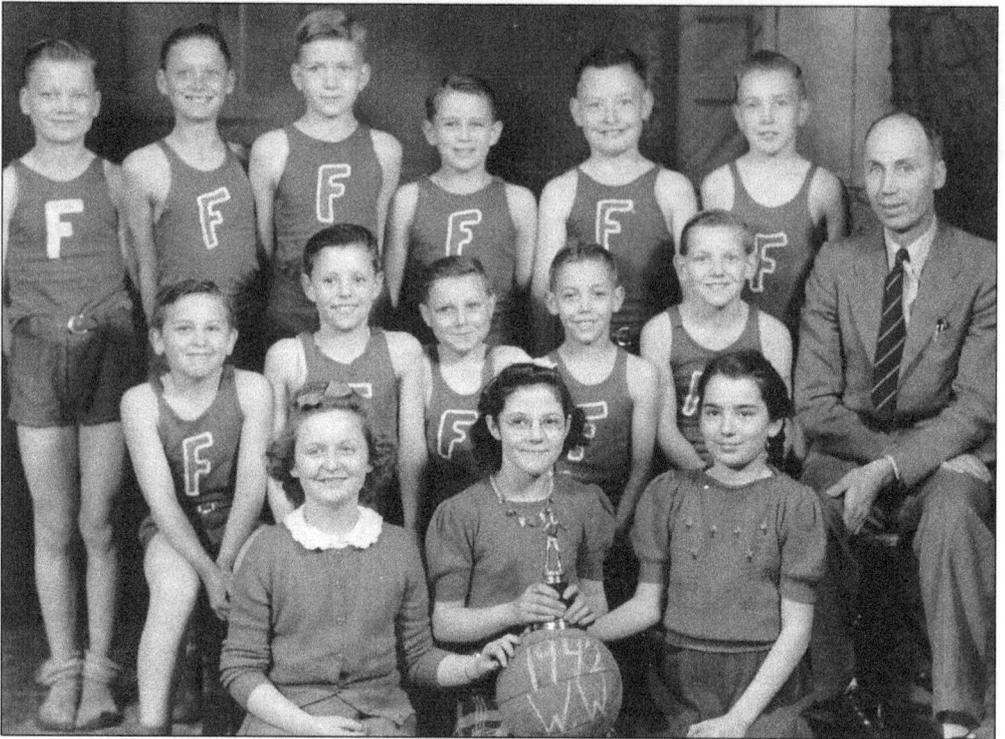

Above is the West Ward School basketball team. James Dean is fourth from the left in the third row; Dean's friend Harrold Rust is second from the right in the second row; Harrold's brother Willard Rust is to the far right in the third row. As adults, Dean gave Harrold his address as 1541 Sunset Plaza Drive, Hollywood 46, California, and his phone number as Ho 75191. Harrold drove his 1954 Ford out to visit Dean while he was making *Rebel Without a Cause*, and Dean got a Ford station wagon to pull his racing car. The photograph below of Fairmount High School was taken on March 14, 1907. The school was commissioned in 1898, and the first class graduated in 1902. (Above, Rust family collection.)

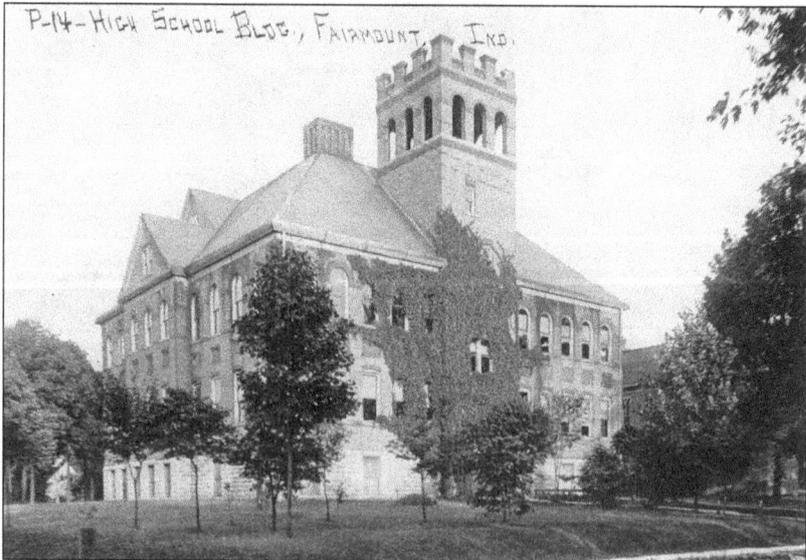

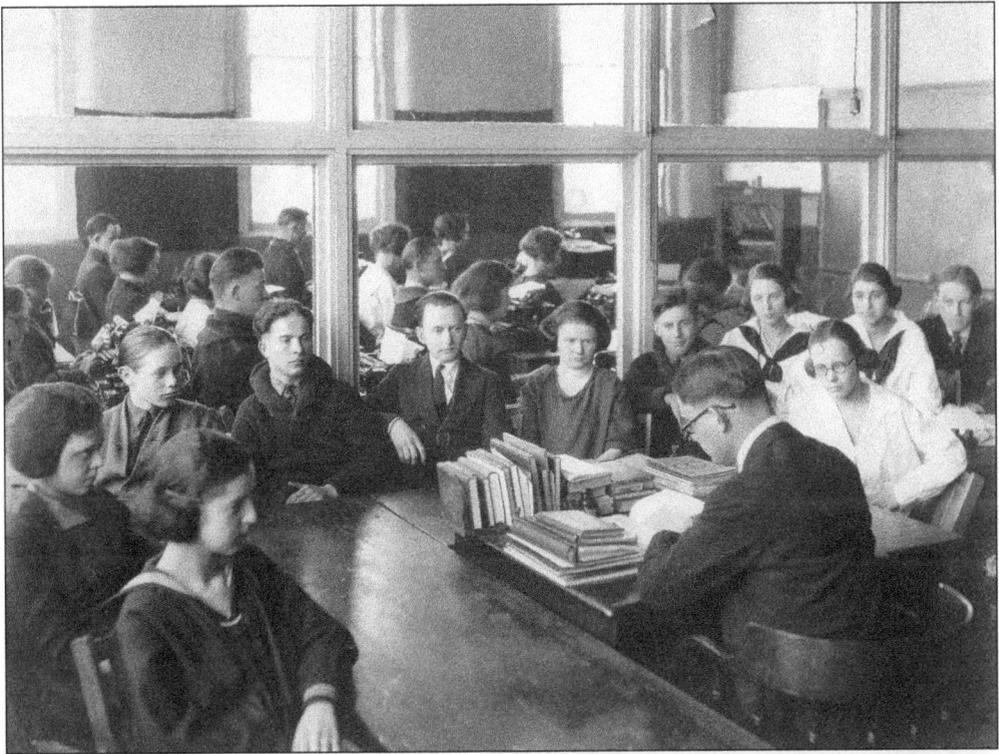

The Fairmount High School commercial class is pictured in 1922. Some girls are wearing the popular sailor suits of the day.

This is the main hallway of the 1898 Fairmount High School (FHS). The first FHS used the original academy building, which was replaced by a new, separate building around 1916. Soon after, an addition joined the two in an awkward manner. This doorway is actually an old, narrow window opening and beyond is an offset ramp down to the new addition. Students had to turn sideways to navigate through the hallway. (Dorothy Leach.)

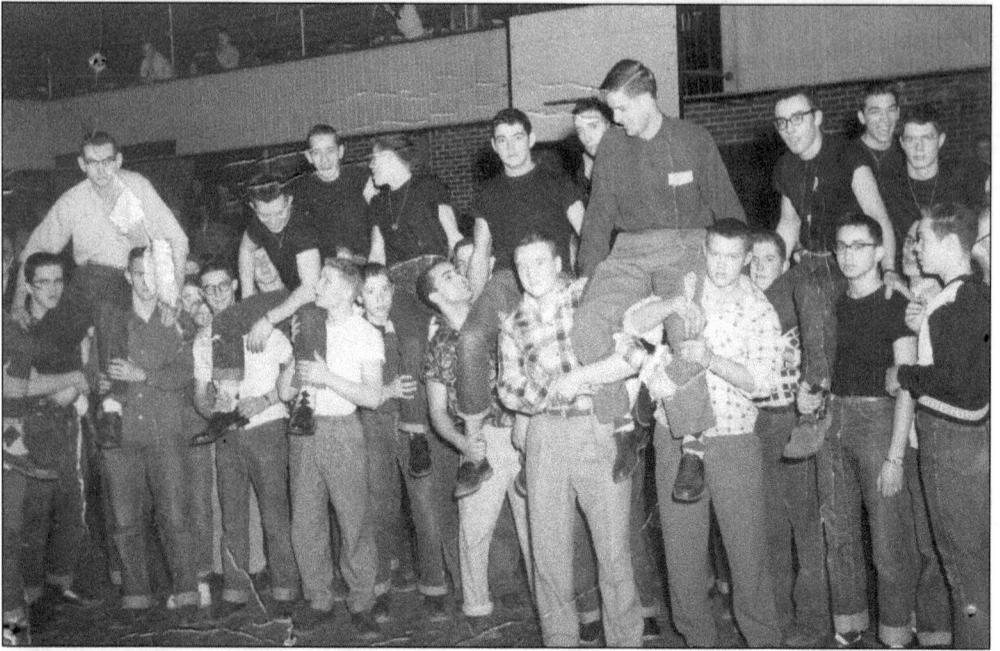

In 1955, the Fairmount Quakers basketball team beat the Marion Giants in a double overtime in the sectional at Memorial Coliseum. The Quakers celebrated in the Fairmount High School gymnasium the following Monday. The team members are in black shirts. People atop shoulders are, from left to right, Fred Barnhart, Charles Himelick, Bob Pernod, unidentified, Dick Stroup, Bob Allen, coach Jim Roth, Larry Stookey, Jim Cromer, and Larry Wood; holding up the coach are Phil Jones and Mike Deeter. After high school, Phil became a CBS network correspondent. CBS officials deemed him "one of the most distinctive and distinguished journalists in the history of our great Washington bureau," reported the *Chronicle Tribune*. Pictured below, a crowd prepares for a bonfire on Fairmount's brick streets to celebrate. Coach Jim Roth holds the trophy. (Both Nancy Wood.)

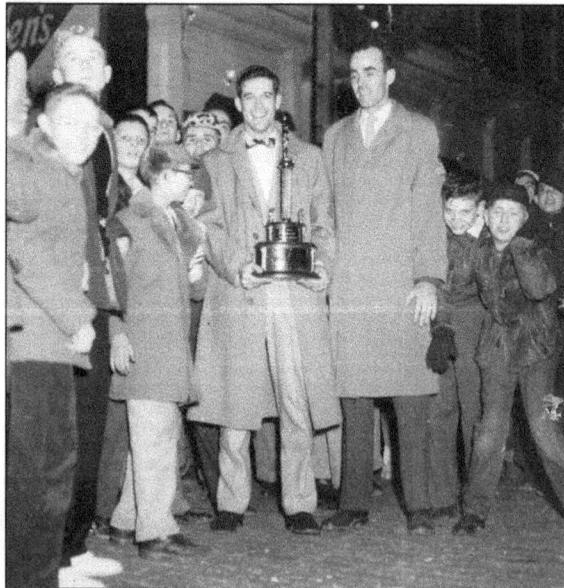

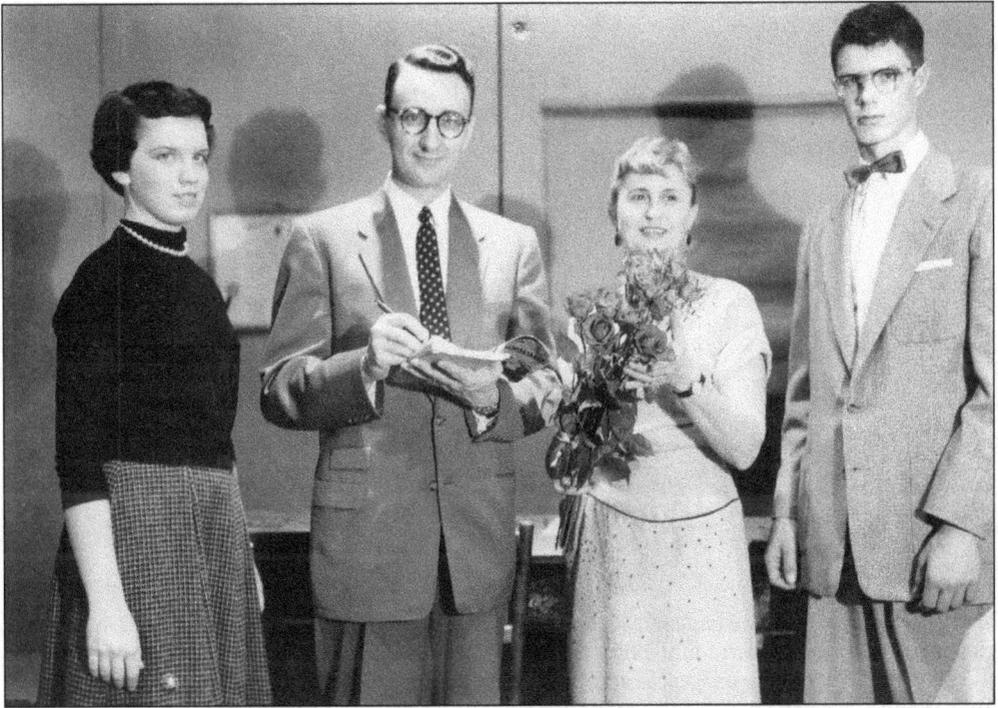

In November 1954, the junior class of Fairmount High School performed the play *The Line of Scrimmage* by Hal O. Kessler. In the above photograph onstage afterward, from left to right, are Linda Ramsey Rogers, Hal O. Kessler, drama teacher Adeline Nall, and Larry Wood—who had a lead part. Nall received flowers, and Kessler came to the show and signed students' programs. The below photograph is of the students, from left to right, (first row) Larry Wood, Nancy Comer, Jerry Black, Marlene Crouch, Joyce Holloway; (second row) Nancy Bush, Dottie Kendall, Linda Ramsey, Sue Gaither, Connie Maple, Jack Skinner, Mrs. Nall, Melba Miller, Martin Lee Davis, and Tom Wood; (third row) Susan Johnson, Jane Crist, Spark Mitchener, Norma Sullivan, and George Thomas. Nall was a talented drama teacher who taught James Dean and helped him get his start in acting. (Both Nancy Wood.)

Cast members of the Fairmount High School junior-class play stand on stage. The setting for the play *The Line of Scrimmage* was an office and a poolroom. In between scenes for set changes, Tom Wood played the piano and Larry Wood put aside his role and played *Stardust* on trumpet. (Nancy Wood.)

James Dean is seen in the lower right-hand corner of this photograph, holding a broom handle, at the rehearsal for *You Can't Take It with You* at Fairmount High School in April 1949. He played Grandpa Vanderhof. On October 29, 1948, Dean portrayed Frankenstein's monster in the Fairmount High School Halloween Carnival play and impressed Fairmount High School student Janiece Payne Duling. "Even with my limited experience, I thought, 'How could anybody anywhere do any better than that?'" Janiece says. (JDG.)

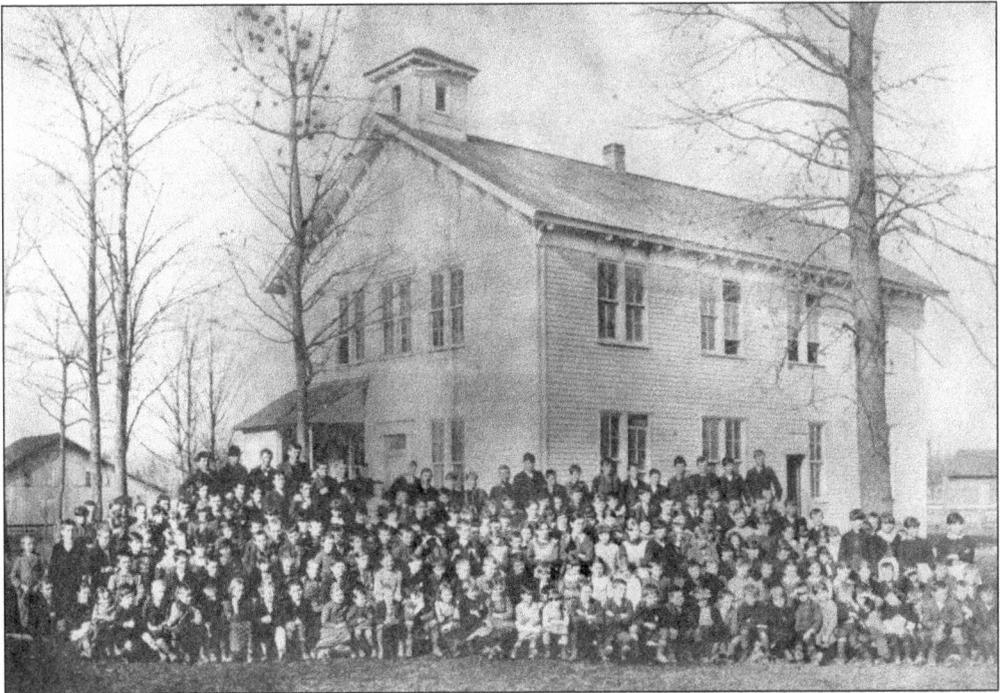

Above, students of the first public school in Fairmount stand in front of the two-story frame building, which was constructed in 1866. The township trustee, Jonathan Winslow, faced opposition for taking on such a project, although the township had nearly 500 school-aged children. In the 1890s, the North Ward School was built at this same location, the 400 block of East Washington Street. The building may have been designed by Arthur LaBelle, an important architect of the day who designed a number of local buildings, including the Citizens Exchange Bank. (Above, Ruth Lewis; below, SFC.)

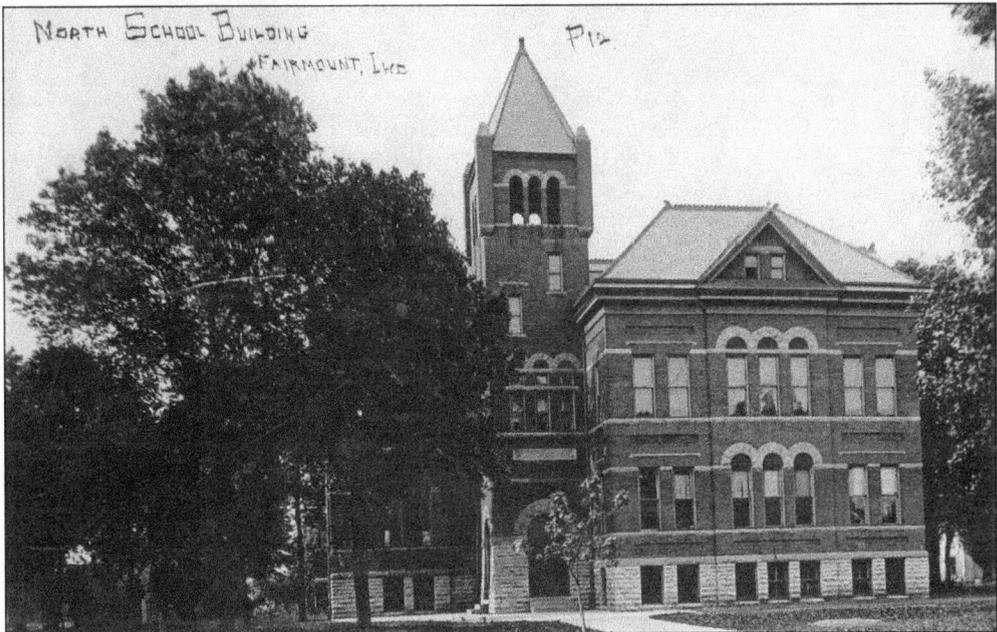

In this 1909 portrait, Dora E. Wilson, Milford Adams's mother, is shown with her brother Hubert. For her eighth-grade graduation, as a 13-year-old, she won first place in the annual Fairmount Township essay contest and recited her winning entry "Too Late for the Train." She served on the 1917 faculty of the academy. (Milford Adams.)

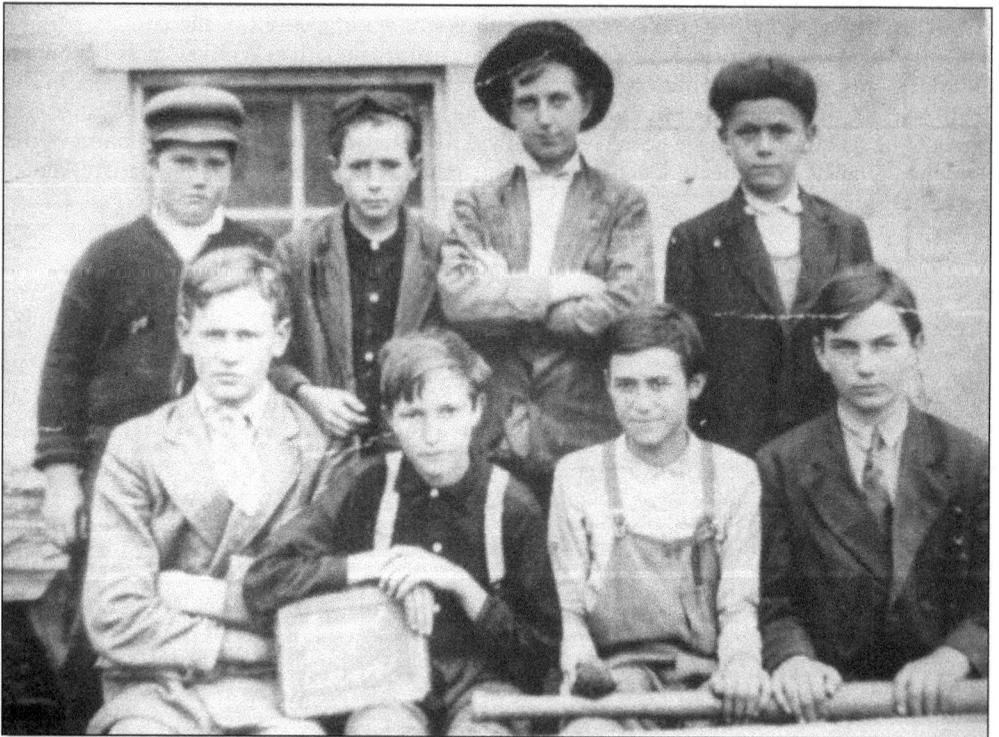

Photographed in 1913, the Grant neighborhood baseball team shows a variety of clothing styles of the time. The players are, from left to right, (first row) Fred Robinson, Burl D. Fowler, Warren Garrison, and Rene Jones; (second row) Charles Mart, Charlie Fowler, Frank Underwood, and Victor H. Payne. (Dorothy Leach.)

Five

BOG LAND

Fairmount Township has many areas of land that do not drain well. Shown is the peat bog area and lake called Lake Galatia, arguably with the poorest drainage of all. This has created challenges and mysteries. In the 1850s, a group of individuals with unique spiritual beliefs formed a town there named Galatia. One member announced he would ascend into heaven at a specific time, and people gathered, including children released from school to watch, only to be disappointed. Myths abound about the lake, which was formed by the last glacier. Before then, the Teays River ran through the county from east to west and was as large as the Ohio River. The glacier filled in the Teays and created the Mississinewa and Ohio Rivers. (Ruth Lewis.)

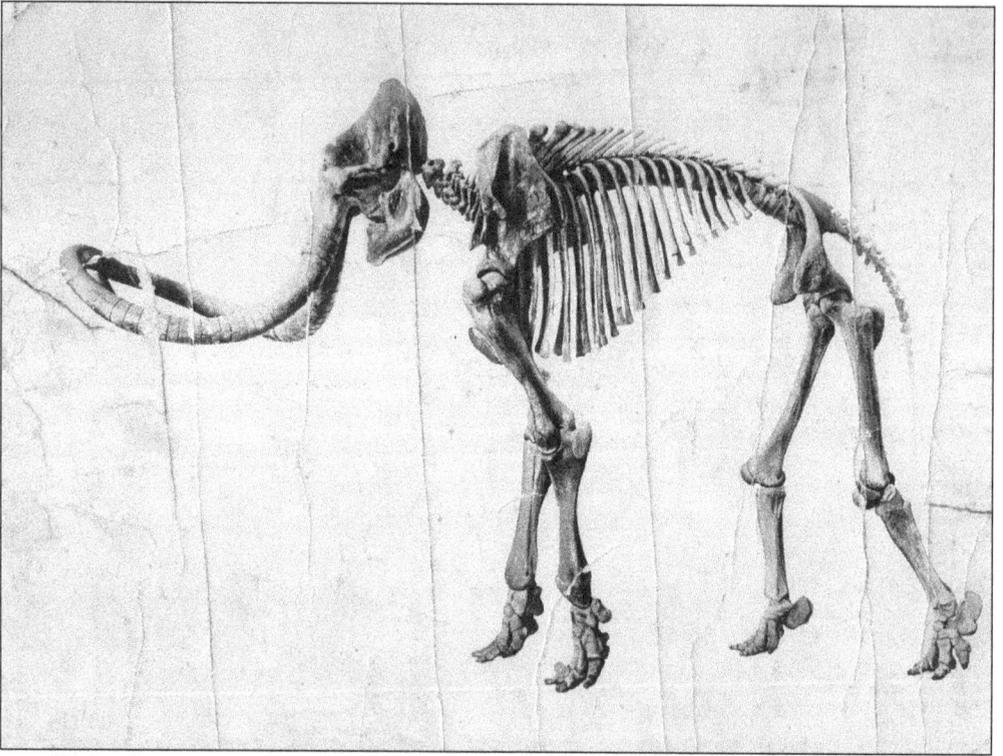

In 1904, bones were found south of Lake Galatia in Barren Creek, and scientists determined they were from a mammoth that lived about 11,000 years ago. According to a 1979 *Chronicle-Tribune* story, the late Ben Lewis was 13 years old when his father, Oliver, discovered the bones. Ben said 30 neighbors dammed up the creek and dug up the bones. (Ruth Lewis.)

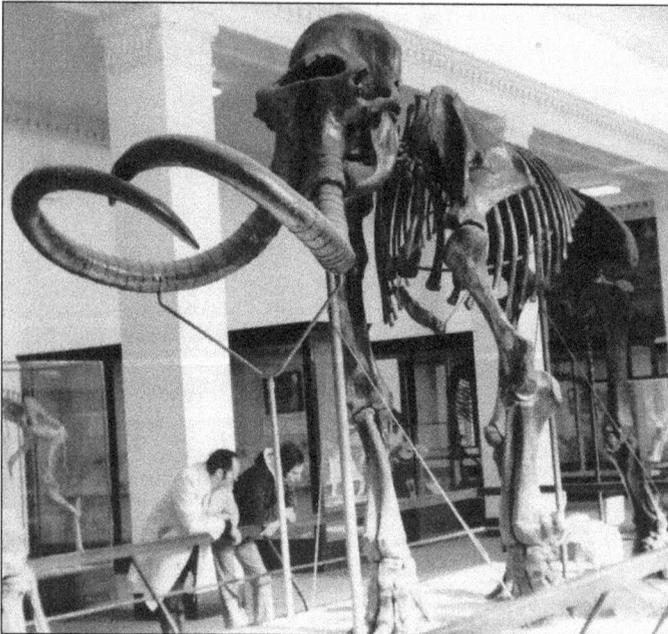

The mammoth bones, with the scientific name of Mammuthus, which were found near Lake Galatia, are displayed at the American Museum of Natural History in New York. Before arriving at the museum, there was a feud about who owned the bones, while about 2,400 tourists paid 25¢ to view it in Fairmount Township. Dora E. Gift won a lawsuit, was named owner, and sold the skeleton to the museum for around $1,200. Experts said it is the most complete skeleton of a mammoth ever found in the United States. (Ruth Lewis.)

Ben Lewis served in the U.S. Army, and an official document from the U.S. Army with the appropriate signatures indicates that on January 13, 1919, he was promoted to corporal. Members of the Lewis family, including Ben, lived at and tended Lake Galatia for many years, offering leisure activities such as boating and picnicking. (Ruth Lewis.)

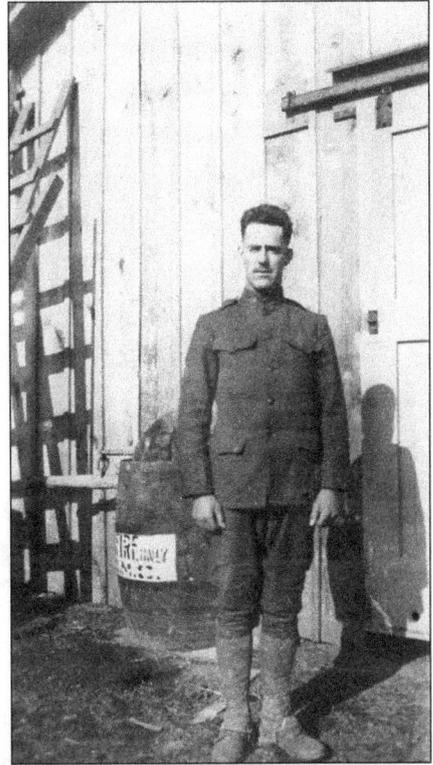

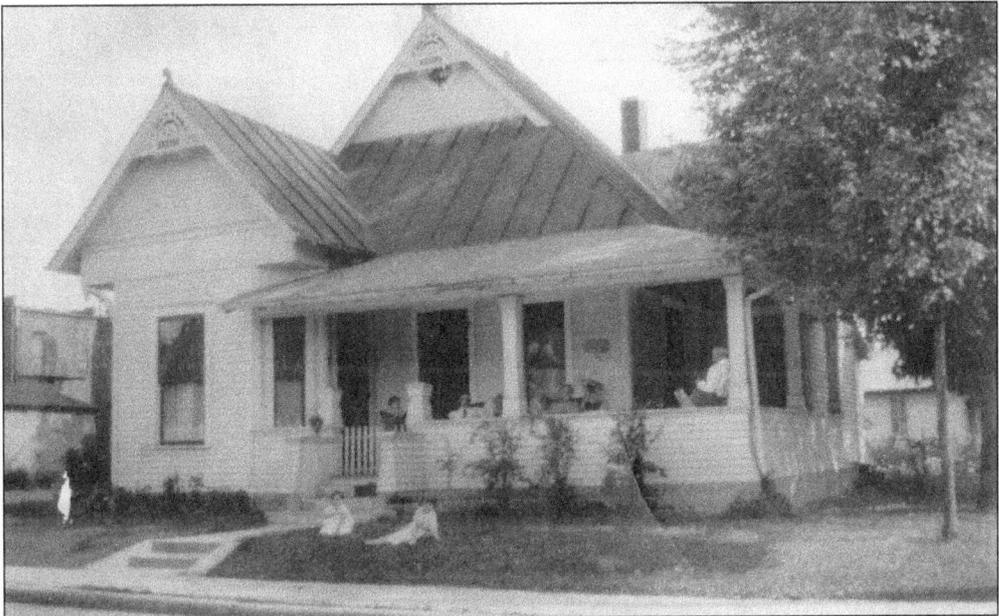

This photograph of the Lewis house on West First Street was taken about 1926. Irene Morrish Jones (left) and Doris Mittank Watts are in front of the house, and other family members are sitting on the porch. In 1981, Ruth and Howard Lewis moved into this home, which belonged to Ruth's great-grandfather and great-grandmother, Henry and Sarahann Davis. Henry was a veterinarian, and the house has been in the family since 1900. (Ruth Lewis.)

Ruth Mittank was a young girl when this photograph was taken. Her future husband, Howard Lewis, is pictured below. (Ruth Lewis.)

This is a photograph of Howard Lewis on a toy made by his uncle Ben Lewis. Ben was the son of Oliver Lewis, who originally owned Lake Galatia. "Ben lived at Lake Galatia after Oliver died. He played the violin for his pleasure. He was everybody's Uncle Ben but never had any kids of his own," Ruth Lewis says. (Ruth Lewis.)

The October 15, 1939, *Chronicle-Tribune* newspaper stated a sinkhole located east of town on State Road 26 created "one of the greatest problems ever faced by the state highway department." Harold Bowman says, "They found seashells in the bottom of the sinkhole. People say years ago, a team of horses and a wagon went down in the peat bog and they never did get them out." (Gib Mitchener.)

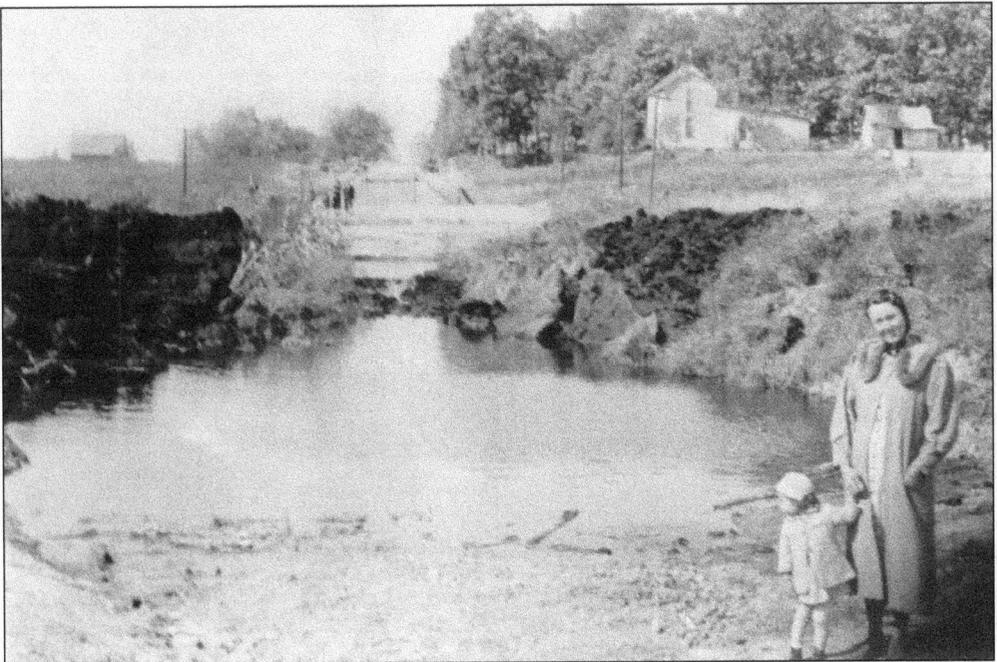

Ethel Smith stands near the sinkhole. Her parents lived in a house about three miles east of Fairmount on State Road 26 for 39 years. Around 1960, the area sank down, and many people still think about whether it could happen again when they drive over it. (TSB.)

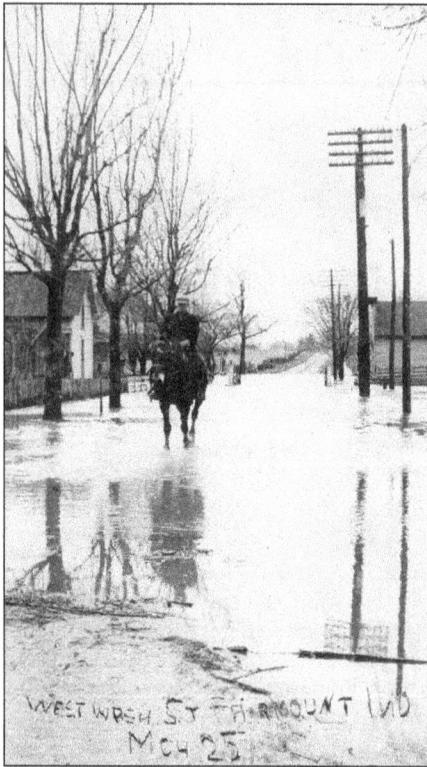

This horseman rides on West Washington Street after the flood in 1913. According to the June 9, 2008, edition of the *News-Tribune*, the 1913 flood was "the state's most devastating flood in modern times" and "caused widespread destruction." It set a record, which all subsequent floods have been measured by. In the summer of 2008, some flooding broke the 1913 record. However, the highest notch on many town flood markers remains from 1913.

The Wood brothers and their friends show the after effects of a major flood in 1913. The young men are, from left to right, Lowell Wood, two unidentified, and Fred Wood. Fred taught at Fairmount High School. This is a photograph postcard. Anyone could buy postcard stock at the drugstore and use a contact printing machine to make postcards.

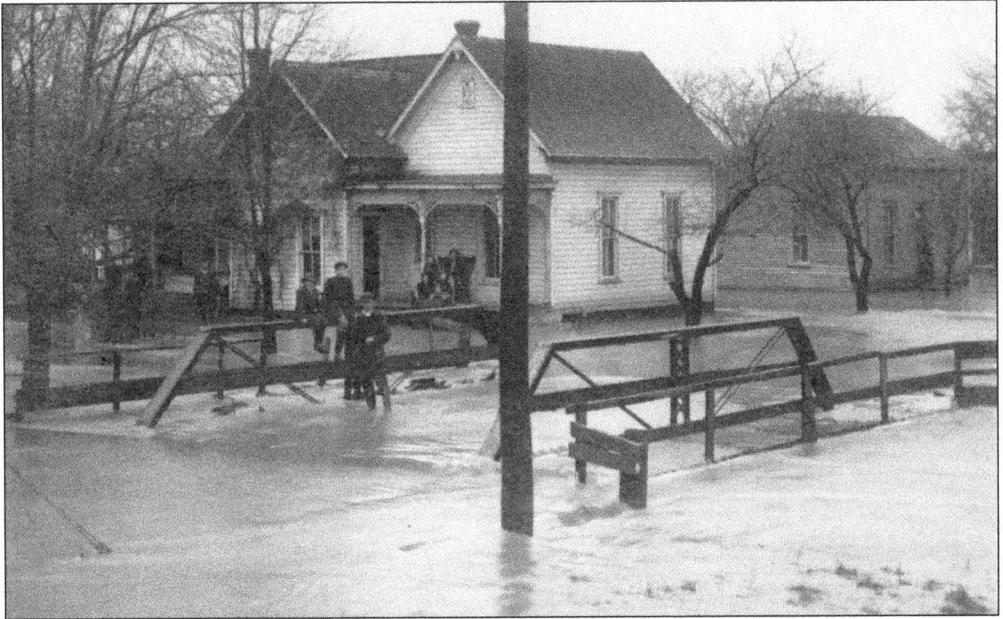

In 1913, a flood that affected the entire state of Indiana dumped eight inches of rain on Fairmount in 24 hours. This photograph of the Washington Street Bridge demonstrates how high the water level was. The channel the bridge is over was dug in 1854 by Irish laborers. Before then, the waters of Back Creek were a boggy half-mile wide.

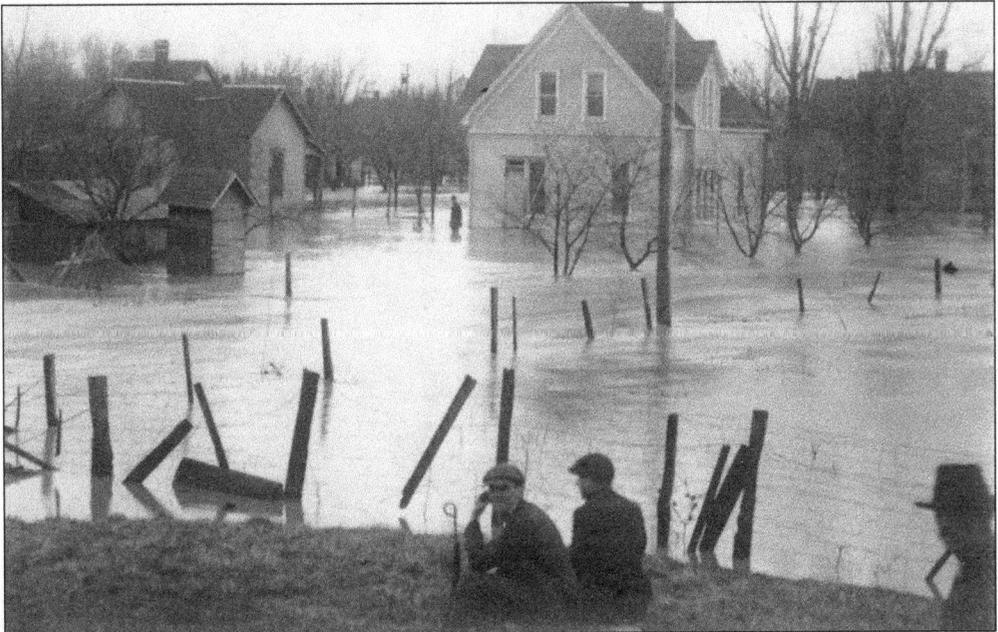

The huge expanse of water after the flood made it difficult to get around in certain areas. This photograph is looking north at a house on First Street. The water was so high that the railroad tracks were washed out.

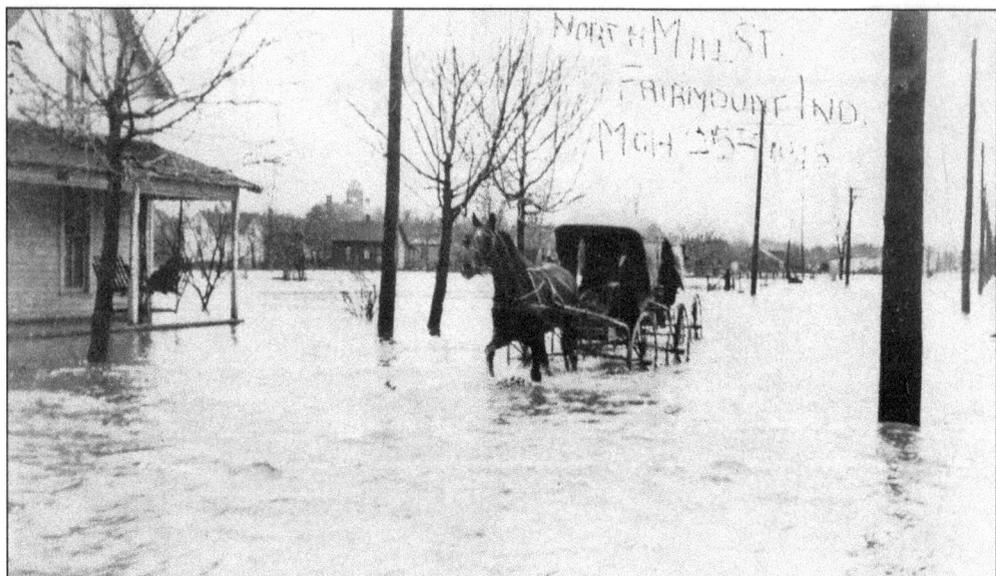

The water from the flood made it difficult, but this man and his buggy manage to get through on Mill Street. The high water compromised the town's water system. The Fairmount Academy bell tower is in the distance.

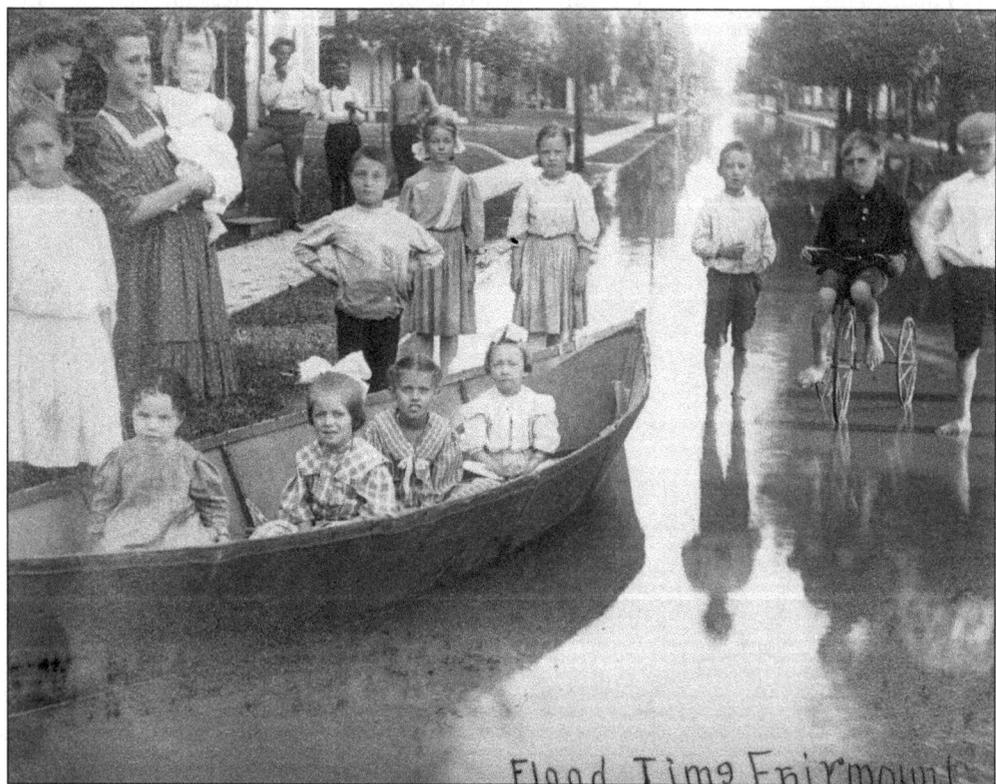

The water from the flood was so deep that these children, possibly located on Walnut Street, were apparently using a boat to make their way around town. Since this was made into a postcard, maybe the boat was to dramatize the flood situation in a mailing to family and friends.

Six

RELIGIOUS LIFE

Religion has played an important part in Fairmount's history, and Quakers from the Back Creek Friends Meeting House have been especially influential. In fact, a large number of early settlers were Quakers who came to the area to live out their convictions against slavery. Back Creek Monthly Meeting of Friends opened in 1838. Enos Harvey was the first paid pastor, serving from 1898 through 1907. Friends were leaders in valuing the role of women in the meeting, and the second paid pastor was Daisy Barr, who served from 1906 to 1910. (WFC.)

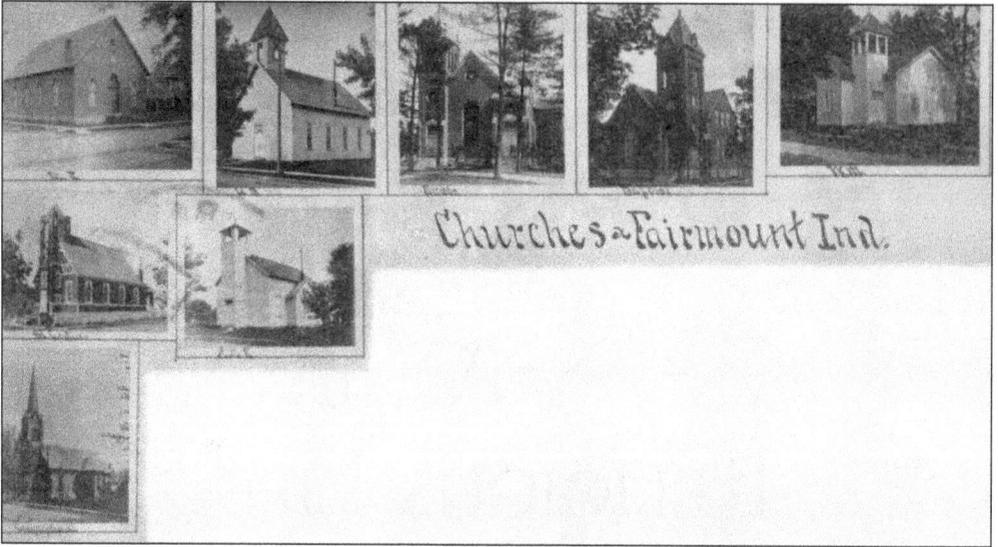

Churches ~ Fairmount Ind.

The leaders of Fairmount wanted to attract new businesses and workers, so they advertised the attractions of the area. This postcard shows the churches in the area.

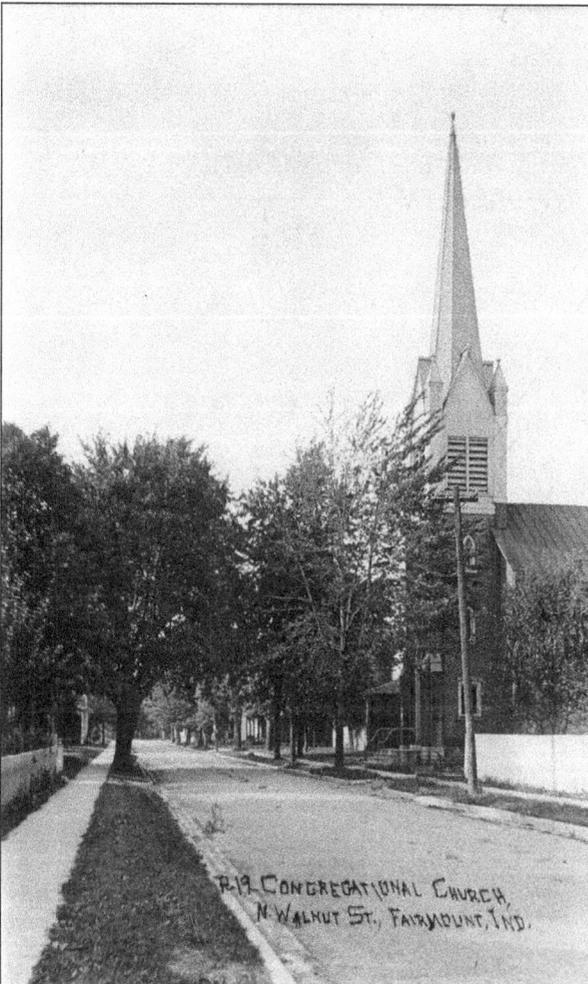

R-19 Congregational Church, N. Walnut St., Fairmount, Ind.

The Congregational Church was organized in 1888 by Rev. William Wiedenhoeft, who was the first pastor. The building was located on the east side of Walnut Street between Washington and First Streets and was dedicated on December 15, 1889. Prominent civic leaders Levi Scott and Dr. A. Henley were members of the building committee. *The Making of a Township* states, "Members of all denominations contributed liberally of their means to the fund for the building." In 1926, the Church of God purchased the building at 114 North Walnut Street from the Congregational Church.

Friend's Church, Fairmount, Ind.

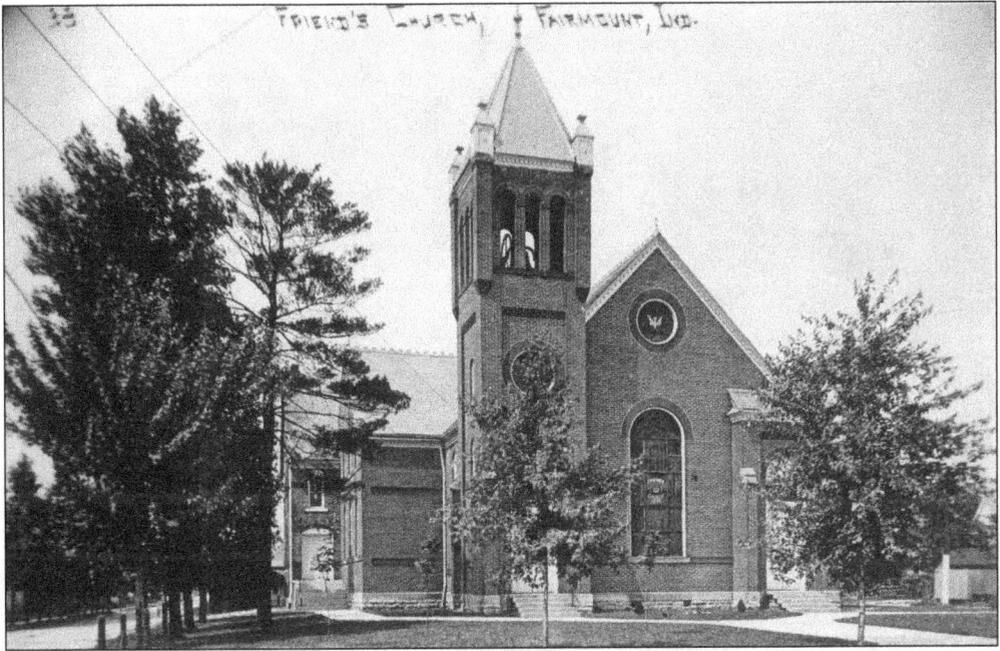

This photograph shows the current Fairmount Friends Meeting House in the early 1900s. It cost $9,085 to build. The building had two front doors, and at one time the Friends required men and women to enter by separate doors. However, there is no record that the sexes were separated when they entered the building. The structure received national attention as the location where James Dean's funeral was held. (Ruth Lewis.)

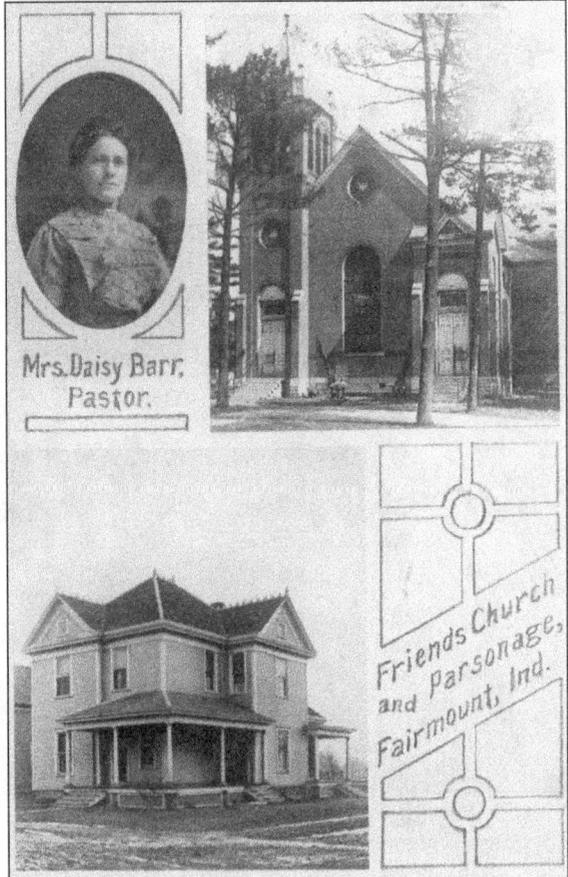

Mrs. Daisy Barr, Pastor.

Pastor Daisy Barr served the local Friends Meeting House from 1906 to 1910. She transferred to Muncie and went into politics, embarrassing the Republican Party by joining the Ku Klux Klan. At the time, the Klan supported many causes she did, such as prohibition and stopping prostitution and gambling among others. By 1923, Daisy was head of the Women of the Indiana Klan. In 1924, the Women sued her in Grant-Delaware Superior Court in Marion for allegedly embezzling $100,000.

Friends Church and Parsonage, Fairmount, Ind.

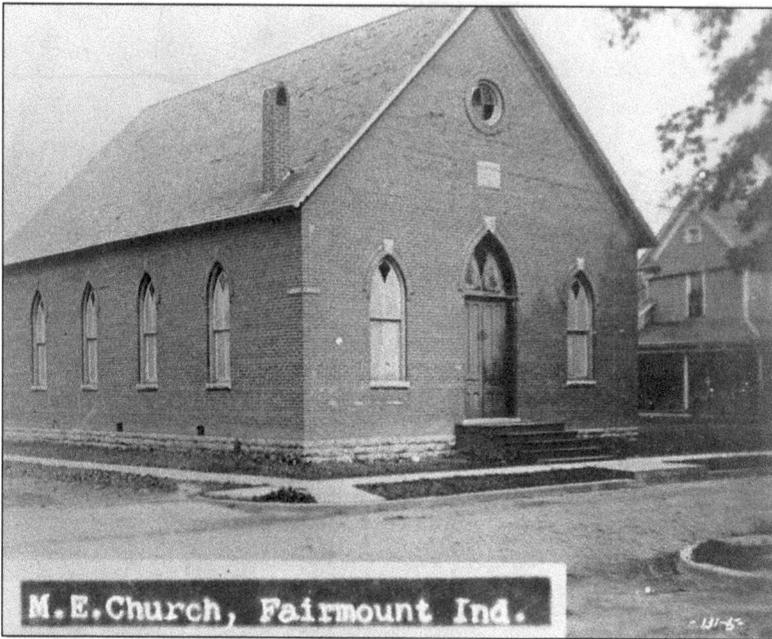

The Methodist Episcopal Church of Fairmount was originally organized in 1861. This building was razed in 1909 to make way for a new structure.

M.E.Church, Fairmount Ind.

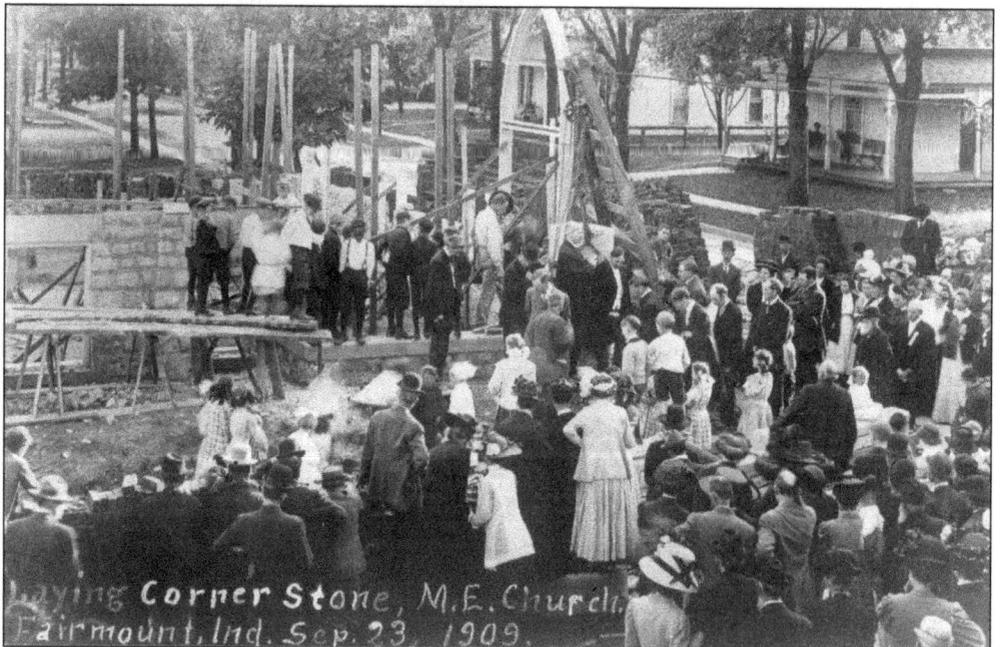

Laying Corner Stone, M.E. Church, Fairmount, Ind. Sep. 23, 1909.

In 1909, a crowd gathers as the cornerstone of the current Fairmount United Methodist Church at 301 South Walnut Street is dedicated. A variety of items were buried in the cornerstone, and when the church celebrated its 100th year, they opened it. (Fairmount United Methodist Church.)

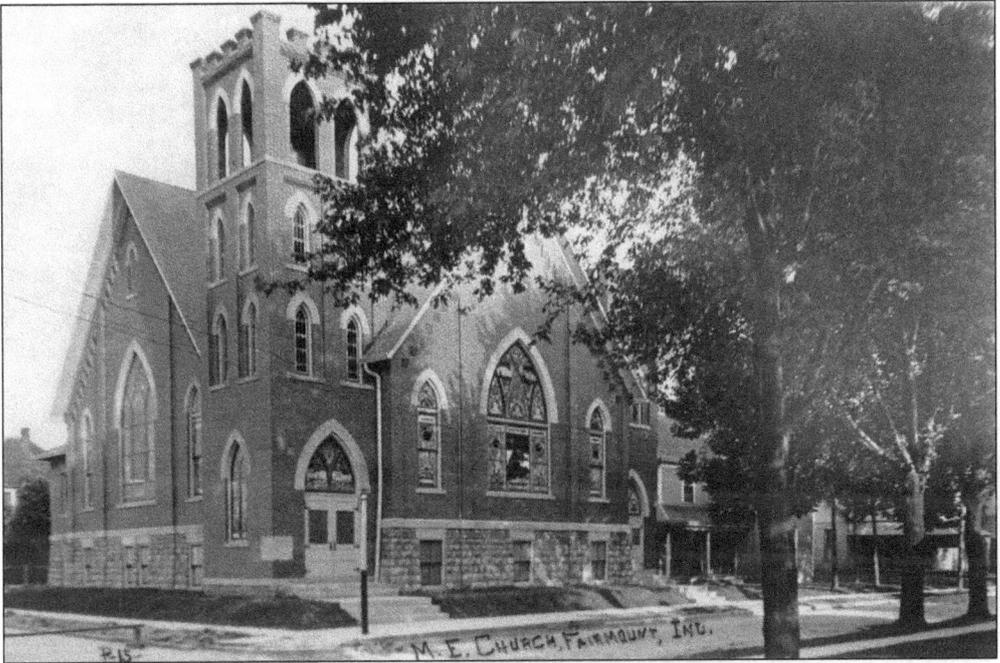
This is how the Fairmount United Methodist Church looked around the 1920s.

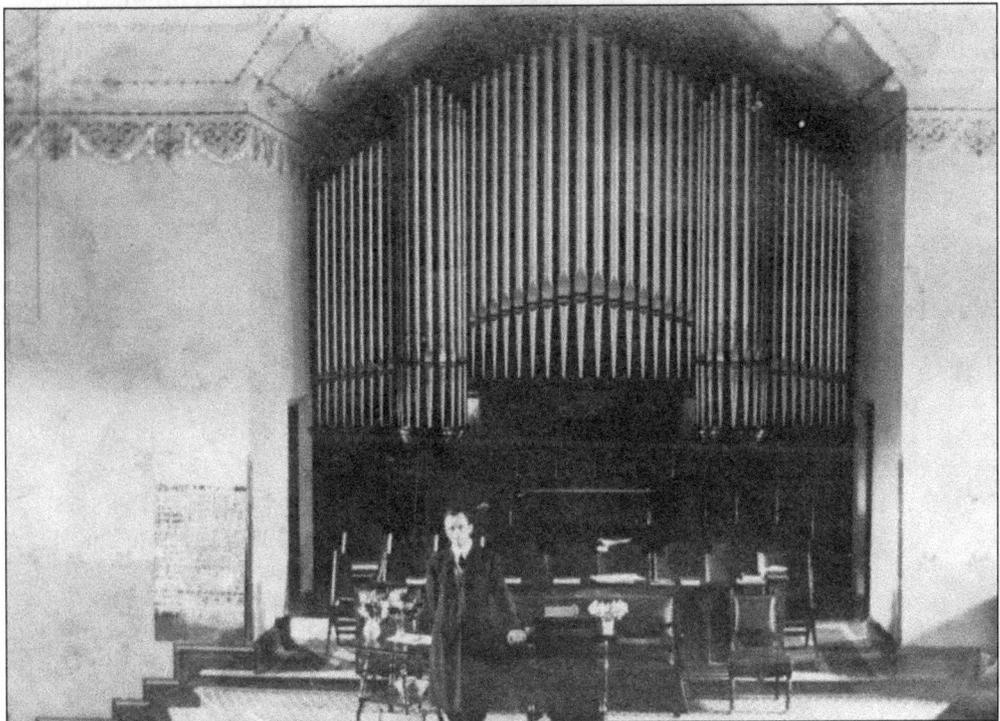
The Fairmount United Methodist Church has a Dale Carnegie organ with an extensive pipe system, which was installed in 1911. The same organ has been refurbished and remains in use. In 1989, a carillon was added by Barbara Couch, Dorothy Wood, Loretta Stansberger, and their families in memory of Lloyd Wood.

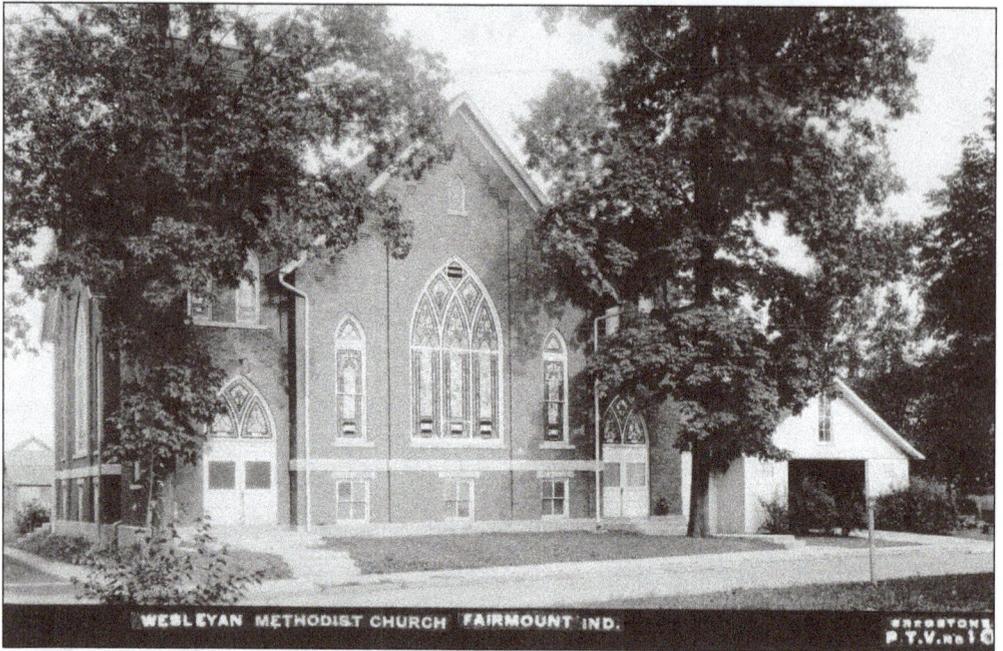

In 1865, the Fairmount Wesleyan Methodist Church was organized by Isaac Meek, who continued as pastor for 11 years. Among the first members were Jonathon Baldwin and his wife. Baldwin donated the ground for the church to be built. The Wesleyan Methodists were a major influence on the civic and cultural life of the Fairmount community. (SFC.)

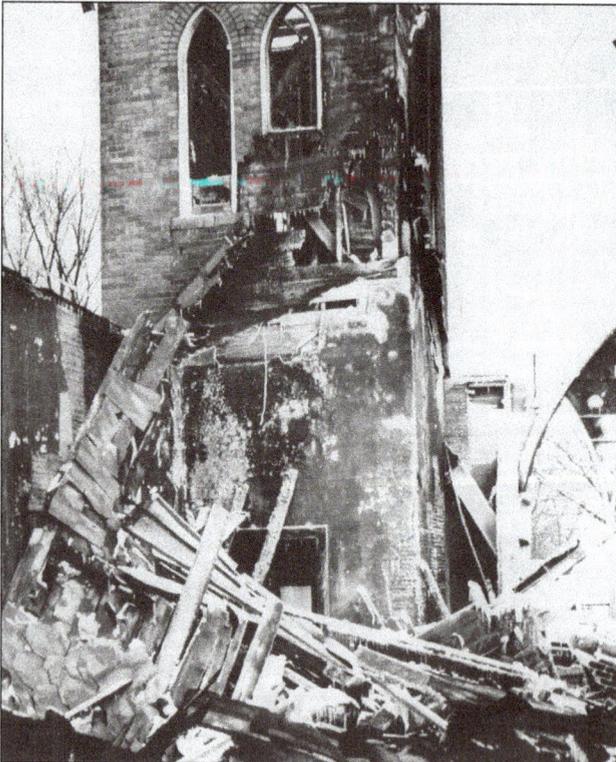

On March 7, 1953, the Fairmount Christian Church was destroyed by fire. The congregation made the decision to use the remaining basement as their worship place and simply erected a new entrance. The church was originally organized in 1903. In 1966, the building that exists today was dedicated. (Roz Carter McCarty.)

In the 1920s, Wesleyan Methodist Church members came to the Fairmount campgrounds for various reasons. The first camp meeting was in 1895. The district owned the grounds, and some buildings and individuals owned shacks, later replaced by cottages. Around 1952, the general conference of the Wesleyan church met in Fairmount. In 1978, they joined with the Pilgrim Holiness Church and dropped the word "Methodist" from the name to become the Wesleyan Church. (Wesleyan Camp Meeting committee.)

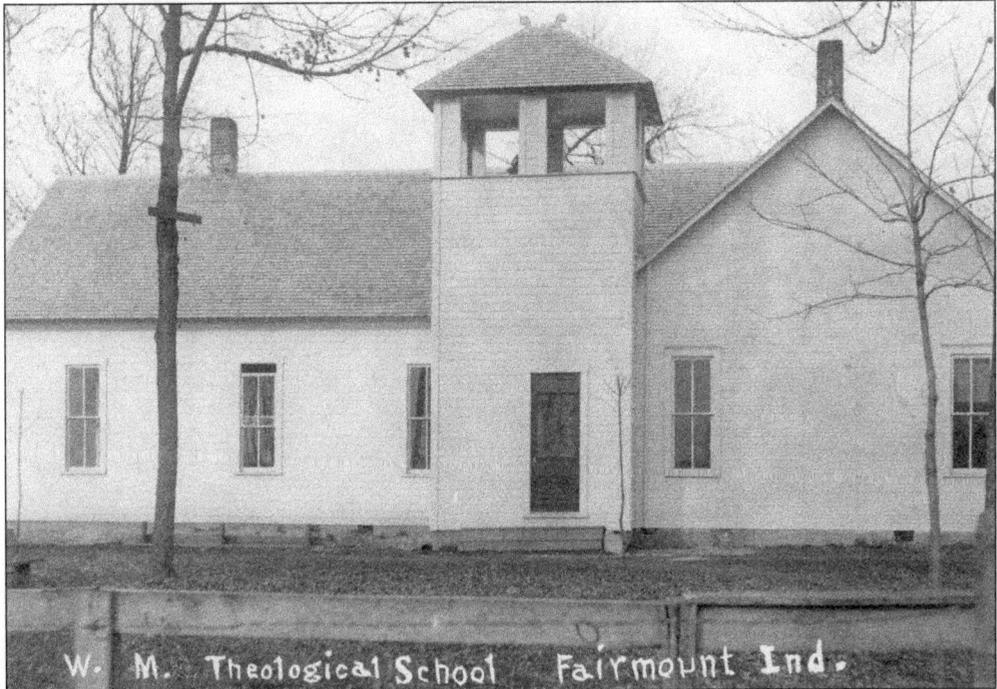

The Wesleyan Theological Seminary opened in 1904, and in 1905 it had 24 students. In 1920, the theological school joined with the Marion Teacher's Academy to become Marion College and diversified its courses to create a liberal arts institution. The offerings continued to expand, and in 1988 the name was changed to Indiana Wesleyan University. Today the university has degree programs tailored to working adults and offers online degrees. The school is thought to be one of the fastest-growing universities.

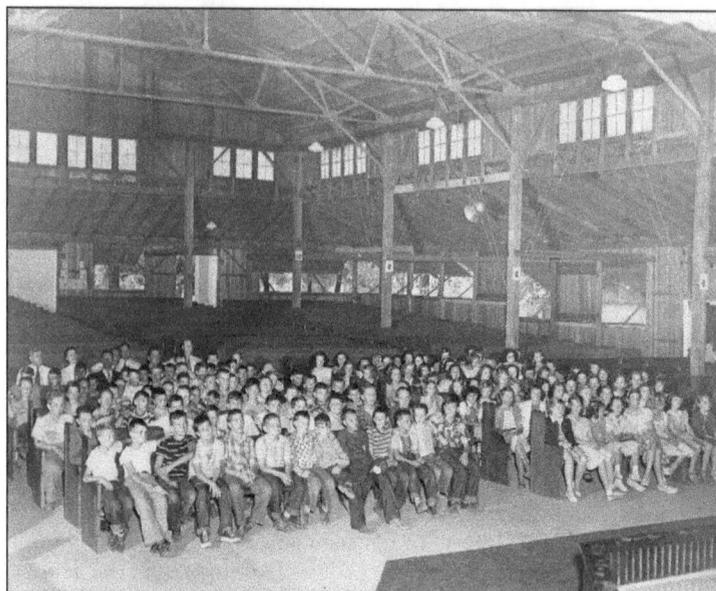

A children's camp in the 1950s meets inside the Bethel Tabernacle of the Wesleyan Campgrounds. The tabernacle was built around 1900. The camp started out with 7 acres and ended up with 22 acres. They purchased the Fairmount Academy building and tore it down. Originally they had a well and a primitive sanitary system, but they went to city water in the 1960s. (Wesleyan Camp Meeting committee.)

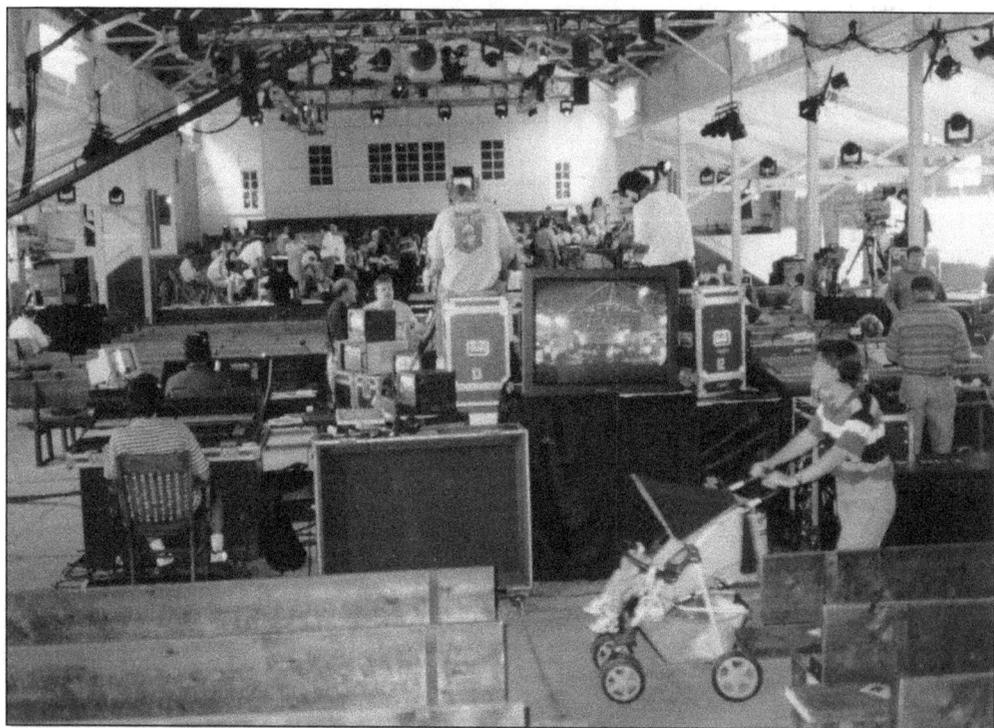

In 1996, a show called *Down by the Tabernacle* with Bill and Gloria Gaither and their homecoming friends was taped at the tabernacle as a gospel singing series. The photograph depicts the massive amount of equipment, with its 200-amp electrical system and a generator, it took to produce the 90-minute production. An estimated 2,500 people attended. Many sat in lawn chairs outside the building to listen. Bill Gaither said he traveled several states looking for the right tabernacle to use. (Wesleyan Camp Meeting committee.)

Seven

COMMUNITY

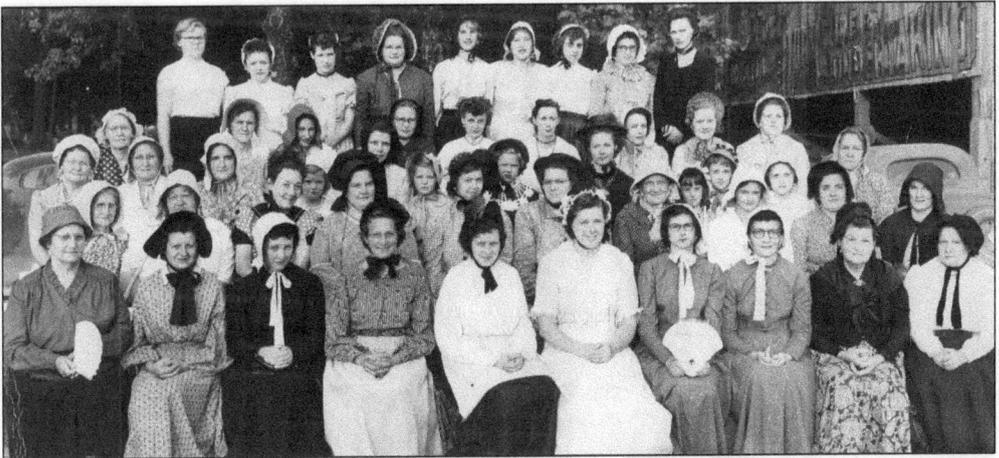

Members of the Bonnet Club pose at the fairgrounds in front of the grandstand. Pictured here are, from left to right, (first row) Nettie Sturgeon, unidentified, Margaret Windsor, Elsie Hindl, Hazel Worthen, Ann Warr, unidentified, Dorothy Smith, Emma Dean, and Agnes Pace; (second row) Lora Broyles, unidentified, Pat Jones, Mary Riggs, Betty Metzger Hiatt, Margaret Miller, Bessie Neal, two unidentified, and Hazel Voorhis; (third row) Gladys Howell, Amelia Green Debow, unidentified, Margaret Latchaw, and Roberta Spence; (fourth row) three unidentified, Donna Parker, Bonnie Ratliff Carter, Marie Swift, Faith Parsons, Martha Crist, and Bette Hiatt; (fifth row) Valarie Pace Logan, ? Underwood, Mary Ward, unidentified, Lucritia Daunhauer, Helen Bright, Colleen Bright, unidentified, and Peggy Cox. (Roz Carter McCarty.)

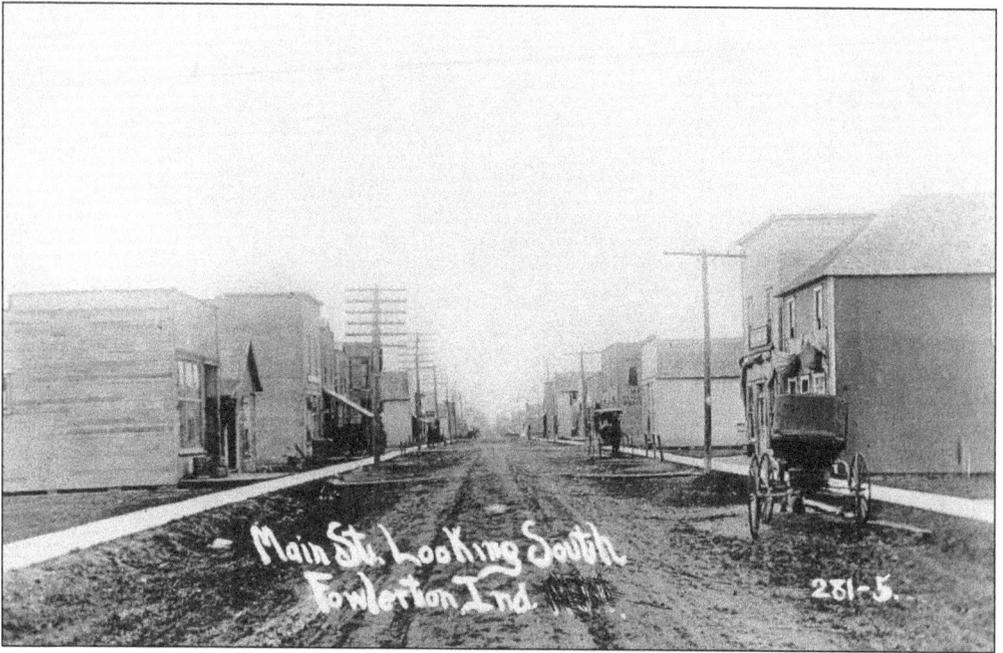

The town of Fowlerton was originally named Leach and got its name when the Fowler family moved its tile factory there in 1895. This is looking south down the main street, which was named Leach Street. (Marion Public Library Museum.)

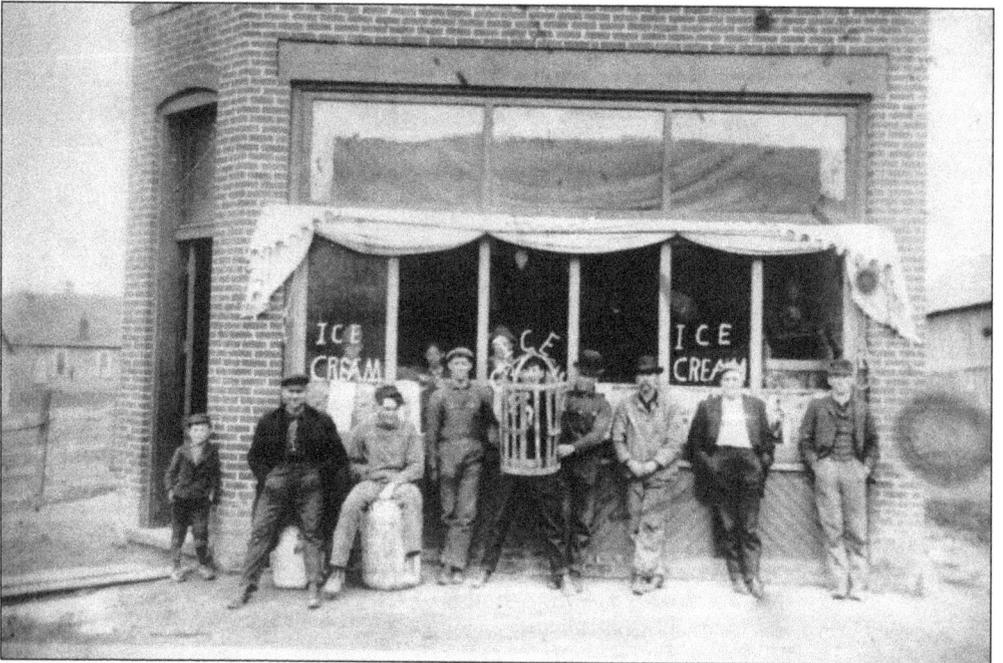

Ice cream has always been a welcome treat in the area, and the building this early ice cream shop was in still stands. In the 1960s, it housed Betty Nottingham's restaurant. (Gib Mitchener.)

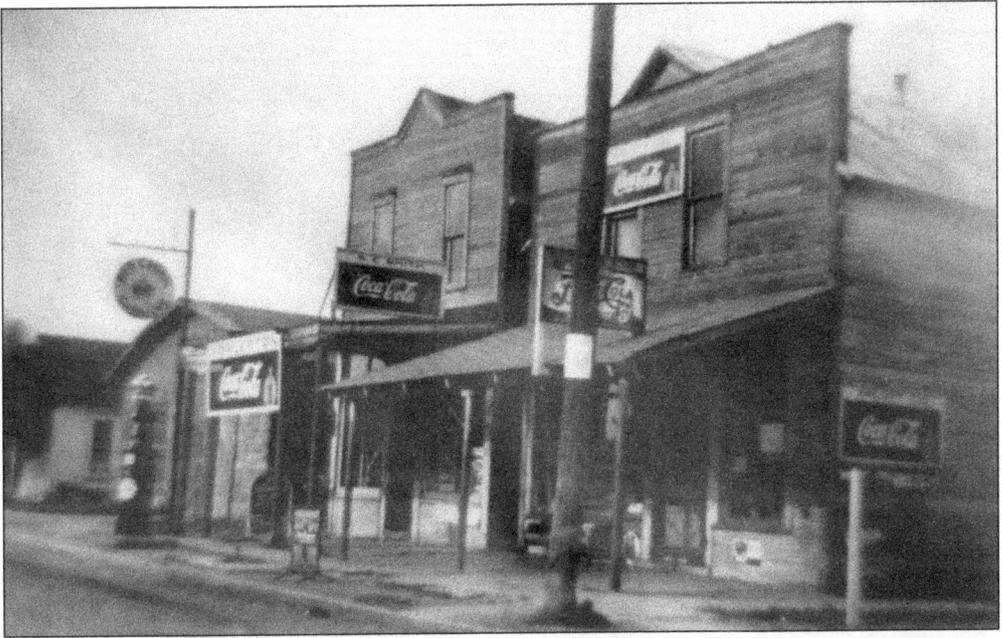

This postcard is looking northeast from the intersection of Second and Leach Streets and shows Fowlerton's grocery store, a drugstore, and the post office. The first two buildings burned down in 1947. (Gib Mitchener.)

Bishop Wright, Orville and Wilbur Wright's father, lived on this farm in the northeast corner of Fowlerton, in section 23 of Fairmount Township, before they were born. A newspaper reported, "Bishop Wright went aloft for the first time when he was 81, in 1910. With Orville at the controls, the elderly bishop repeatedly shouted 'Higher! Higher!' With his usual amiable gruffness, he would comment only that 'People look pretty small down there.'"

Stories abound that the Wright brothers gave airplane rides at the Wright farm near Fowlerton. Orville Wright said in a newspaper article, "We were lucky enough to grow up with a home environment where there was always much encouragement to the children to pursue intellectual interests; to investigate whatever aroused curiosity. In a different kind of environment, our curiosity might have been suppressed long before it could have borne fruit." Orville died in Dayton, Ohio, in 1948.

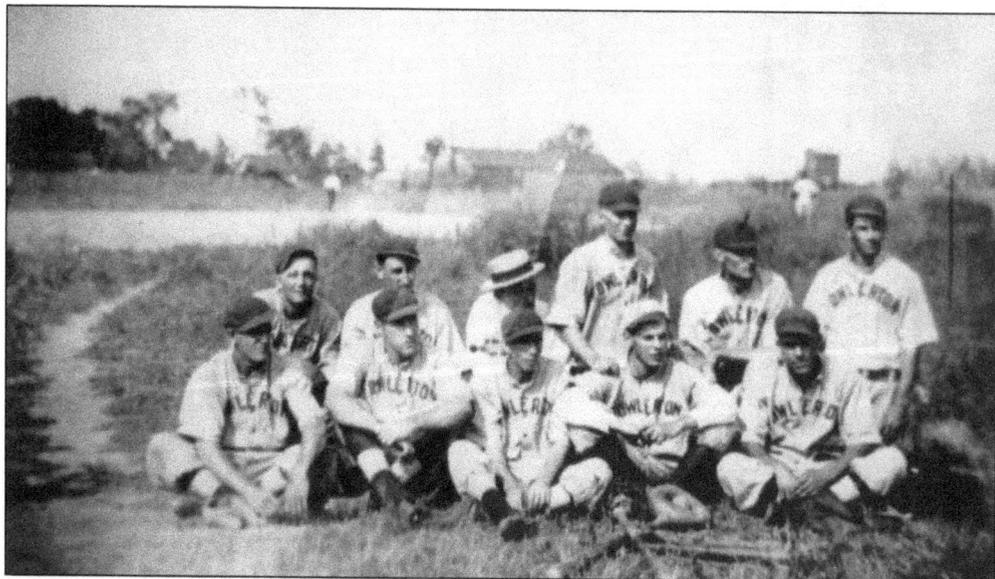

Baseball was a favorite pastime, and this was a team representing Fowlerton. One resident who was a baseball fan and a player was Bill Mitchener, and he played on the Fowlerton baseball team as a young man. (Dorothy Leach.)

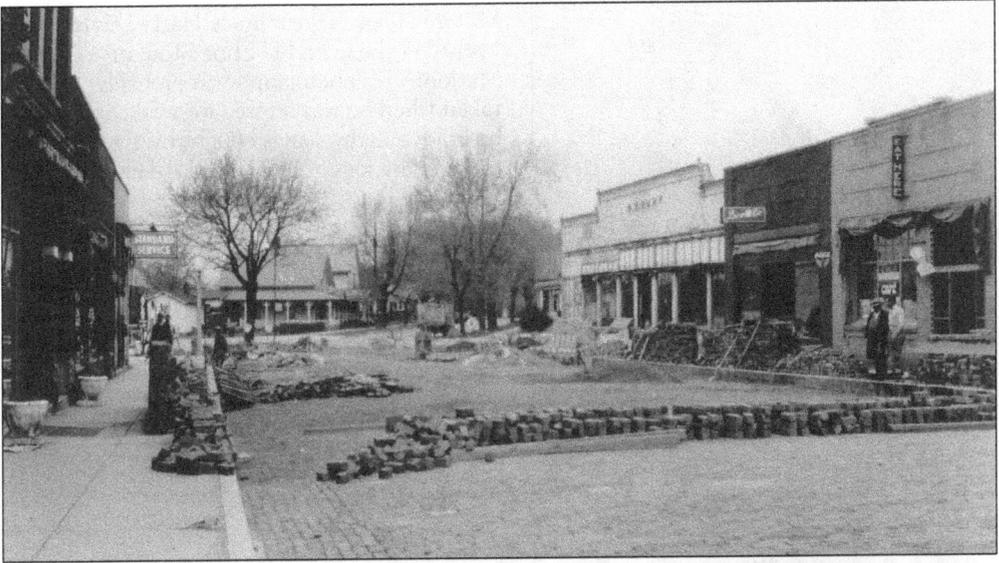

In 1912, there were 25 miles of cement sidewalks and five miles of brick streets in Fairmount. This WPA project involved turning over the existing bricks to expose the sides undamaged by the impact of horseshoes.

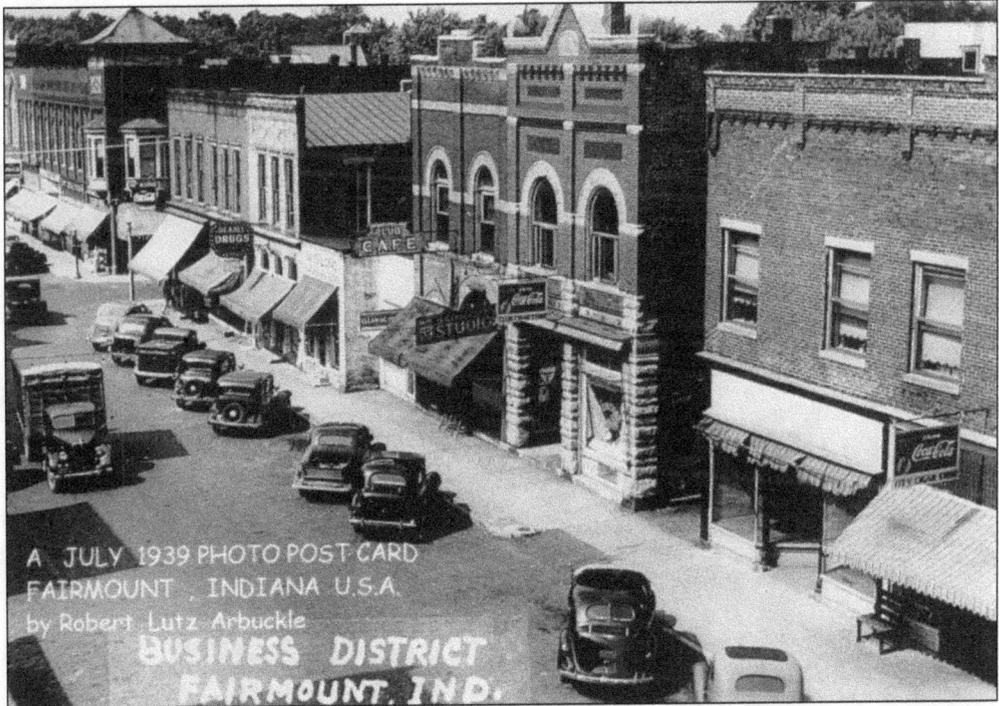

Robert Lutz Arbuckle took this photograph from the roof of the harness shop. Pharmacist Xen Edwards wanted to sell the postcards at his Rexall drugstore. Arbuckle, a 1941 Fairmount High School graduate, lived on Mill Street and worked in Hockett Studio as well as finishing photographs for the drugstore. The store had everything, from wallpaper to Evening in Paris cosmetics. Ruth Mittank Lewis would run down to Rexall at lunch on school days to serve her fellow classmates lunch. (SFC.)

Milford Adams's great uncle Harry Davis worked at the C and H Shoe Store in Marion. This photograph was probably taken when he was dressed for work, and he holds a derby. Davis bought his five-room house for $500. (Milford Adams.)

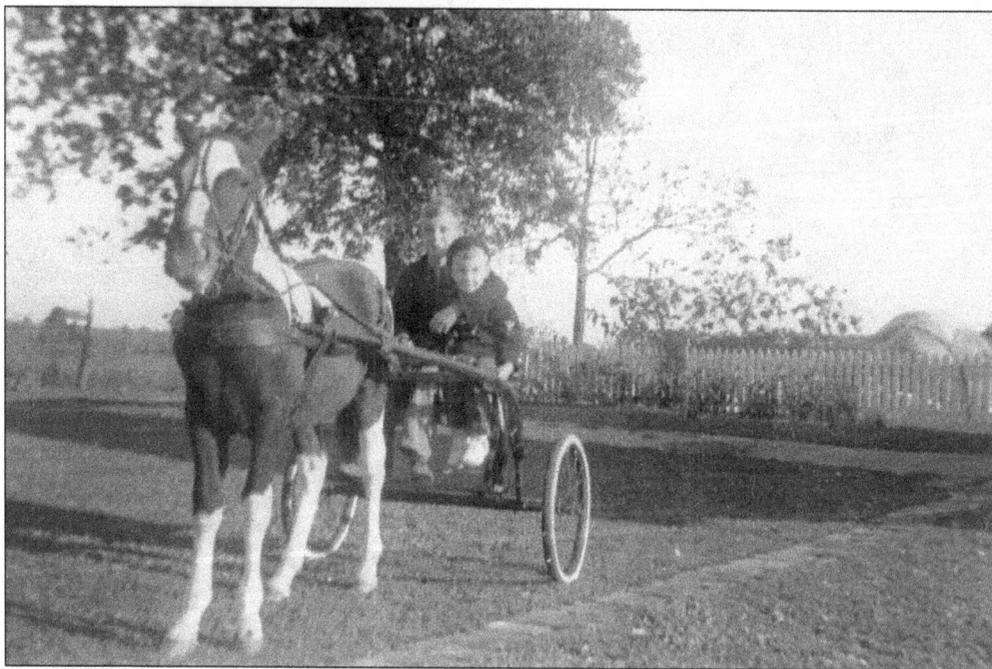

Bruce Gossett and his brother Jan pose in 1938. He would ride it around the Wesleyan Campgrounds, and there was not any traffic getting over there on what is now State Road 26. Traffic was so slow, Mae Duling Gossett recalls she and her brother Fred Duling would ride their bikes from the log house where they lived to Lake Galatia Road and coast down that hill. Bruce's wagon was painted red, and his father, Clyde, made it with 24-inch bicycle wheels. The pony was named Dandy, and his dad made the shaves. (Bruce Gossett.)

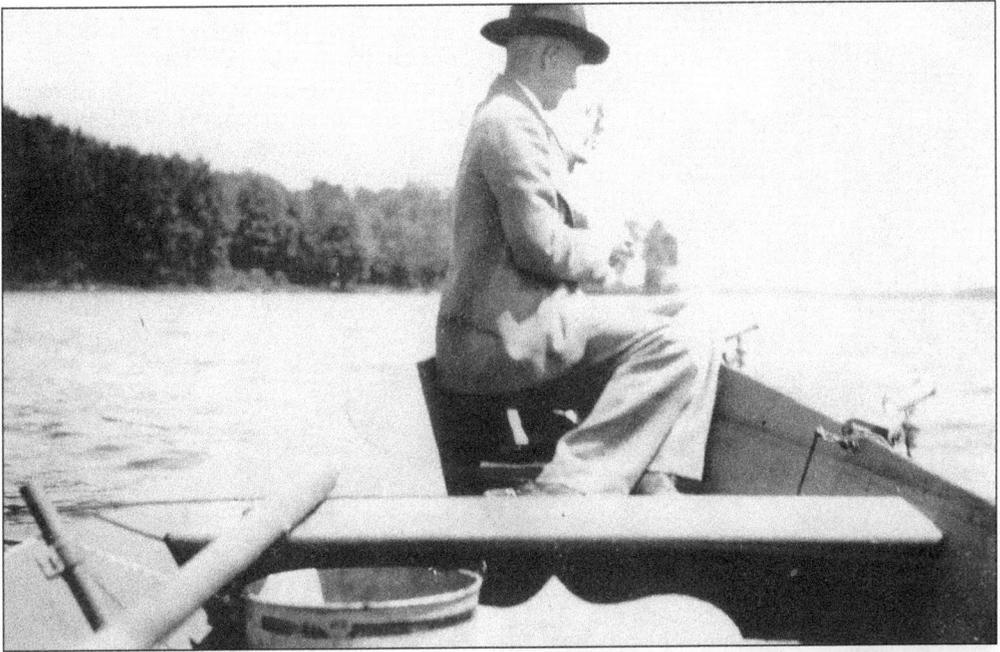

Glen Gift invented the Lazy Rod Holder, which was patented by Kelgie Manufacturing Company of Fairmount on May 27, 1930. He is dressed up in this photograph, which was probably used for promoting his gadget that helped fishermen.

Roscoe Henry George was born on December 9, 1896, and graduated from the Fairmount Academy in 1915. In the early 1930s, while an electrical engineering professor at Purdue University, he worked on television tubes. (Charline Mitchener.)

Lee Drawhon is seen here with his 1924 Ford car. He managed the Lee Drawhon Automobile Agency on South Main Street, where a neighbor purchased a 1939 sedan for $875. A prominent member of the community, he became a charter member of the American Legion Post 313 on March 16, 1946. He was volunteer auctioneer at a white elephant sale held for Liberty School.

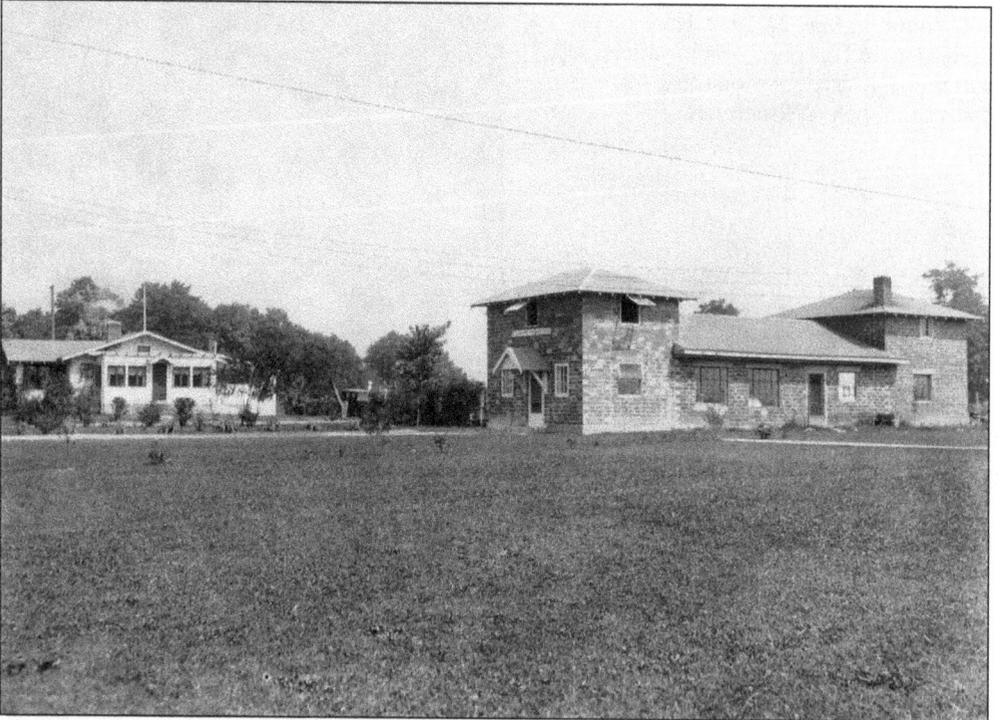

Emory Adams, Milford Adams's father, ran Adams Dairy Products in the building on the right. The business made cottage cheese, ice cream, buttermilk, and milk for delivery to grocery stores. Emory, his wife Dora, and their family lived in the house across the street. (Milford Adams.)

In 1934, the Adams family opened the Dutch Mill drive-in, which sold ice cream. On one 100-degree July day in the 1930s, about 100 cars surrounded the building. "Nearly every Sunday evening we would go out as a family," Bob Roth says. "Us kids would get out and swing and sit at the picnic table and have ice cream. My dad and I always liked orange pineapple." (Milford Adams.)

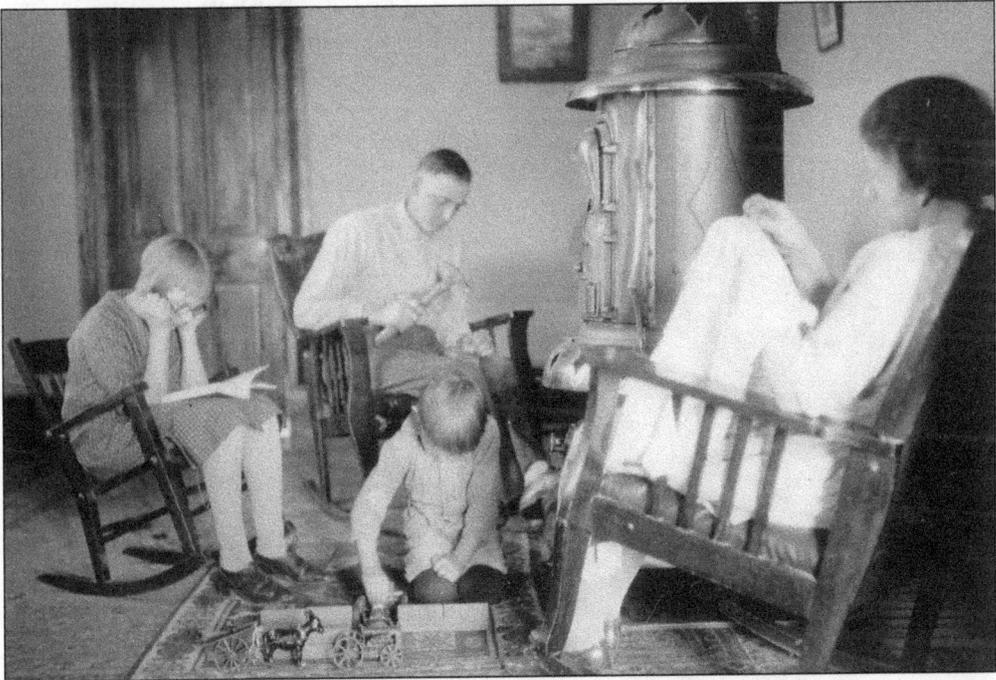

This is the Broyles family in 1924. Sitting in the chairs from left to right are Evelyn, Charles, and Lora, with Leo playing on the floor. The photograph was posed for and taken by their good friend and Upland poet Barton Rees Pogue for an illustration. It appeared alongside Pogue's poem "On Long Winter Nights" in the book of poems, *The Omnibus*, which was first released in 1925. (David Broyles.)

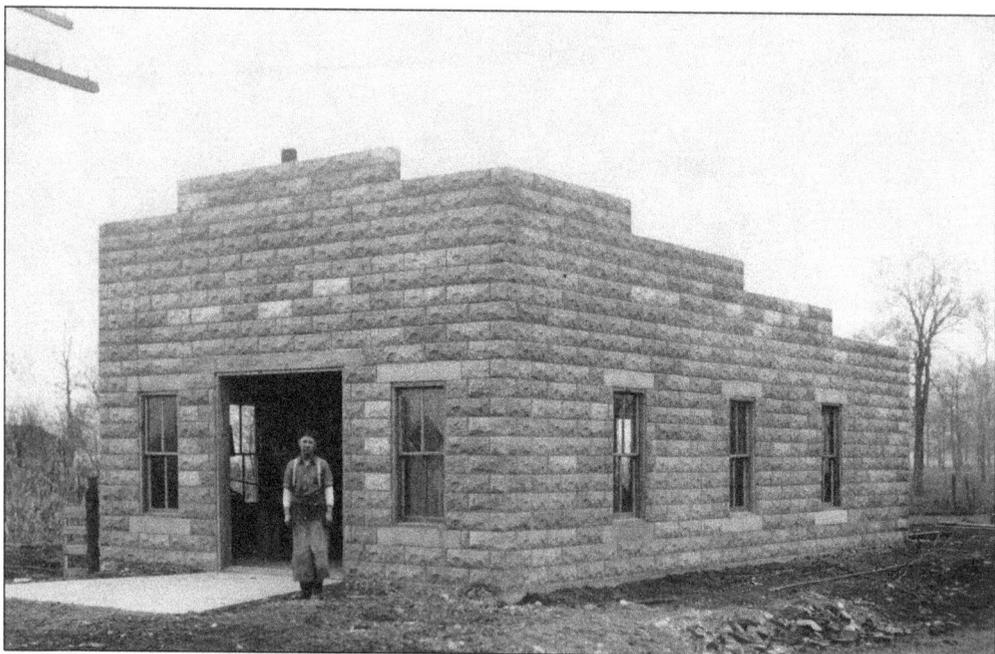

Elmer Flint's blacksmith shop of cement blocks was located at the first crossroads south of Fairmount in 1917. One Christmas, Elmer and his wife, Pearl, sent their greetings with this photograph postcard. Shortly before his death, Fairmount historian Ralph Kirkpatrick said, "We used to bring a team and wagon in and he'd work on the wagon and reset the wheels. He heated the rim and shrunk it to the wood."

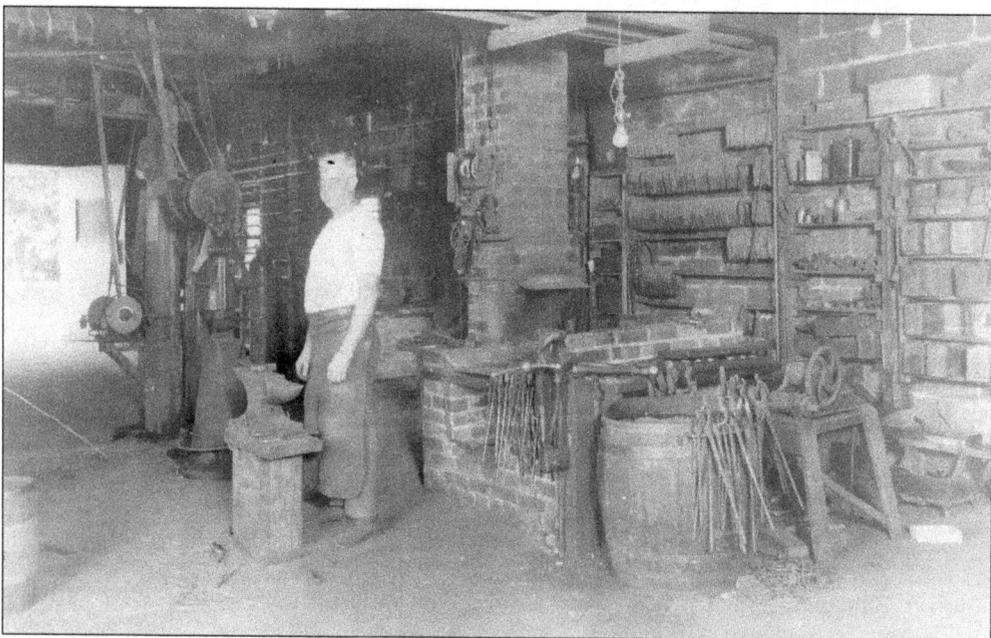

Frank Ray's blacksmith shop was on Washington Street east of the railroad. The sound of the ring of his anvil carried far, his tools were coated with residue from the sparks that flew off, and he had bellows to stir up the fire for his work.

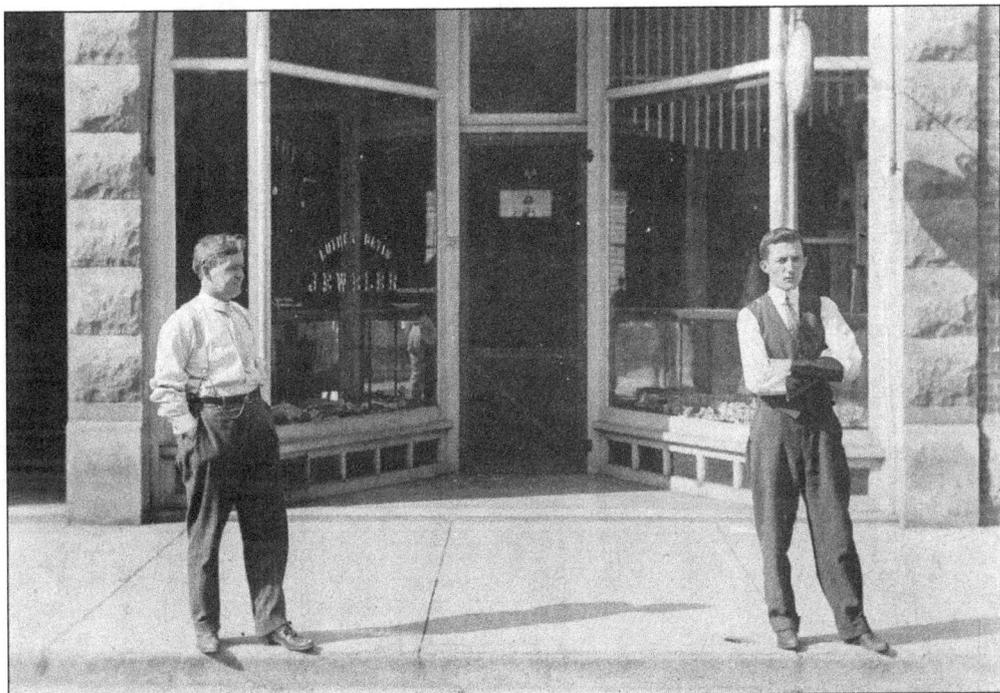

Luther Davis (left) and Leonard Montgomery are standing in front of Luther Davis Jeweler on Main Street around 1909. Located at 124 South Main Street, the store advertisement in the *Fairmount News* at Christmas stated that they "were willing to lay away customers' selections." The store was about 18 feet by 110 feet and was devoted to jewelry and fine china among other items.

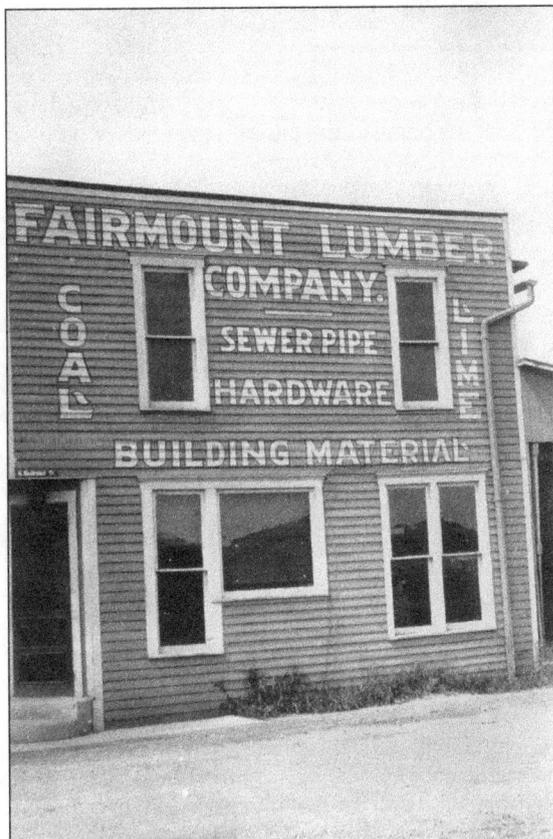

This building, with its bold, distinctive lettering, housed the Fairmount Lumber Company for many years. Members of the Duling family and many of their neighbors were carpenters or worked with wood to make what they needed, so this was an important business. Don Duling built a handful of the houses in Fairmount.

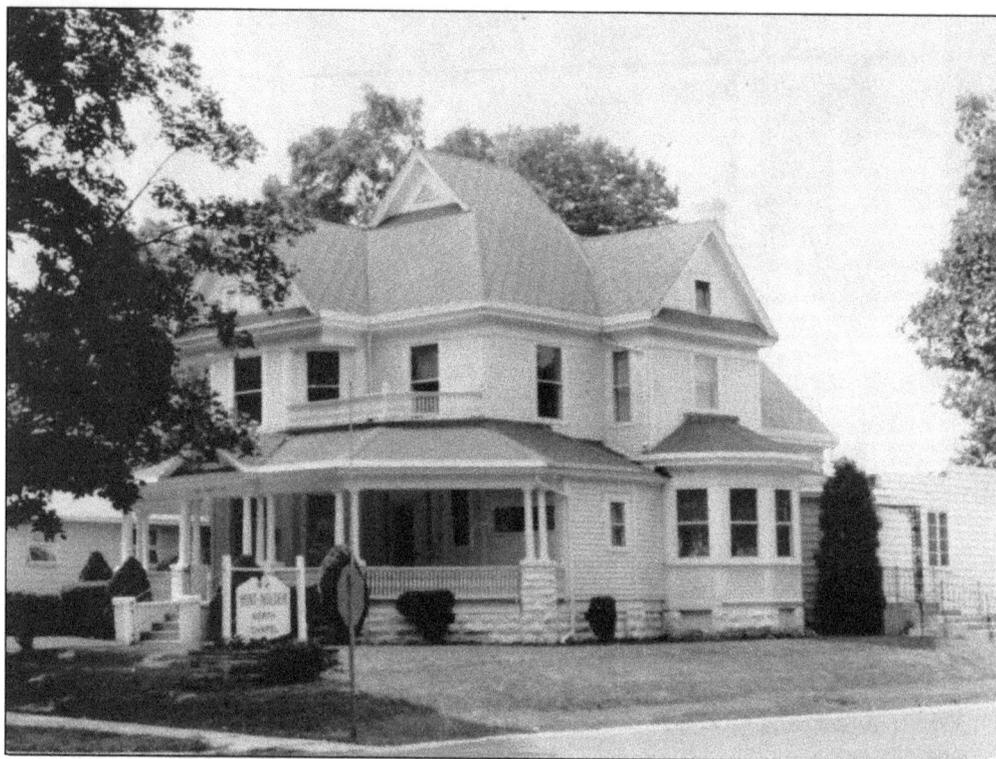

In 1903, John Wilson, a local doctor who owned several businesses, built this structure at 425 North Main Street. This 1960s image shows the building when it was a funeral home. In 1988, it became the home to the James Dean Gallery, a museum, exhibit, and gift shop, which celebrates Dean's birthday on February 8 among other events throughout the year. (JDG.)

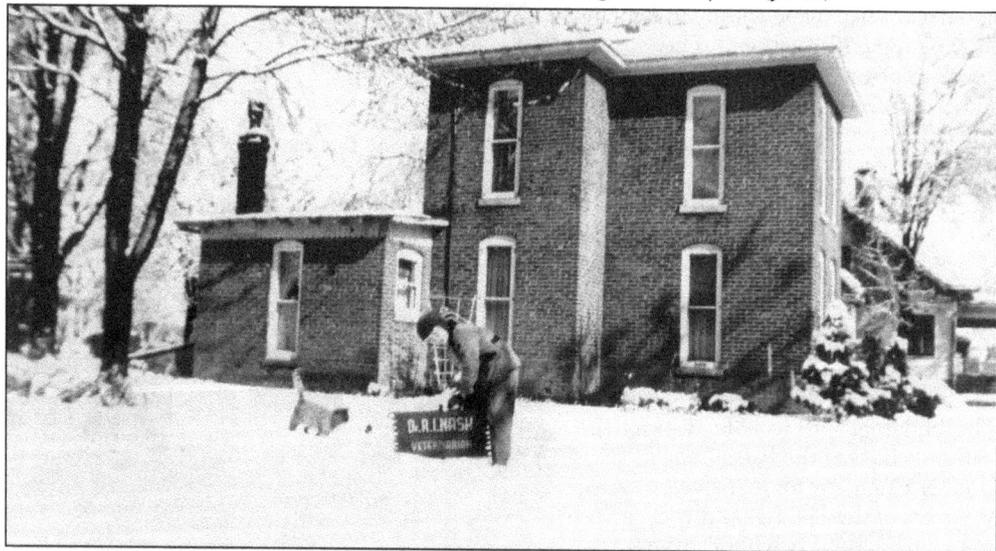

In winter 1945, Jill Riley Henry's brother Tony plays a couple of houses down from their home on Henley Street. The sign is in front of the home of veterinarian Rex Nash and his wife, Clara Bell. Dr. Nash had the neighborhood kids over annually to make gigantic kettles of hog medicine, which he sold in huge jugs. "It was very smelly," Jill says. (Jill Riley Henry.)

In 1959, these girls participated in the Fairmount Public Library's summer reading program. From left to right are unidentified, Jill Riley Henry, Cathy McManaman, unidentified, and Karen Richardson; Judy Harvey is hidden behind Cathy. (Jill Riley Henry.)

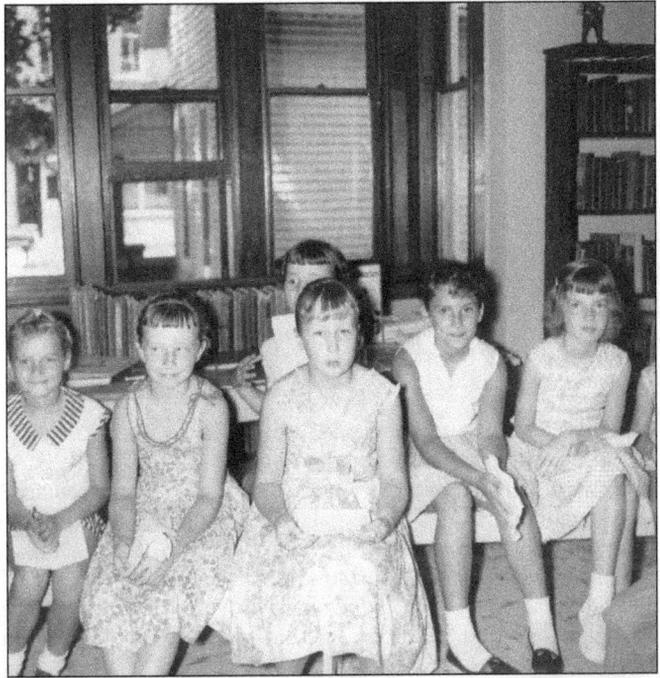

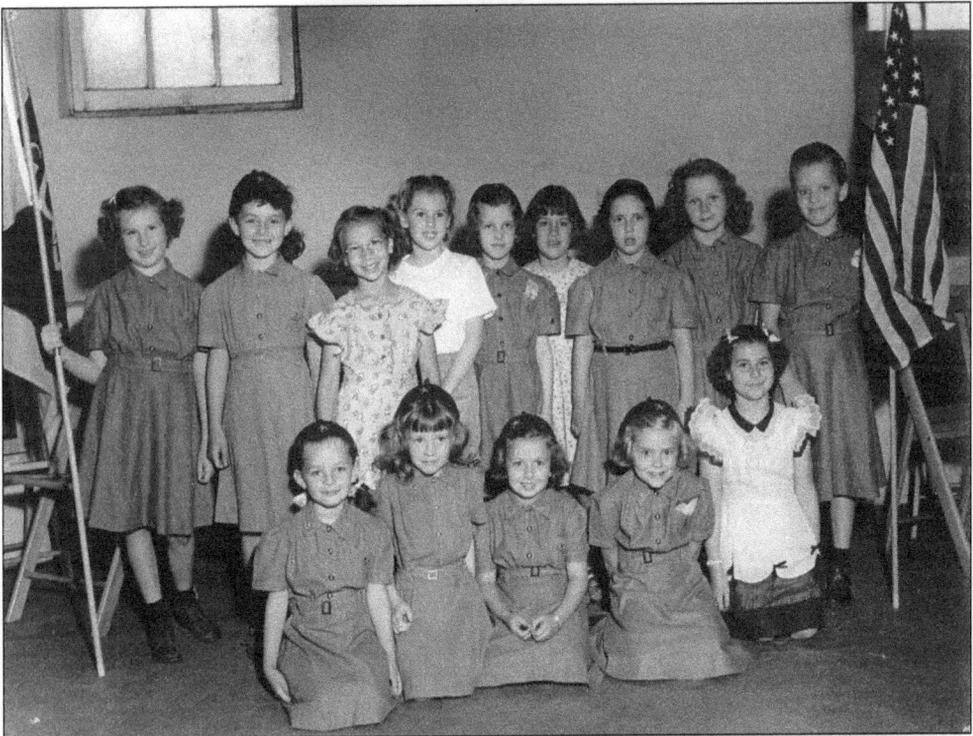

This June 1950 photograph shows a Fairmount Brownie troop. Troop members from left to right are (first row) Sharon Pernod, Nancy Roth, Patty Jones, Nancy Latchaw, and Marjorie Downing; (second row) Sandra Buch, Becky Pernod, Rebecca Ricks, Deborah Wood, Linda Windsor, Dian Shields, Jean Jones, Rose Ann Butcher, and Janet Rogers. (Dian Hoheimer.)

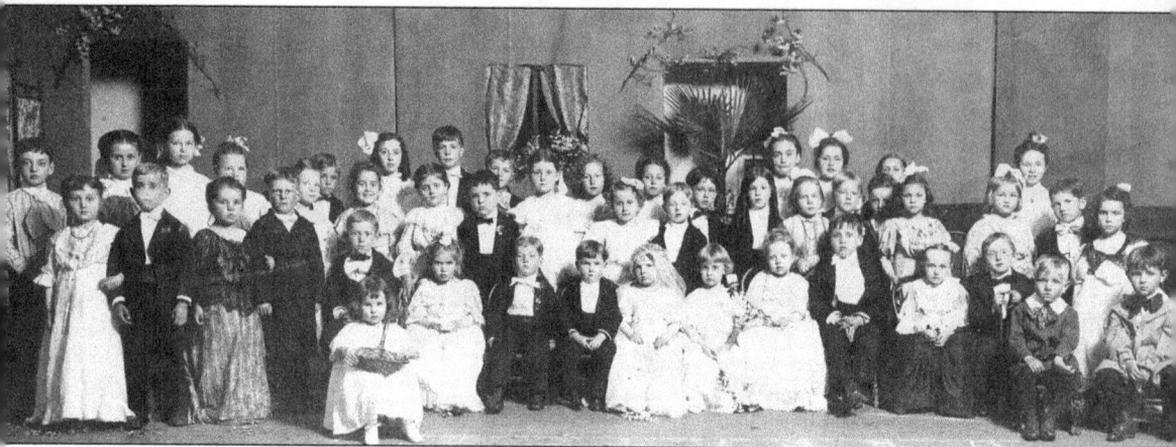

In 1905, children from the community pose on stage at the Scott Opera House on Main Street. They were involved in a performance of *Tom Thumb Wedding*. According to a *New York Times* story dated June 16, 1991, the real Tom Thumb was a midget named Charles Stratton who was an entertainer with the P. T. Barnum Circus. In 1863, he married a dwarf, Lavinia Warren. P. T. Barnum gave them a lavish and highly publicized wedding. The popular spectacle led to a humorous play, *The Tom Thumb Wedding*, performed by community troupes across the country. The plays featured children as actors and were used as community fund-raisers. (Fairmount Antique Mall.)

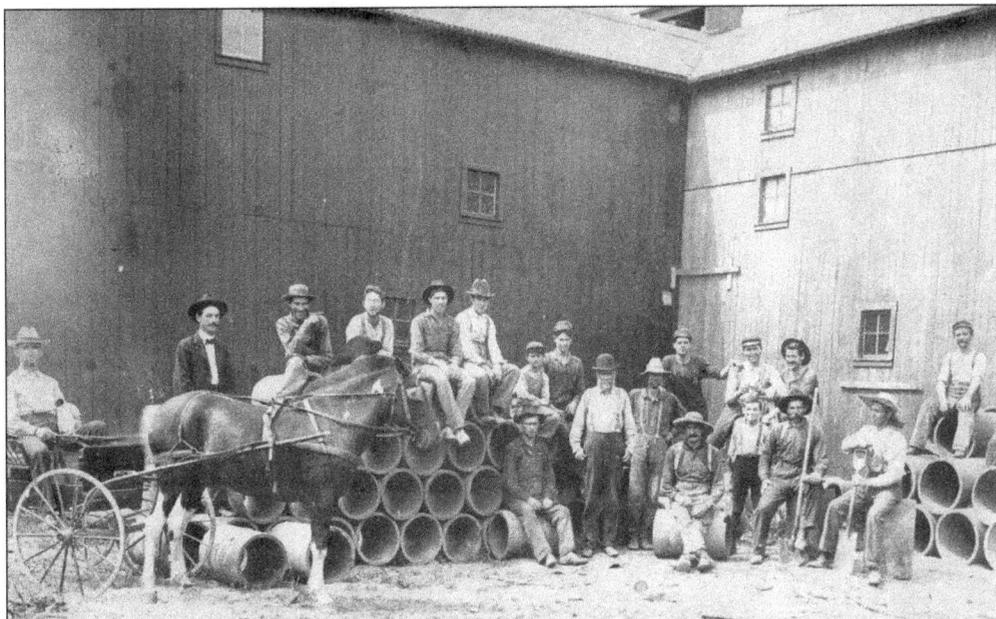

These workers, seen around 1910, are at the Asa Wright Tile Mill, located two miles west of Fairmount. Tony Payne is one of those pictured, who later became president of Fairmount State Bank. The mill pressed out wet clay through a tube from two to six inches around and cut it in one-foot lengths before drying and then burning them in a kiln.

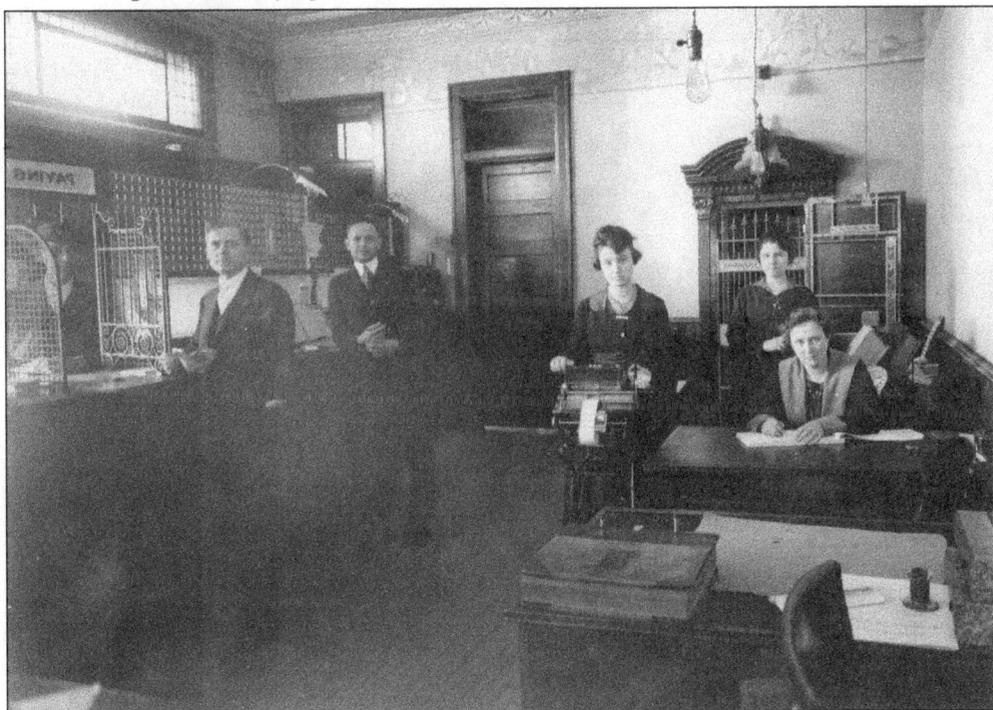

The Fairmount State Bank has been the cornerstone of Main and Washington Streets for decades. Pictured are, from left to right, Tonny Payne, Earl Morris, Jenny Monahan, Leola Roberts, and (seated) Nora Allen. (Bob Mcmanaman.)

This 1959 photograph shows a neighborhood picnic at "The Point" near where Jill Miller Henry grew up at 416 Henley Avenue. From left to right are Maxine Riley, Dr. Charles Yale, Dorothy Wood, and Miriam Hunt; Virginia Yale is standing. (Jill Miller Henry.)

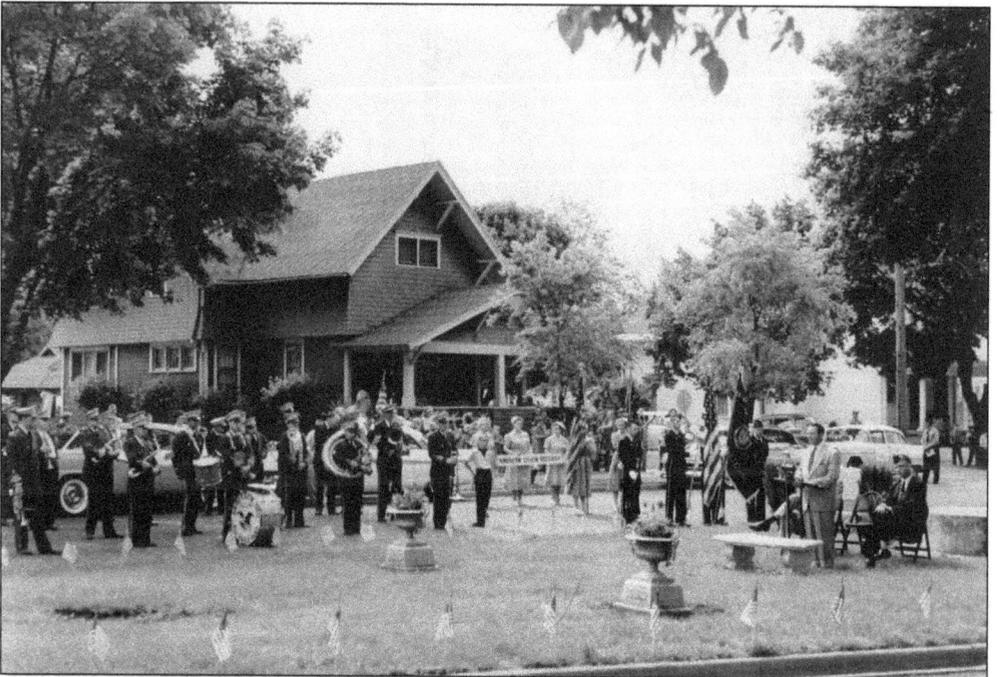

This annual Memorial Day ceremony, photographed in the 1950s, included a march down to the cemetery where there was a gun salute. Two women hold a banner for the American Legion Auxiliary, and the band likely played patriotic tunes. (Roz Carter McCarty.)

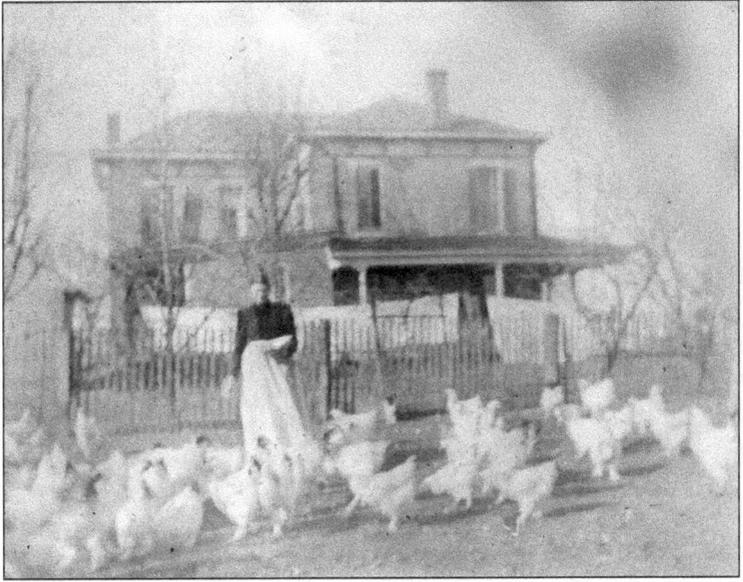

Taken around 1900, this photograph of the east side of Nixon Winslow's Washington Street home shows chickens running in the yard. It is believed that the woman is Nixon Winslow's wife, Cynthia. (WFC.)

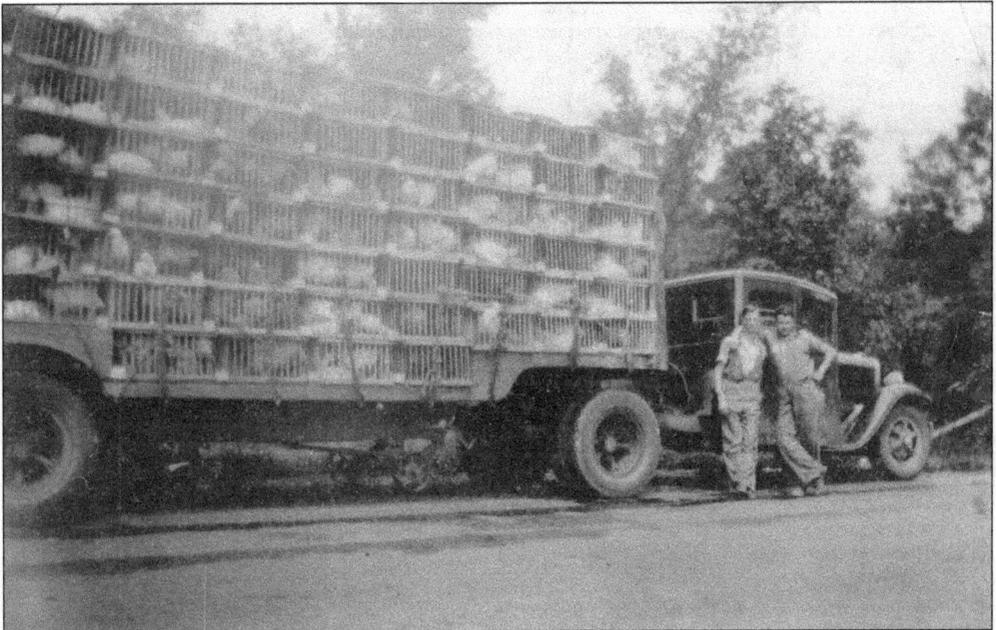

Joe Payne and Kenny Brookshire drove chickens from the old mill on Mill and Washington Streets to Pennsylvania. Later when they started their egg and poultry business, Frieda Payne would weigh the eggs and grade them. There was a $5 fine if the chickens were brought to market with their legs tied together, because they were supposed to be brought there in a humane condition. (Joe E. and Frieda Payne family.)

Payne's Hatchery was run by Joe E. and Frieda Payne in the 300 block of South Sycamore Street. (Joe E. and Frieda Payne Family.)

The Ben Franklin store was a mainstay in the community. This shows the store's opening in 1936. By 1950, the store had expanded into the space to the south of it, but it burned in 1967 and never reopened. There is a dollar store at the same location today.

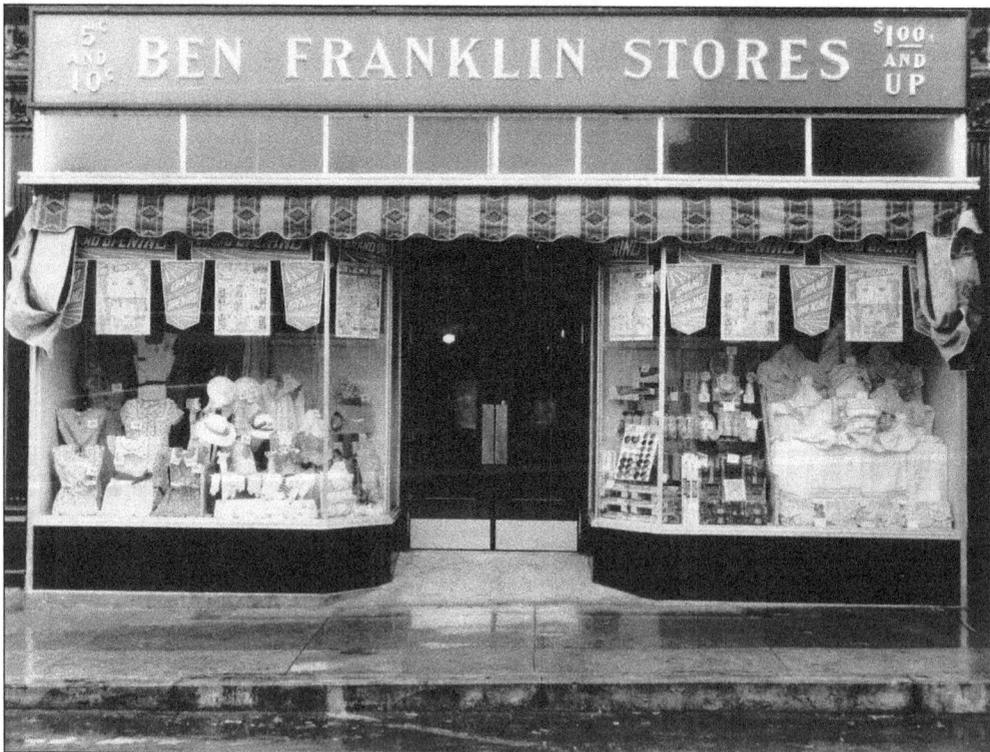

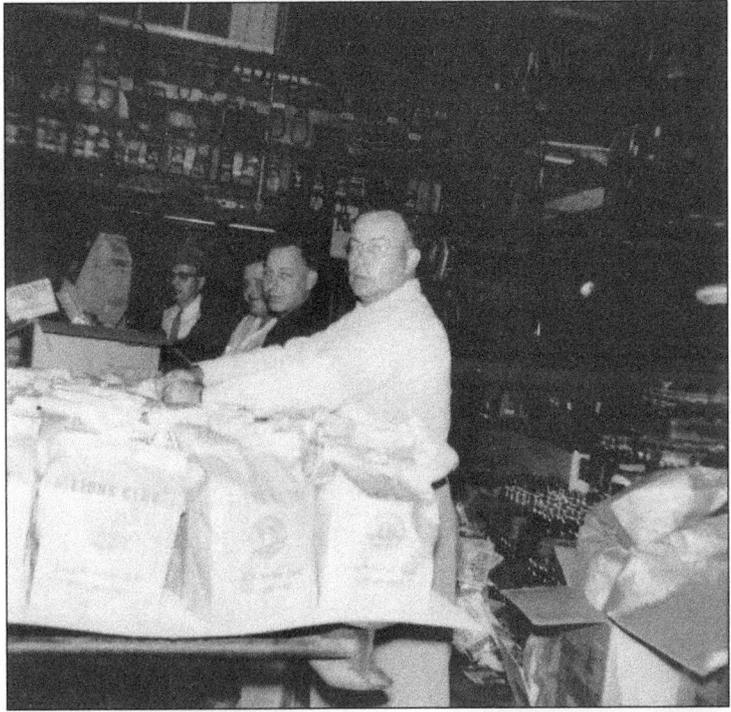

At right, Harold Hackney and members of the Fairmount Lions Club are working on a project in 1950 in his garage. Harold was very involved in the community and brought in the Harlem Globetrotters. He also played Santa Clause in the 1960s. His convenience store, which offered a wide variety of items and was part of his gas station business, was one of the first of its kind in the area. (Both Curt Hackney.)

Homer Carter was a veterinarian in Fairmount for 50 years, from 1940 until 1990. He was a friendly, familiar face to farmers and pet owners alike. (Roz Carter McCarty.)

The Kesler Ford dealership was one of several automobile dealerships in Fairmount over the years. The photograph shows the dealership being awarded special recognition. In the 1950s, Ralph Riley owned the Dodge dealership. He later joined Kesler Ford and became their top salesman. (Roz Carter McCarty.)

In May 1949, James Dean (second row, left) and his classmates from Fairmount High School went on their senior trip to Washington, D.C. For many years, taking that trip was a tradition for the senior class. They all talked about it for years afterward. (JDG.)

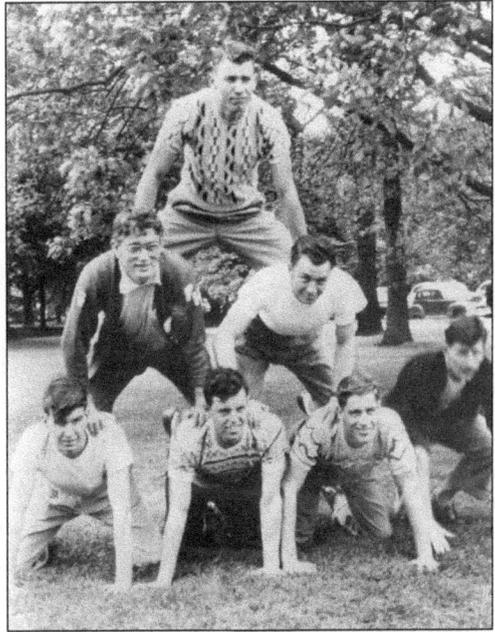

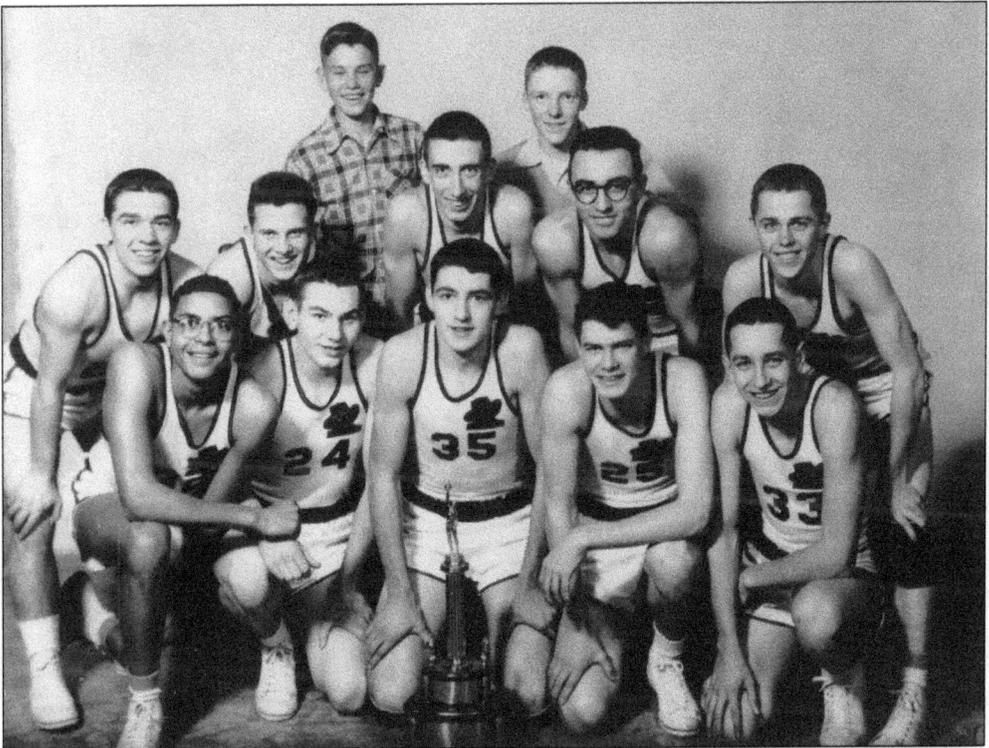

The Fairmount Quakers basketball team of 1955 won the sectional. The players, from left to right, are (first row) Jim Pettiford, Fred Barnhart, Dick Stroup, Larry Wood, and Bob Pernod; (second row) Jim Cromer, Charles Himelick, Bob Allen, Larry Stookey, and Jerry Blake; (third row) managers Kenneth Eccles and Bob Sheets. After high school, Bob Sheets earned his doctorate in meteorology and was director of the National Hurricane Center among other achievements.

In this street scene, the Ben Franklin Store still existed. It burned down in 1967. On the right, the big IGA sign advertises Driskill's Supermarket, a family-owned staple in the community for decades. Years before this, there were more unusual downtown sights. "There was a stockyard off Tyler Avenue. So cows and livestock would go through town," Ray Bush says.

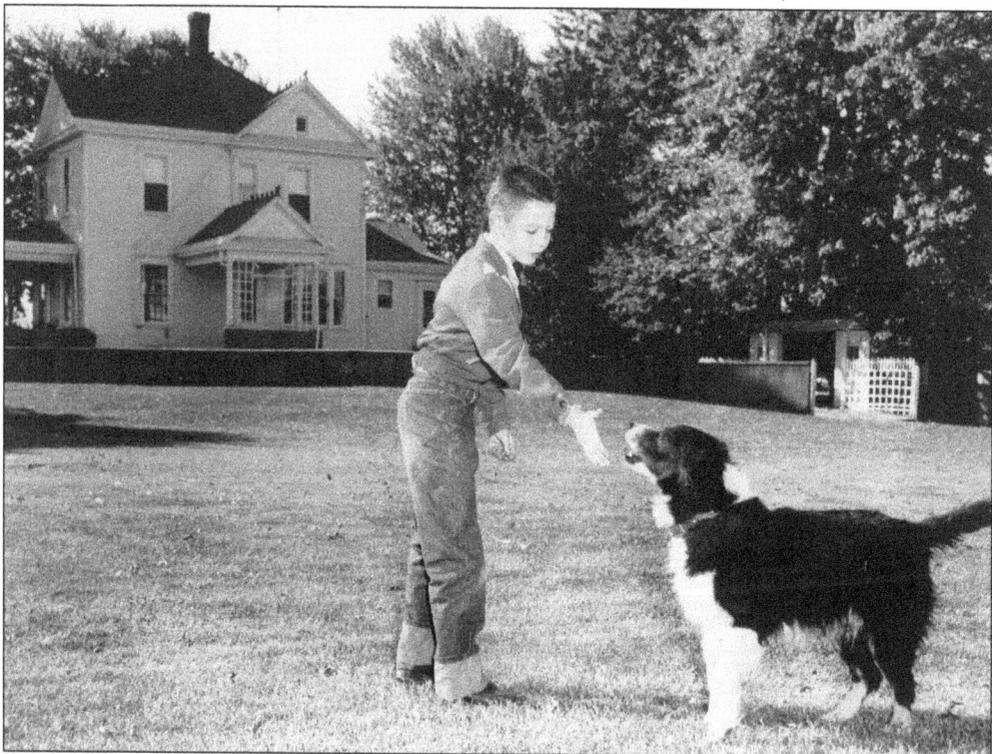

This 1957 photograph shows Marcus Winslow Jr., James Dean's cousin, with his dog Tuck. By the time Marcus was born in 1943, Jimmy Dean was a member of Marcus and Ortense Winslow's family. So when Joan Winslow welcomed her baby brother home, Jimmy did too. The cousins were close. Dian Shields Hoheimer was classmates with Marcus and remembers being envious one day when Marcus was called out of school early because his cousin was home to visit. (JDG.)

Eight

GARFIELD'S JIM DAVIS

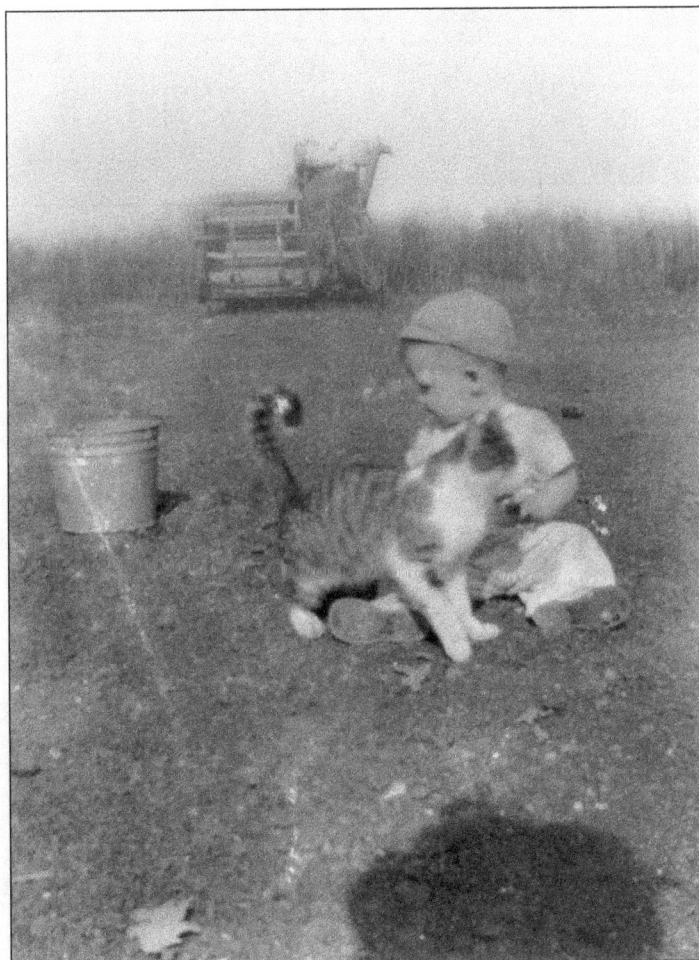

This photograph was taken in 1946 of Garfield creator Jim Davis when he was about one year old. Jim was born on July 28, 1945, and was raised on a farm near Fairmount. He credits the many farm cats he had around him growing up for his current success with his famous, grouchy cat. A piece of farm machinery sits in the background. (Mr. and Mrs. James W. Davis.)

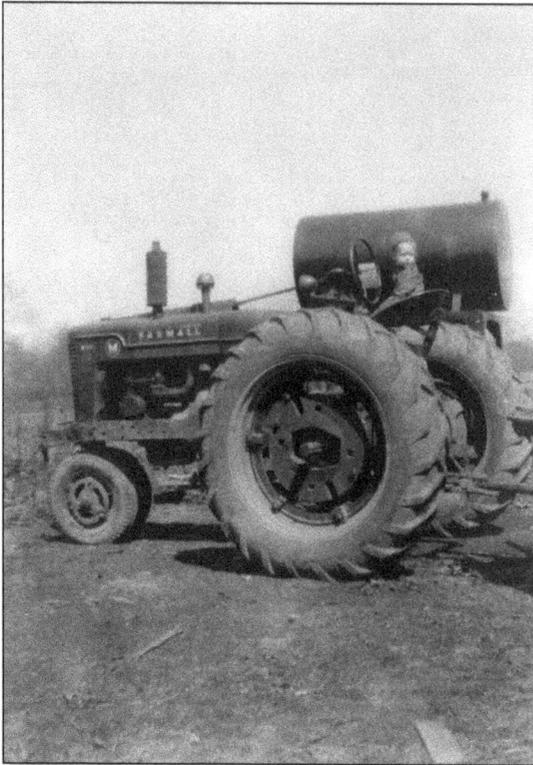

Jim Davis sits on a Farmall tractor on his parents' farm. His dad raised Black Angus cattle. As a child, Jim had asthma, which limited his ability to participate in some childhood activities. (Mr. and Mrs. James W. Davis.)

Jim Davis is a toddler in pastel overalls in this 1948 photograph. Davis has said he was a farm boy through and through. The down-to-earth hominess of his cat's character may have come from his farm upbringing. Guinness World Records named Garfield "The Most Widely Syndicated Comic Strip in the World." (Mr. and Mrs. James W. Davis.)

In 1949, Jim Davis checks out a Dick Tracy comic book. He enjoyed many comic book characters, including Mort Walker's *Beetle Bailey*, and he also enjoyed reading the newspaper, especially the funnies. Because of his asthma, he spent a lot of time resting in bed when he was young. (Mr. and Mrs. James W. Davis.)

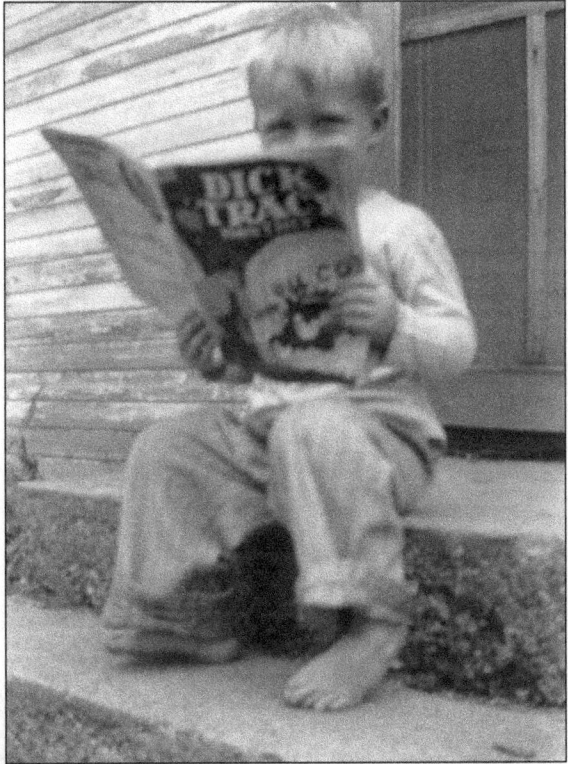

Jim Davis sits in his high chair. One of the most popular aspects of the Garfield comic strips is the cat's love affair with food, especially lasagna. (Mr. and Mrs. James W. Davis.)

Jim Davis poses in a metal tub at about three years old. His mother, Betty, shared her love of drawing with him at an early age. While he needed to stay quiet because of his asthma, she gave him pencil and paper and helped him draw. They shared a talent for art. At first, he had to label the things he had drawn. But his skills improved along with his health. (Mr. and Mrs. James W. Davis.)

In this 1951 photograph, Jim Davis (left), his mother Betty, and his brother "Doc" are celebrating Christmas. Although Jim's asthma was improving by this age, in grade school he began stuttering. A special teacher helped him overcome this challenge, partly by reminding him to think before he spoke. Today that concept serves him well during interviews. (Mr. and Mrs. James W. Davis.)

Jim Davis holds his birthday cake in 1951. In his book, *20 Years and Still Kicking: Garfield's Twentieth Anniversary Collection*, Jim also celebrates Garfield's "birthday." He tried several other comic strips with limited success. Every year he celebrates June 19, 1978, the day Garfield debuted in newspapers. He came up with the name for his comic strip from his grandfather James A. Garfield Davis. (Mr. and Mrs. James W. Davis.)

In this photograph, a young Jim Davis has on a shirt with details similar to what a cowboy would wear, a style that was popular with everyone raised on a farm. Cowboy boots were also a common sight on little boys around Fairmount. (Mr. and Mrs. James W. Davis.)

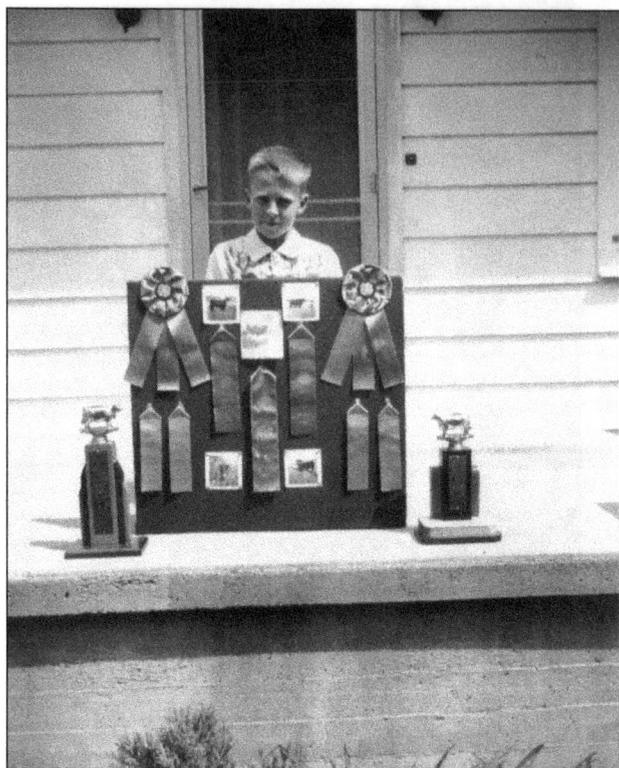

Jim Davis poses with a poster of his many 4-H ribbons. He would raise a calf to show. Perhaps the 4-H motto, "To make the best better," inspired him during the time he assisted cartoonist Tom Ryan on *Tumbleweeds* and spent his nights and weekends working on his own comic strips. (Mr. and Mrs. James W. Davis.)

In 1954, Jim Davis added some flair to his look in this semi-formal photograph. In his book *20 Years and Still Kicking! Garfield's Twentieth anniversary Collection*, Jim wrote, "Being a country boy at heart, I really enjoyed those strips with mom and dad." (Mr. and Mrs. James W. Davis.)

"Doc," whose real name is Dave, is shown with Jim Davis as they play with kittens. Doc Boy in the comic strip is his brother, Dave. Jim's early farm life gave him an appreciation for nature, and he has underwritten a number of environmental projects in his home state. Jim was awarded the National Arbor Day Foundation's Good Steward and Special Projects Award and the Indiana Wildlife Federations' Conservationist of the Year Award. (Mr. and Mrs. James W. Davis.)

This 1950 photograph of James Garfield and Lydia Davis, grandparents of Jim Davis, shows the inspiration for the naming of and some of the characteristics of Garfield the cat. Jim has said Garfield is a composite of all the cats he remembered from his childhood all rolled into one feisty orange fur ball. In 1981, Jim founded Paws, Inc., which manages the worldwide rights of Garfield and is located in Muncie, Indiana. (Mr. and Mrs. James W. Davis.)

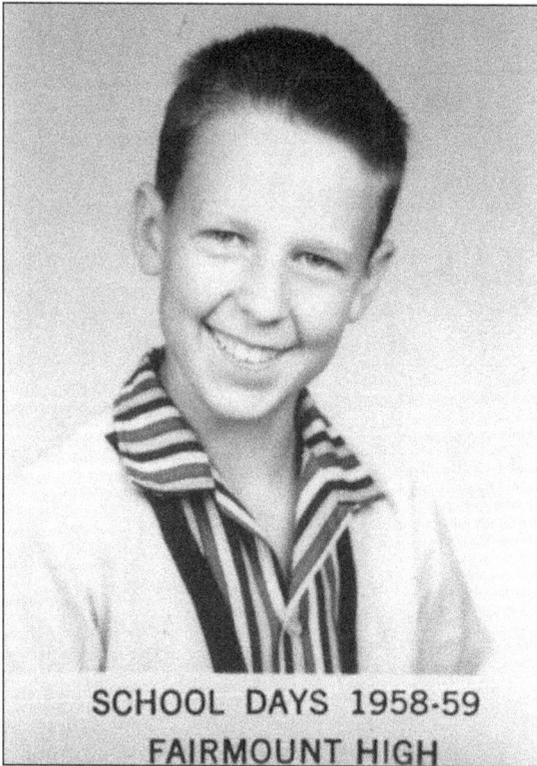

SCHOOL DAYS 1958-59
FAIRMOUNT HIGH

This school days pose was taken of Jim for the 1958–1959 school year at Fairmount High School. He did okay in school, but drawing was his true love. When he got to college at Ball State University in Muncie as an art and business major, he wrote the following in his book *20 Years and Still Kicking! Garfield's Twentieth Anniversary Collection*, "I distinguished myself by earning one of the lowest cumulative grade point averages in the history of the university."

Jim Davis wears his letter jacket from Fairmount High School in this 1962 photograph. Jim drew characters in the senior yearbook, which predicted, "If this lad develops his artistic skill, his drawings will take care of any big bill." (Mr. and Mrs. James W. Davis.)

Nine

ACTOR JAMES DEAN

American film actor James Byron Dean was born on February 8, 1931. When his mother died in 1940, he was nine. He came to live with his Uncle Marcus and Aunt Ortense Winslow on their farm a couple of miles north of Fairmount. Years later, after graduating from Fairmount High School in 1949, he would return to the farm numerous times to visit his family. In 1955, Dean brought well-known photographer Dennis Stock to Fairmount. They went to many places in town, and Stock took photographs of Dean. (WFC.)

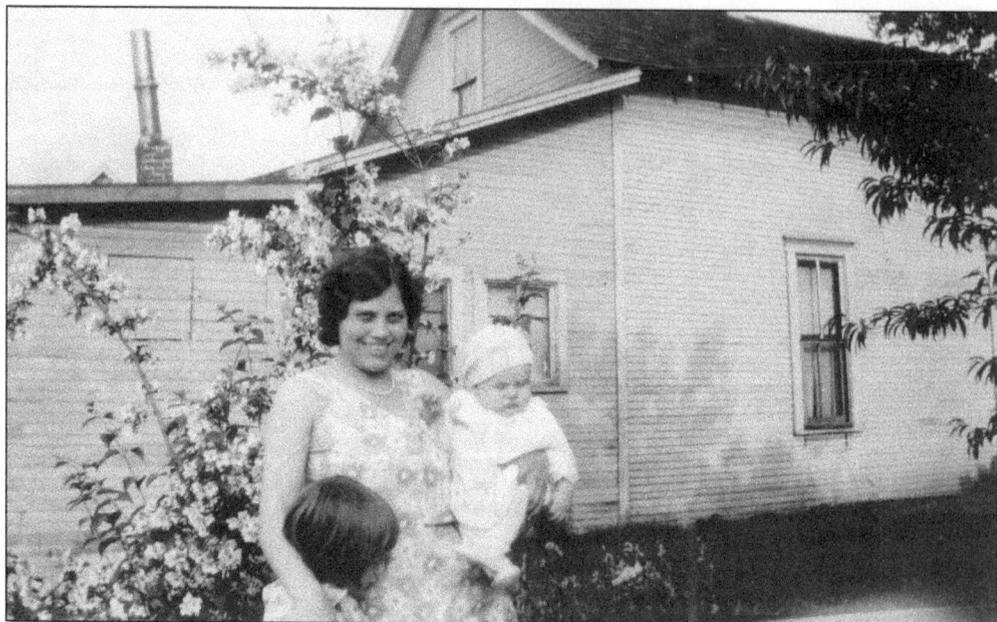

This is baby Jimmy in his mother Mildred's arms at their house on West First Street with cousin Joan standing beside them. Jim and his parents, Winton and Mildred Dean, lived in several different homes in Fairmount, and Jimmy often visited his Uncle Marcus and Aunt Ortense on the farm. (WFC.)

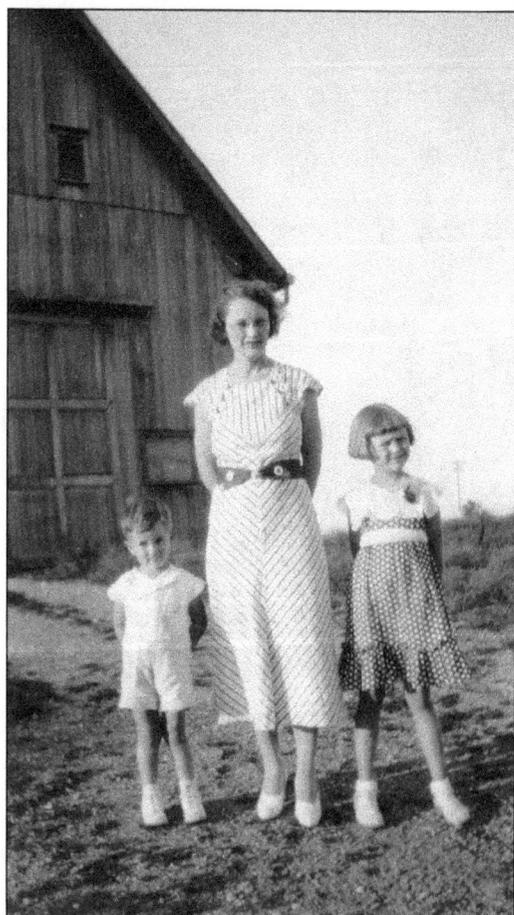

James Dean was about two years old in this picture with his Aunt Ortense and cousin Joan, which was taken on the Winslow farm. "I used to babysit Jimmy when he was three years old," Joan Winslow Peacock says. "He was a real normal boy. He liked to play hide and seek. He'd always hide from us and we'd have to find him." (WFC.)

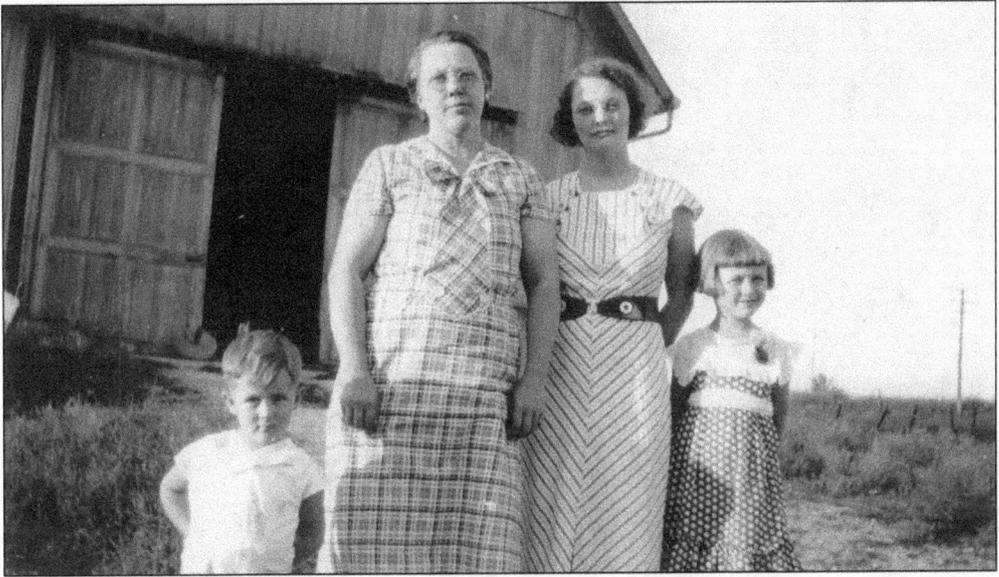

Young Jimmy Dean often came to the Winslow farm. In this photograph, he is pictured with family members and their housekeeper. From left to right they are Jimmy Dean, Martha ?, Ortense Winslow, and Joan Winslow. When his mother died, Jimmy was living with his family in California, where his father worked as a dental technician at the Veterans Administration Hospital. Jim's grandmother Emma Dean rode the train from California and brought nine-year-old Jimmy and his mother's body back to Fairmount. The family decided it best to have the boy stay with his Aunt Ortense and Uncle Marcus Winslow. (WFC.)

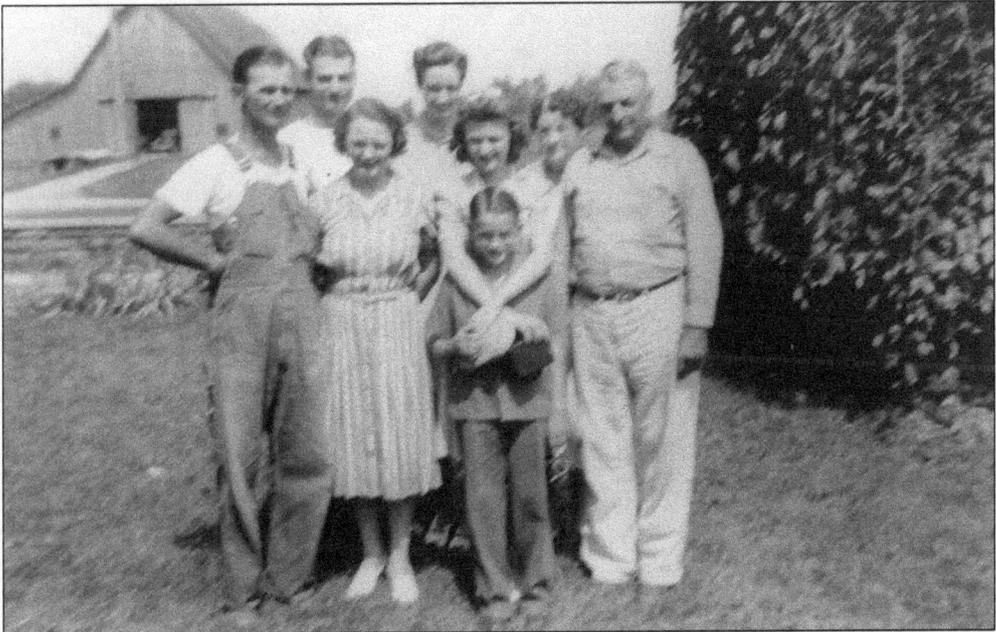

This photograph was taken the day Jimmy's mother's body was brought back home. Members of James Dean's family, from left to right, are (first row) Marcus Winslow Sr., Ortense Winslow, Joan Winslow with her arms around Jimmy, and Grandpa Charles Dean; (second row) Jimmy's uncle Charles Nolan Dean, Aunt Mildred Dean, and Grandma Emma Dean. (WFC.)

This is Jimmy Dean standing at the side of the house on the Winslow farm around 1941. Jimmy and his cousin Marcus Winslow remained close after James Dean went to Hollywood and began getting acting parts. (WFC.)

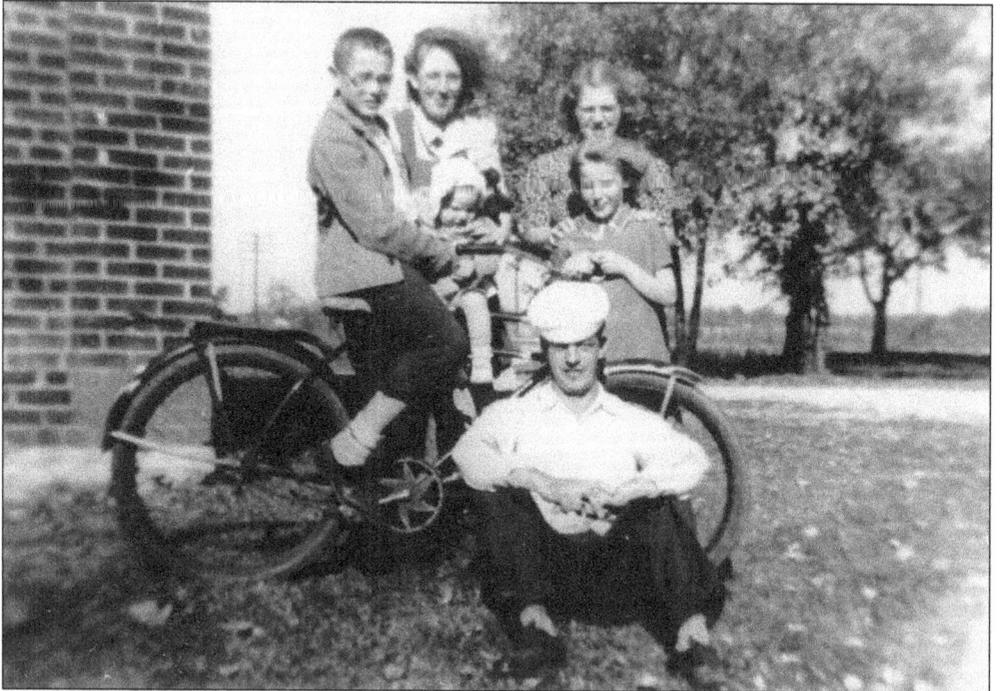

Jim Dean is sitting on a bicycle with members of the Harrold Rust family in front of the Back Creek Friends Meeting House. The Rusts lived in the house south of the church. Years later, Harrold and Jimmy stayed in touch after high school. (Rust family collection.)

Jimmy poses at the side of the house on Winslow farm. The mischievous look on his face and his posture might have been the first hint of the attitude that served him well in his movie *Rebel Without a Cause*. He made it clear farming was not his future occupation. (WFC.)

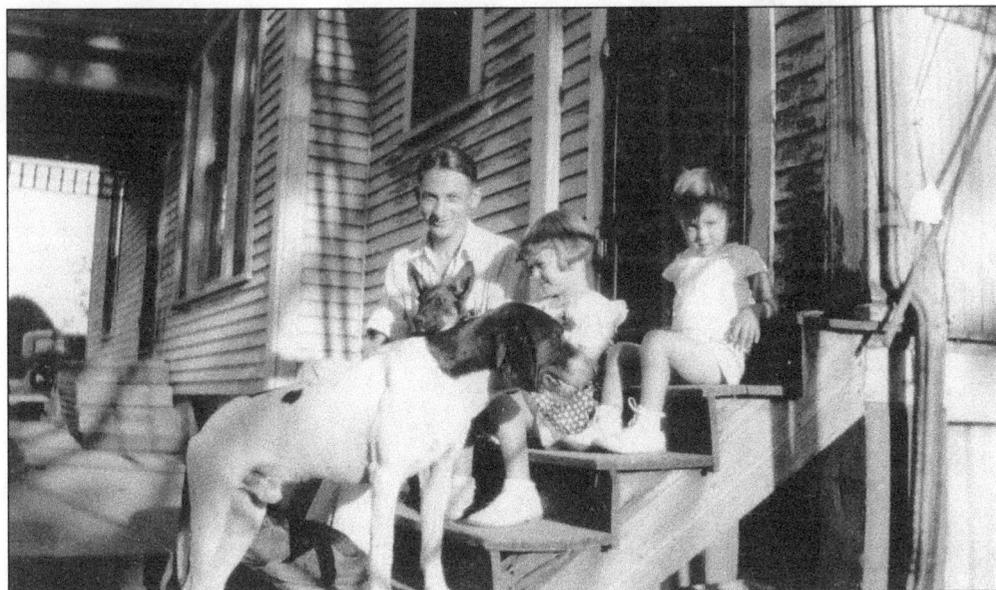

Winton, Jimmy Dean, and Jimmy's cousin Joan Winslow pose with their dogs on the side porch of the Winslow home. (WFC.)

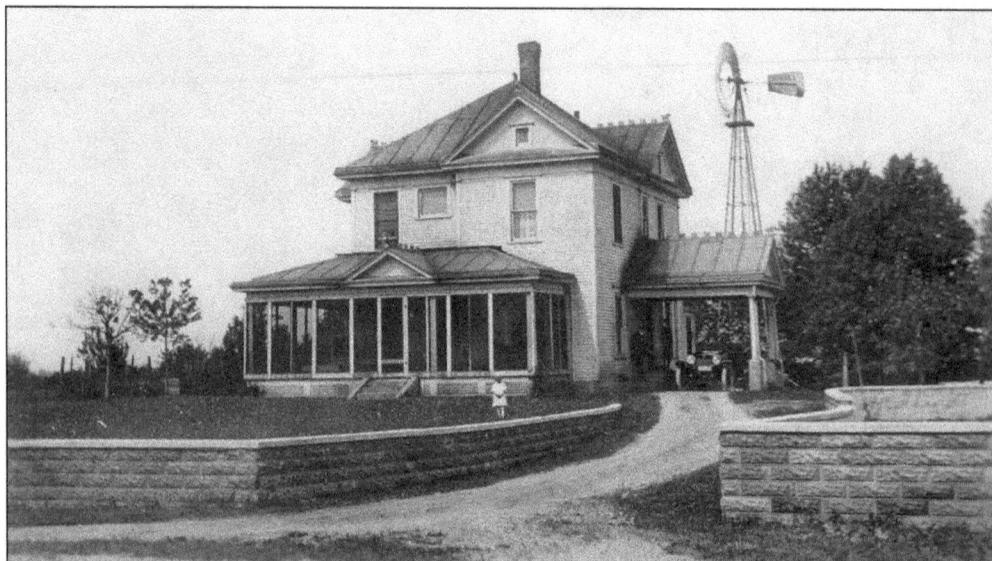

The Winslow farm is about 180 acres. This is how it looked around 1915. (WFC.)

Jimmy Dean liked to ride his bike. In this photograph, he is seen on the Winslow farm by the carport with a 1937 Chevrolet nearby. (WFC)

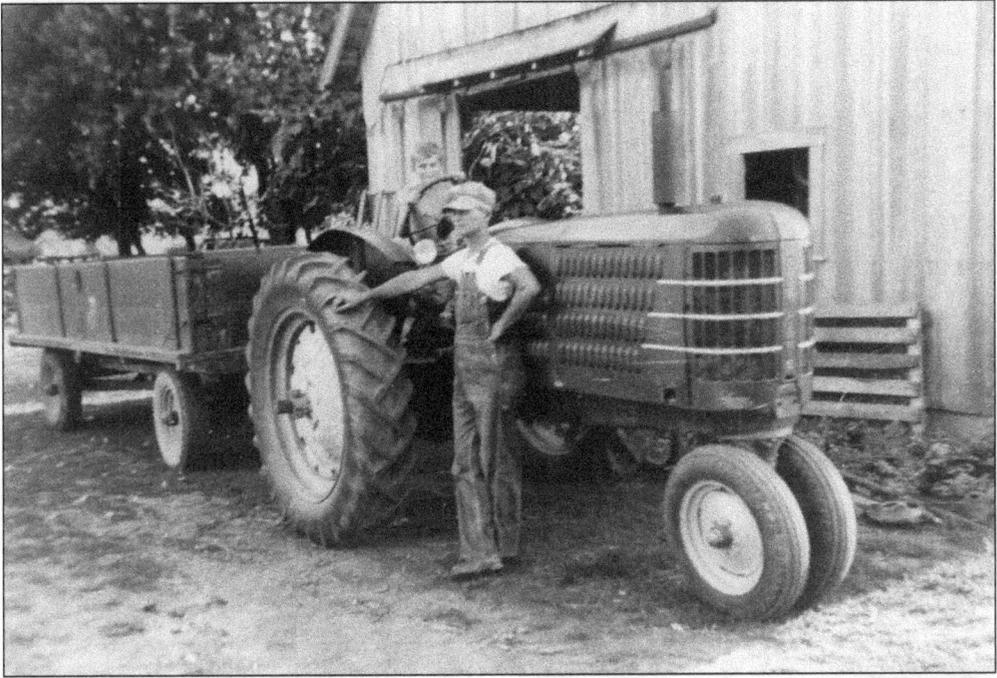

In about 1942, this photograph of young Jimmy Dean and his Uncle Marcus looked similar to those in many other farm families' scrapbooks. They are photographed with a Massey Harris Tractor. Although Jimmy never minded having his picture taken, he did not plan to grow up to be a farmer. (WFC.)

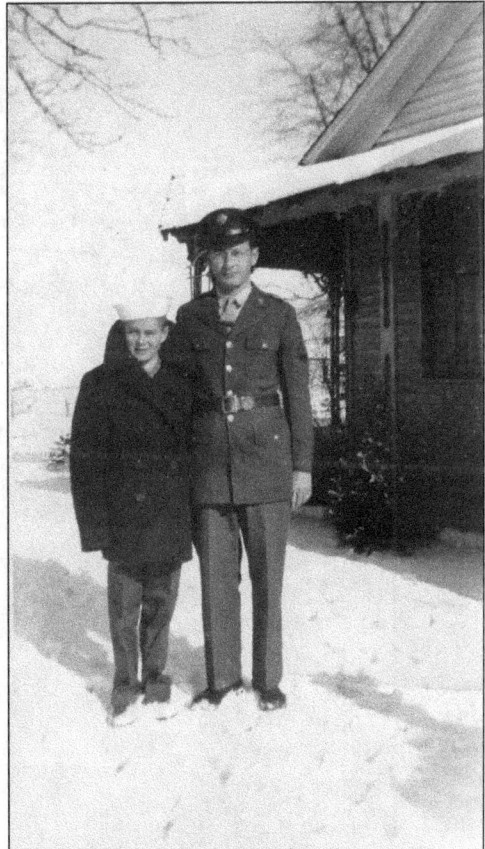

This photograph is of Jimmy Dean with his father, Winton Dean, in 1944 at Grandma Emma and Grandpa Charles Dean's house at 802 East Washington Street in Fairmount. Winton visited whenever he could, but he worked as a dental assistant in the service and was stationed in California. (WFC.)

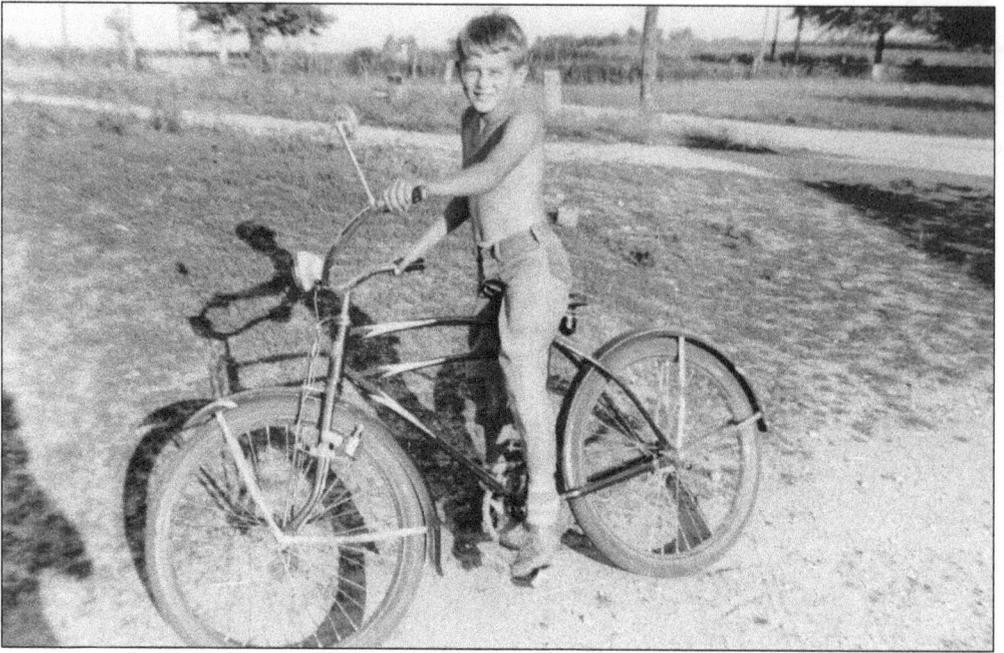

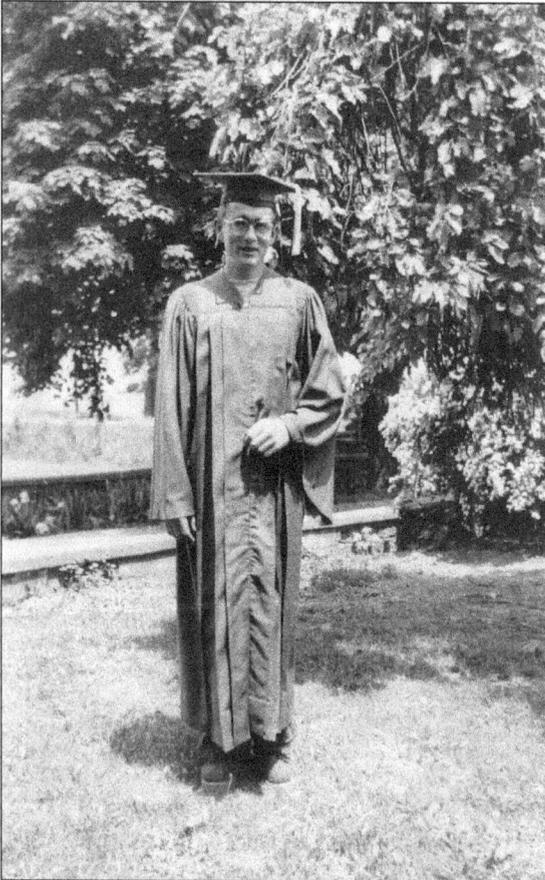

Above, Jimmy is pictured at about age 10 on a bicycle his Uncle Marcus fixed up with a light and a generator so he could get around after dark. This early set of wheels was replaced when Jimmy was around 15. His Uncle Marcus gave him an inexpensive motorcycle from Czechoslovakia, which he pushed to its maximum 50 miles per hour. After Dean graduated, Jim Gaddis says he remembers playing a kind of game with him on his motorcycle once. They would pass each other, taking turns being in the lead on the road going beside the Winslow farm. The photograph to the left is James Dean shown in his graduation gown. The graduation ceremony was held at the Wesleyan Campgrounds in Fairmount. (Both WFC.)

After making just three movies, which were *East of Eden*, *Rebel Without a Cause*, and *Giant*, James Dean's life was cut short at age 24. He was killed in a car accident on September 30, 1955. At right is a photograph of Fairmount minister Xen Harvey at Park Cemetery where he participated in a ceremony commemorating the first anniversary of Dean's death. The photograph below shows that Dean was such a popular actor that the ceremony commemorating his death was well attended. (Both Roz Carter McCarty.)

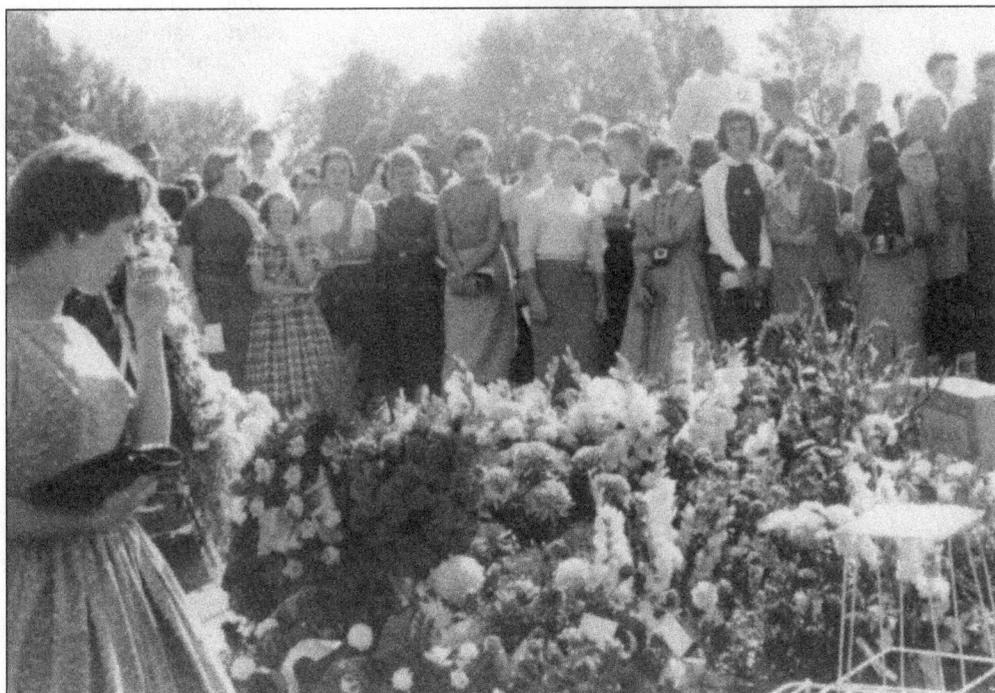

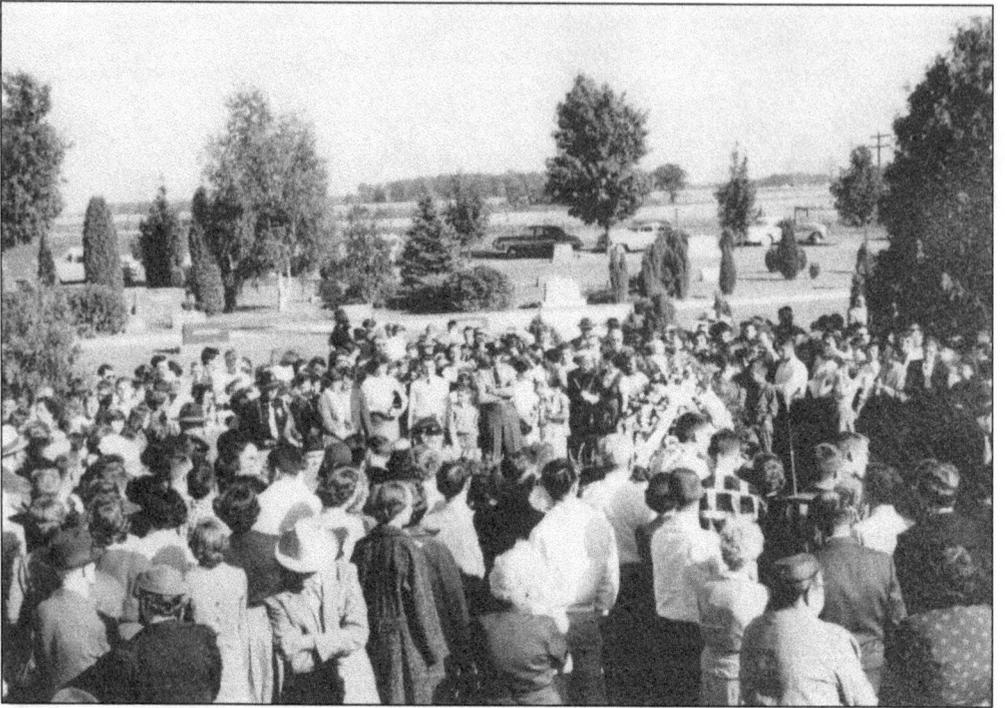

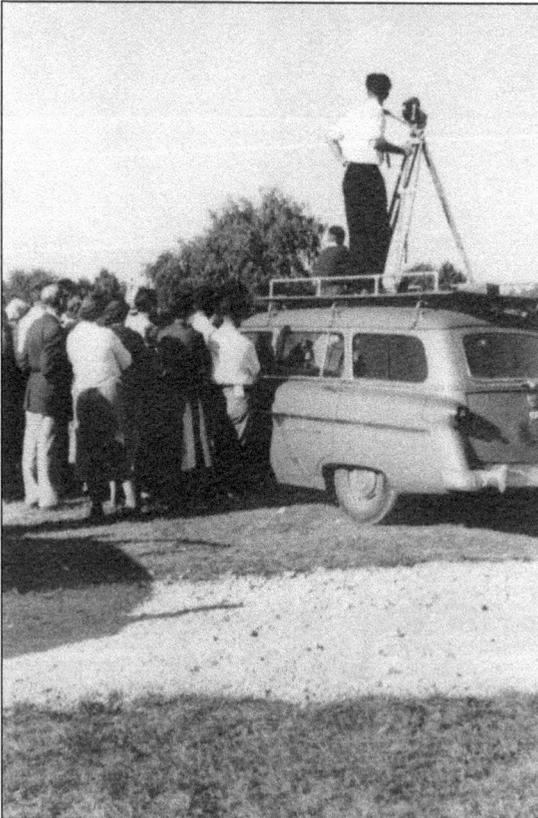

The above photograph shows the size of the audience that attended the one-year memorial service of James Dean's death. The photograph to the left is evidence that the media attention surrounding James Dean continued after his death. A photographer is standing on top of his car to get a better shot of the ceremony. (Both Roz Carter McCarty.)

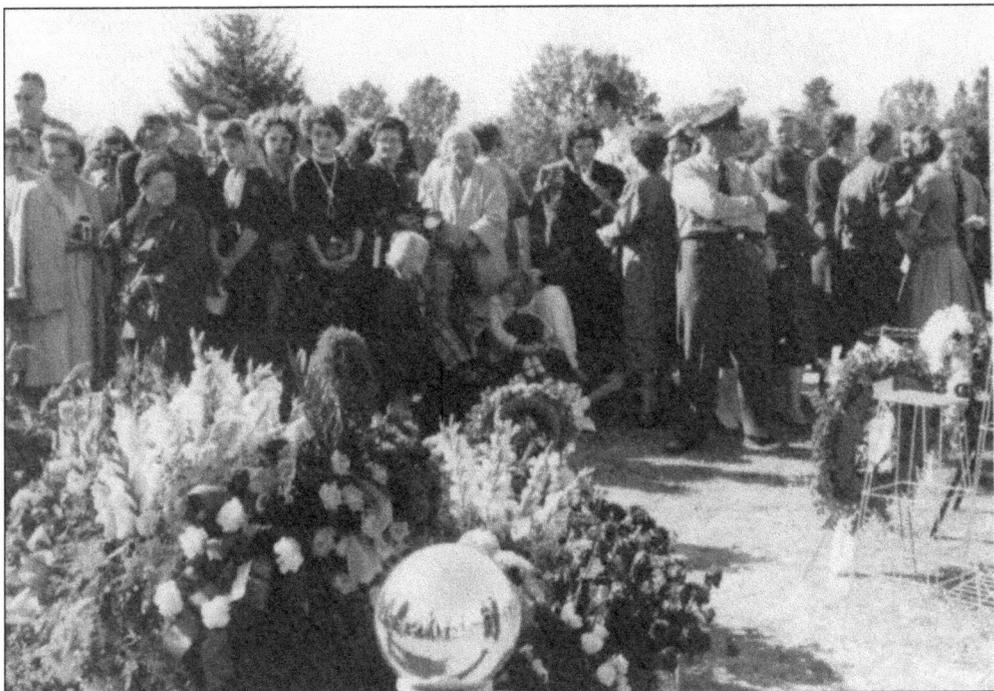

These photographs show the many flowers and wreaths sent for the commemorative ceremony for the first anniversary of James Dean's death. Above, an officer surveys the crowd. (Both Roz Carter McCarty.)

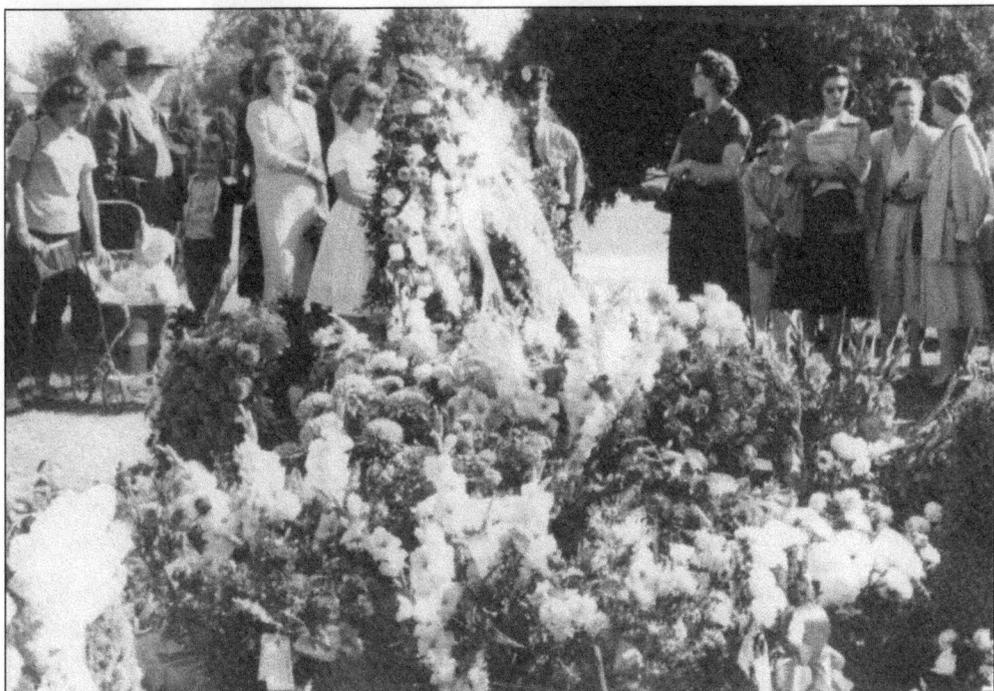

Friends remember that Dean loved the spotlight. On February 12, 1955, the Fairmount High School had a sweetheart dance. James Dean was living in California, but he was in town and went to the dance. This is a photograph in the gymnasium, which was decorated for the dance. It turned out to be his last trip home. (Ron Payne.)

At the sweetheart dance, an unidentified person and Pat Ellsroth (center) visit with James Dean. On a previous visit home, Jimmy shared his inquisitive, fun-loving personality with students attending Fairmount High School. He demonstrated his newly acquired bullfighting skills for the students and also played a game of basketball. "After the game, he crawled out of the gym on his hands and knees with his tongue hanging out, claiming the boys had warn him out," says Bill Payne. (Ron Payne.)

Roger Pulley and Nancy O'Brien get autographs from James Dean at the sweetheart dance at Fairmount High School in 1955. Dean often came to Fairmount High School when he was home. Sometimes he visited the classroom of his drama teacher, Adeline Nall. (Ron Payne.)

James Dean is playing the conga drums with, from left to right, Brenda Ellingwood Hayes, "Sparky" Phil Mitchener, and Martin Lee Davis looking on at the sweetheart dance. "It was real cold that night," said Mitchener. "We dressed up in suits and ties. We were all talking to Jimmy before he started playing the congas. I think he asked Brenda if she wanted to play the congas and she said no. Now she wished she would have." Mitchener said they did not pay that much attention to Dean because he "was just part of Fairmount." (JDG.)

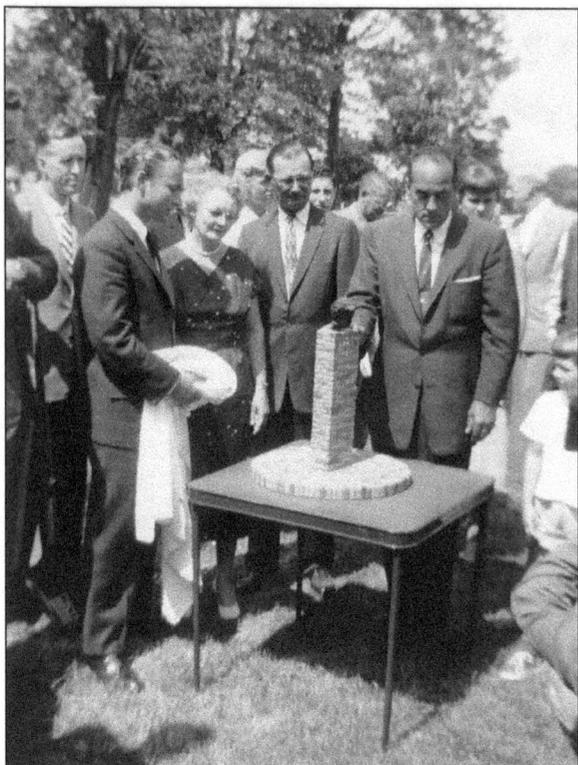

In 1957, actor Nick Adams participated in a ceremony to unveil a bust of James Dean created by Kenneth Kendall. The people in front at the ceremony are, from left to right, Nick Adams, Ortense Winslow, Marcus Winslow, and Howard Miller. Adams had a television show called *The Rebel*, and Miller was a popular disc jockey. (JDG.)

In 1956, a James Dean Memorial Foundation was formed. Members of the foundation are listed, from left to right, as John H. Siegel, F. Stanton Galey, Marcus Winslow Sr., Joe W. Payne, and Les Johnston. The purpose was to continue the James Dean legacy and sponsor scholarships. The organization created an acting school, and the students performed plays at various venues. (JDG.)

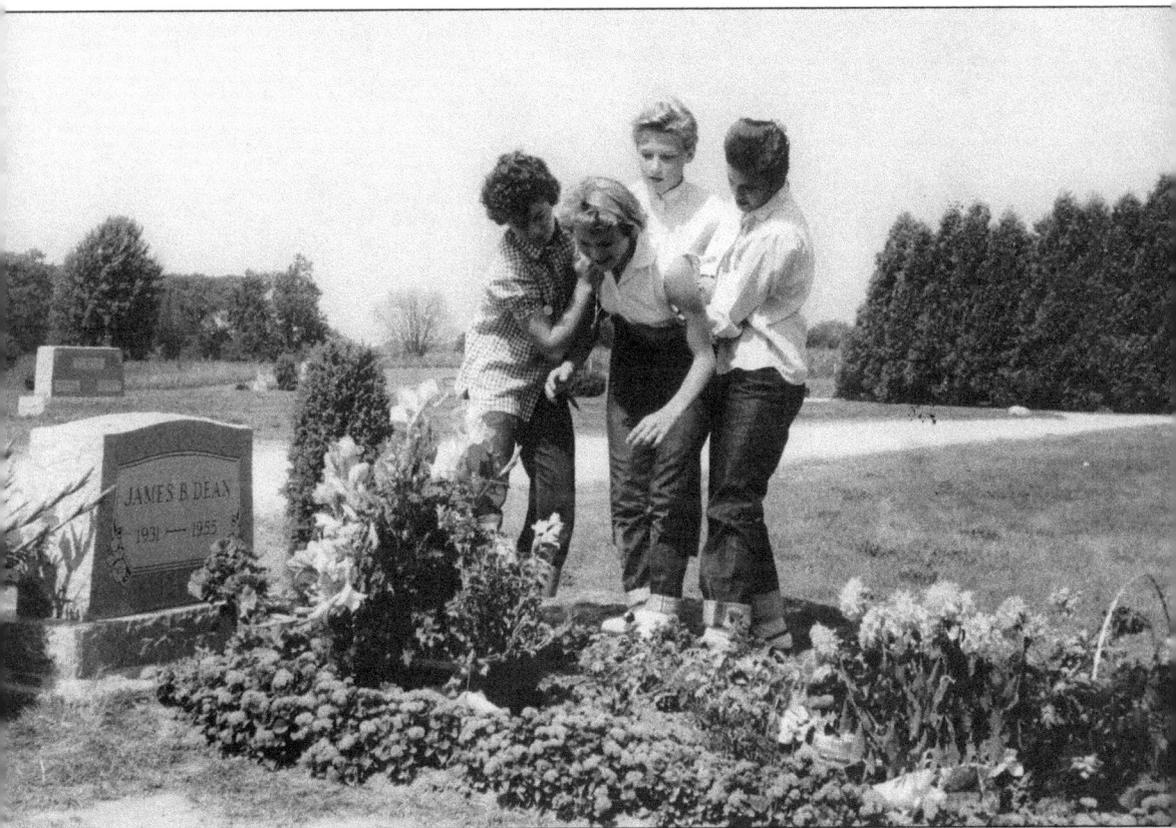

In 1956, *Marie Claire*, a French magazine, came to Fairmount to do a story on James Dean. The magazine writer went to Fairmount High School and asked these girls to create some drama for the photograph shoot. So they are pretending to mourn James Dean's death. The story appeared in November of that year. It is easy to imagine Dean would have appreciated this acting on his behalf. (JDG.)

BIBLIOGRAPHY

Baldwin, Edgar M. *The Making of a Township*. Fairmount, IN: Edgar Baldwin Printing Company, 1975.

Cuba, Stanley L. *Olive Rush: A Hoosier Artist in New Mexico*. Muncie, IN: Minnetrista Cultural Foundation, Inc., 1992.

Davis, Jim *20 Years and Still Kicking! Garfield's Twentieth Anniversary Collection*. New York: Ballantine Books, 1998.

Glass, James A, and David Kohrman. *The Gas Boom of East Central Indiana*. Chicago: Arcadia Publishing, 2005.

Hoover, Dwight W. "Daisy Douglas Barr: From Quaker to Klan 'Kluckeress.' " *Indiana Magazine of History* (June 1991): 171–195

Kingman Brothers. *Combination Atlas Map of Grant County Indiana*. Knightstown, IN: The Bookmark, 1987.

Perry, George. *James Dean*. New York: DK Publishing, 2005.

Warr, Ann and Harry. *Area History of Fairmount, Indiana*. Curtis Media, Inc., 1997.

INDEX

Visit us at
arcadiapublishing.com

www.ingramcontent.com/pod-product-compliance
Lightning Source LLC
Chambersburg PA
CBHW080629110426
42813CB00006B/1640